DRAWINGS Of CHOICE

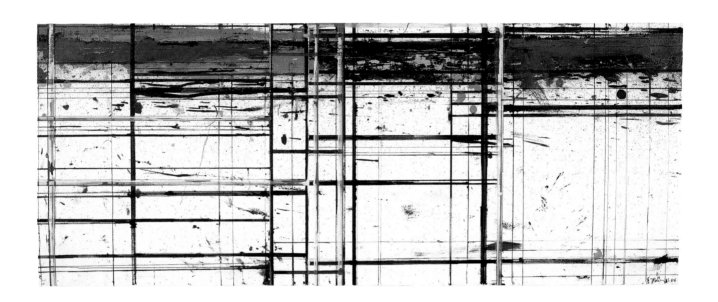

Edited by
Josef Helfenstein and Jonathan Fineberg

DRAWINGS Of CHOICE

from a New York Collection

With contributions by

Kavie Barnes
Sarah Louise Eckhardt
Eun Young Jung
Amy M. Kuhl
Jordana E. Moore
Li-Lin Tseng
Chang Wang
Dawson Weber
Phoebe Wolfskill

Krannert Art Museum · University of Illinois at Urbana-Champaign
Arkansas Arts Center · Little Rock, Arkansas

This book serves as the catalogue for the exhibition,
Drawings of Choice from a New York Collection,
organized by Krannert Art Museum.

Concept: Josef Helfenstein
Curatorial assistance: Sarah Eckhardt
Collector's registrar: Amy Eshoo
Production assistance: Karen Hewitt, Cynthia Voelkl,
 Sarah Eckhardt, Rhonda Bruce
Copyeditor: Robert McCarthy
Designer: Evelyn C. Shapiro
Design assistance: Sarah Eckhardt

On the cover: Sol LeWitt, *Bordered Rectangles Within Bordered
Rectangles,* 1992, gouache on paper, 11 $\frac{1}{2}$ x 9 $\frac{1}{2}$ inches each.

Opposite title page: Brice Marden, *Masking Drawing No. 20,*
1983–1986, oil, ink and gouache on paper, 14 × 32 $\frac{7}{8}$ inches.

Krannert Art Museum
College of Fine and Applied Arts
University of Illinois at Urbana-Champaign
500 East Peabody Drive
Champaign, Illinois 61820

Permissions and photography credits located on page 172.

Library of Congress Control Number: 2002107662
ISBN 0-295-98285-3

Distributed by University of Washington Press

Manufactured in the United States

Lenders to the Exhibition

The Collector
The Museum of Modern Art, New York

Exhibition Schedule

KRANNERT ART MUSEUM, University of Illinois at Urbana-Champaign
September 4 to November 3, 2002

ARKANSAS ARTS CENTER, Little Rock, Arkansas
November 14, 2002 to February 2, 2003

GEORGIA MUSEUM OF ART, University of Georgia, Athens, Georgia
February 11 to March 23, 2003

BOWDOIN COLLEGE MUSEUM OF ART, Brunswick, Maine
April 10 to June 8, 2003

CINCINNATI ART MUSEUM, Cincinnati, Ohio
August 22 to November 16, 2003

Funders to the Exhibition

BankIllinois
Gay Roberts
Anne Slichter on behalf of the William H. G. FitzGerald Family Foundation
Illinois Arts Council
Research Board of the University of Illinois at Urbana-Champaign

Contents

Acknowledgments

Soon after my arrival at Krannert Art Museum in the fall of 2000, I visited the collector in New York, and we discussed the possibility of embarking on a research and exhibition project based on his outstanding collection of postwar American drawings. The collector most generously agreed to undertake the experiment even though the first comprehensive presentation of his collection, organized by Harvard University Art Museums in 1997, had barely completed its international tour. Without delay, we began work on a preliminary selection of drawings to include in the exhibition and publication. An additional meeting in New York with the collector and with Townsend Wolfe, director of the Arkansas Art Center, provided the security necessary to begin the final phase of preparations.

This book and the exhibition it accompanies present an outstanding set of contemporary American drawings from the 1960s through the present. Compiled over more than three decades, the collection includes single works and groups of drawings by forty-six artists. Based on the collector's distinguished taste, his commitment and his personal preferences, the collection is particularly strong in its concentration on minimal artworks and works by conceptual artists of the 1970s and 1980s. This collector is a connoisseur; he has a longstanding passion for and broad experience with drawings and their various functions in the creative process. Therefore he has always had an interest in new work, and many drawings in his collection are by artists little known to collectors or museum curators.

Drawings of Choice from a New York Collection reflects the wide range of contemporary drawing—from the casual sketch to the elaborate picture, presenting preparatory studies as well as accomplished, technically labored drawings. The selection of more than 100 works emphasizes the crucial role of drawings in the development of creative thinking and artistic processes. The very personal character of this collection and especially its exceptionally high level of quality make it a perfect subject for the study and teaching of contemporary drawing and art in general.

Numerous people have contributed to the success of this exhibition and publication and deserve our thanks. First and foremost, the collector, who has been most generous in offering his outstanding collection for this exhibition. Throughout the preparation of this project, he has offered advice and help in his typically generous and supportive manner. His insight and passion for the work in this collection and for drawings in general as well as his sense of humor have made it a pleasure and a privilege to work with him. In addition, the collector generously opened his files and library to the authors of the catalogue entries, thus offering a unique research and learning experience to our graduate students at the University of Illinois at Urbana-Champaign.

We are most grateful to Amy Eshoo, the collector's Registrar, for her tireless generosity in giving advice, insight and assistance to all of us, especially the students. Amy has answered numerous questions, assisted the students with their research and also kindly offered her help in connecting them with the artists and galleries. Peter Muscato was instrumental in installing the show, and Lesley Spector has patiently answered phone calls and questions from us. We must also thank Gary Garrels, Chief Curator of Drawings and Curator of Painting and Sculpture at the Museum of Modern Art, New York for graciously loaning several works that previously had been part of the collection.

We are grateful to Jonathan Fineberg, who not only generously shared his knowledge and enthusiasm by co-teaching a seminar on minimal and conceptual art, which has served as an ideal basis for the preparation of this publication and exhibition, but also edited the entries. The student authors deserve our special thanks. Kavie Barnes, Sarah Eckhardt, Eun Young Jung, Amy Kuhl, Jordana Moore, Li-Lin Tseng, Chang Wang, Dawson Weber and Phoebe Wolfskill all contributed hard work and dedication in researching and writing the essays. Jane Block, Head Librarian, and Christopher Quinn, Assistant Librarian of the Ricker Library of Architecture and Art at the University of Illinois at Urbana-Champaign, provided gracious assistance.

Sincere thanks go to Gay Roberts for her generous and continuing support of Krannert Art Museum exhibitions, Anne Slichter for her gracious support on behalf of the William H. G. FitzGerald Family Foundation, Paul Bohn, Interim Vice Chancellor for Research and Howard Guenther, Executive Secretary of the Research Board of the University of Illinois, Urbana-Champaign for providing necessary support for the research and development phase of this project. The Frances P. Rohlen Visiting Artists Fund of the College of Fine and Applied Arts made the related lectures and visits possible. We would like to thank the Rohlen Committee and, in particular, the Dean of the College of Fine and Applied Arts, Kathleen Conlin. We also thank Rosalyn Schwartz, Chair, and the other members of the Visiting Artist's Committee of the School of Art and Design for their collaborative work on our lectures.

This exhibition was possible only through the hard work of the members of the Krannert Art Museum staff. In particular we thank Sarah Eckhardt, Curatorial Assistant, for her commitment and abilities in coordinating all the student essays as well as the publication of this catalogue. Karen Hewitt, Asssociate Director, was crucial in overseeing and coordinating the many aspects related to the publication of the catalogue as well as the exhibition. Cynthia Voelkl, Assistant to the Director, managed correspondence and exhibition and venue coordination. Kathleen Jones, Registrar, was instrumental in coordinating loans and organizing the exhibition. Diane Schumacher, Assistant to the Director for Public Relations and Special Services, coordinated events and programs and was responsible for public relations work. Ann Rasmus, Education Director, oversaw programming and public events. Kerry Morgan, Curator, and Rhonda Bruce, Department Secretary, helped review and prepare the final manuscript. Eric Lemme, Exhibits Designer, and Lisa Costello, Exhibits Preparator, provided indispensable assistance in mounting the exhibition along with Nathan Westerman. Dale Brown and the staff at Professional Graphics deserve thanks for their careful attention to the color separations of the drawings. We also sincerely thank Evelyn C. Shapiro for the design and development of this catalogue as well as the pleasure of another productive collaboration.

We are also grateful to our colleagues Brian Young, Curator of the Arkansas Art Center, William Eiland, Director of the Georgia Museum of Art, Romita Ray, Curator of the Georgia Museum of Art, Katy Kline, Director of the Bowdoin College Museum of Art and Timothy Rub, Director of the Cincinnati Museum of Art for joining us in presenting this exhibition.

Finally, we must thank the artists, not just for the strength and quality of their drawings which we have the privilege to show but also for their accessibility and willingness to answer questions from our student writers. Our warmest thanks go to the collector, our friend, for making the works accessible to students, artists, art historians and the broader public. Whether in Illinois, Arkansas, Georgia, Maine or Ohio, it is a rare opportunity for most museums outside of major metropolitan areas to be able to present a collection of this caliber to our public. We are very grateful for that. ❖

Josef Helfenstein
Director, Krannert Art Museum

Townsend Wolfe
Director, Arkansas Art Center

About a year ago, Josef Helfenstein and I decided to teach together a graduate seminar on American art in the 1960s and 1970s. We focused the course on minimal and conceptual art with the idea that it would prepare graduate students in the program to research and write a catalogue of about 100 works from one of the most distinguished New York private collections of contemporary drawings. Each of the students took about a dozen artists—some well known, some unknown to most of us—and began work on the essays included in this volume. With the gracious help of the Provost of the University of Illinois, Richard Herman, and the Interim Vice Chancellor for Research, Paul Bohn, and grants from the School of Art and Design and the College of Fine and Applied Arts, we raised enough money to take the students to New York to look at the originals and to study the collector's files. We then talked about what we saw, in many cases telephoning the artists to discuss this or another aspect of their work. The students then wrote and we edited the essays with a great deal of back and forth about form and content.

These students from the Art History program at the University of Illinois were not advanced doctoral candidates but ranged from first year M.A. students to a few just beginning the Ph.D. None was far enough along to have finished a doctoral exam, and yet the work is professional. The project provided a wonderful opportunity for the students to see the complexities and demands of organizing a major exhibition and catalogue. It was only possible with a museum director such as Josef Helfenstein, who has done so much through the Krannert Art Museum to nurture the intellectual life of this university and in particular to engage students and faculty in museum projects. ❖

Jonathan Fineberg
Professor of Art History
University of Illinois at Urbana-Champaign

Concept, Process, Dematerialization

Reflections on the Role of Drawings in Recent Art

Josef Helfenstein

Drawing has a long history as a practical as well as a theoretical tool in the artistic process. Despite its relatively subordinate role over the centuries, drawing to a certain degree always has been an independent medium. But since the 1960s it has become even more so. From the beginning of visual production, drawings were considered and valued as physical records of thoughts. Artists were the first to discover the multidimensional, fluctuating capacities of drawings, to realize the structural similarity of this medium with the relentless process of conceptualization and perception and to utilize it productively for their own purposes. Drawing has long been considered the best medium for transmuting abstract ideas into perceptible form, for translating and synthesizing the complexity of concepts and processes into something immediate and tangible. In the 1960s, many artists rejected the prevalence of the artist's hand and sought to separate drawing from the idea of private, introspective experience. Many of these artists also left the private space of the studio and worked in public environments. Nevertheless, drawing continued to serve as a means of conceptualization and, in contradiction to this, the autographic quality of drawing continued to be valued. Therefore drawing, more than any other medium, continues to be connected with the notion of authenticity.

Potentiality

Since drawings are so intimately related to process and genesis, they have a dimension of openness; they seem fundamentally connected with latent, undisclosed possibilities, with transition and reconfiguration. In that sense, drawing is less categorical than other mediums. Drawings seem to be less defined by their ends; often, the territory of their meanings and functions remains open: They evoke and indicate as much as they analyze and define. They are used as a sharp analytical tool and as an indicator of a largely undefined territory of potentiality. This ability to serve various roles seems identical with one of the most fundamental aspects of the medium—the complexity of the line. Lines, too, have the advantage of being fundamentally ambivalent: They can separate as well as join, and in many cases, old and modern masters used these seemingly opposite characteristics at the same time.

Process

Drawings have the ability to fluctuate between thinking and doing, to function as a link between concept and execution. This predisposes them in a fundamental way to define themselves as a process-related medium. This trait became especially meaningful in the general climate of analysis, investigation and experimentation of the 1960s and 1970s. This vast process of critical reconsideration not only addressed the artwork and the paradigms of artistic production but also extended to the critique of the institutions, the audience, the marketing and the dissemination of art.

In the 1960s, many artists felt there was no longer a possibility of genuine renewal within the traditional forms and formulas of painting and sculpture. Instead, they focused their attention on the revision of traditional artistic categories and on the conceptual origins of ideas. They used new methods of representation such as context-dependant installations or linguistic, photographic and serial means. In order to record happenings and performances, photography and new time-based mediums such as film and video took on a new role. Unlike the mechanical passivity of the camera, drawing kept a reflexive, critical quality, therefore offering itself as a tool in the increasingly analytical process of redefining the categories of art. Artists who were more interested in processes and concepts than in the final product used drawing as an economic and flexible tool to develop and encapsulate ideas quickly on paper—in the form of diagrams, situation sketches or plans reflecting different stages of projects. Drawings, more than ever, seemed especially appropriate to reflect intellectual processes—thinking,

exploration, examination and redefinition. Drawing is of course not the only medium to reflect these tendencies, but the increasingly diverse and complex functions of drawings make them particularly sensitive to the fundamental changes and developments in the arts of that period.

Mind map, concept, dematerialization

In the course of the 1960s and 1970s, some artists tended to foreground thought and knowledge over the physical materials as the underlying essential component of the artwork.[1] Other artists focused on the materials themselves with an equal degree of concentration. Both of these inclinations represent a degree of analytical consciousness that characterizes this period. Since more and more works are anchored in thought, the directness with which drawing relates to mental processes gives it a prominent role as a tool in registering these ephemeral crosscurrents.

At the same time, many artists emphasized the intellectual over the commercial aspect of art. Some deliberately chose to abandon the creation of objects altogether and to rely on the use of documentation including maps, drawings, language and photographs. Several projects or "exhibitions" by Douglas Huebler, Lawrence Weiner, Mel Bochner and others took form only on paper or as hearsay. These documents often function as self-reflexive studies of aesthetic production rather than as aesthetic objects per se. In some ways, insisting on using drawings was also a political act on the part of the artists to "de-marginalize a medium" that historically was considered subordinate and commercially less viable.[2]

Sol LeWitt launched the term "conceptual" in his *Paragraphs on Conceptual Art* of 1967 and *Sentences on Conceptual Art* of 1969. One of his definitions specifically emphasizes concept over craft in the realization of an aesthetic idea. According to LeWitt, the cognitive content of a work has priority over its perceptual form. Since drawing is fundamentally connected to conceptualization, LeWitt's premise underscores the role of drawings in the artistic process.

Structure

LeWitt's work is especially interesting for the discussion of the role of drawing in minimal and conceptual art. LeWitt, who sought to distinguish his work from the tradition of sculpture, referred to his objects instead as "structures." When in 1965 he showed his first *Modular Cube Structures*—in which he had removed the structure's skin altogether and

revealed the underlying armature—it became obvious that these open, modular structures, with no real volume or mass, suggested a relationship not so much with sculpture or painting as with drawing. In Carl Andre's work we find a similar transition from formal to structural concerns as it moves from the early timber pieces, each of which still has a unique form, to the brick and plate works in which system and place take precedence.

In LeWitt's work, this was made even clearer since many structures were preceded by working drawings with explicit descriptions and instructions. The formal simplicity and the repetitive extension of most works are counteracted by a sense of perceptual complication or even an irrational component. Drawings seem to be the appropriate medium to capture this tension and to reveal the dialectic of rational, repetitive form and this irrational element. Drawings also have the discursive potential to indicate the gap between knowledge and experience, as in a LeWitt structure where the realization of the rational and knowable generative system contrasts with the immediate experience of the physical work. The dematerialized quality of drawing, its association with language and thought processes, makes it a natural medium for conceptual art.

LeWitt's idea to use the conceptual potential of "drawing" as the medium for the execution of an idea becomes even clearer when, in 1969, he realized a "total drawing environment" by using a given room as a complete entity, as a single idea. The written instructions and working drawings for the piece point to the critically important mental as well as time-related territory between conception and execution, between the idea of the work and its physical form. However, drawings can only indicate but never replace the spatial and temporal experience of three dimensions.

Working drawing versus mechanical production

Minimal sculpture by Andre, Donald Judd, Dan Flavin and LeWitt seems materially and formally self-evident, emphasizing industrial and standardized production rather than handcrafted materials. Standardized fabrication was a vehicle to eliminate the individual touch of the artist. Paradoxically, since many of the objects had to be constructed industrially, the working drawing as a means of instruction became a technical necessity. If we examine the working drawings by Flavin, LeWitt and even Judd in this collection, we realize that they definitely convey more than

what Judd claimed—they are more than simple mechanical instructions for the production of standardized forms with industrial materials. Despite the neutrality of the execution and the mechanistic intention to serve as instruction, Judd's drawing (cat. 43) reveals a sense of sketchiness, openness and even of subjective intuition. The notion of the autographic, the visualization of process and time, the transitional quality of the drawing are undeniable, as are the aspects of balance, composition and visual perfection in the case of the Flavin drawings (cat. 21–23).

In their capacity to convey process and conceptual foundations, these works on paper by Judd and Flavin almost become the counterpart of the sculptural objects to which they are related. By disclosing the idea of the system and the plan for construction, the drawing acquires a critical, demystifying role: It demystifies the act of creating art as well as the antiseptic perfection of the industrial object. The working drawing also questions the authoritarian myth of the object displayed in the preconditioned environment of the gallery or the museum, where art is automatically designated as art. The techno-aesthetic look of minimal sculpture takes reductive modernism to the border of banal, fashionable design. Drawings are important in that context, because they subvert the formal and technological rigor of the sculptures.

Robert Smithson's drawings in this exhibition (cat. 90–93) almost reverse this relationship. Smithson's projects are inherently process-oriented, unstable and complex, whereas the drawings freeze the entropic action of the projects in an aspect or a moment of time. Since many of his works were large-scale, outdoor pieces in remote places—difficult to execute as well as to access—drawings were often the only available, comprehensive documents of these complex interventions in space.

Revision, transition

Drawings related to sculptures or site-specific installations don't have to be limited to a preparatory role. The time frame can be reversed, with drawings referring to existing pieces which can therefore be copied, modified, elaborated. Drawing becomes a tool to revisit and redefine the piece, to put the work or its concept back into the flux of thinking. Here drawing reaffirms its role as a driving force of process and creation.

Drawings are thus an instrument to reflect the provisional status of the work; it becomes clear that the act of conceiving, temporarily placing and sometimes destroying a piece

can take precedence over the permanent physical presence of the work. The operational and temporal dimensions of drawings connect them with process art, dance and performance.[3] The drawings of Trisha Brown in this collection are especially interesting in that context (cat. 10–13), demonstrating how the body is used as a material in a temporal process. They convey a non-narrative, non-linear way of registering the movement of the body in space.

The time-based, transitional status of drawing leads beyond the static notion of the final product. In that sense, drawings question the object as an authority and a commercial fetish; they reflect the skepticism about the traditional role of art in society, a common attitude among many artists in the 1960s. Robert Morris and other artists argued for an art that could exist beyond objects. Again, drawing as the most dematerialized of the traditional media can serve as a surrogate in that discourse.

Drawings have always been used as an instrument in the process of investigation, redefinition and critical construction of art. A thorough study of the role of drawings in the 1960s and 1970s would have to consider their function within the broad movements of the time. In particular, we would need to consider drawing's relation to the rejection of traditional definitions of objects and mediums as well as to the critique of institutions. This critique formed the political and cultural framework for the dominant aesthetic discussions in that period. Many of these ideas and paradigms have been revisited and modified by a subsequent generation of artists, many of whom are represented in this collection. By developing their own distinctive vocabulary and extending the notion of artistic process, these artists such as Glenn Ligon, Christine Hiebert, Suzan Frecon and Marsha Cottrell, have further developed the possibilities of the medium. ❖

I thank Jonathan Fineberg for his critical reading and help in editing this essay.

[1] Anne Rorimer, New Art in the 1960s and 70s. Redefining Reality (London: Thames & Hudson, 2000), 86.

[2] Cornelia H. Butler, "Ends and Means," in Afterimage: Drawing through Process (Los Angeles: The Museum of Contemporary Art: 1999), 101.

[3] Pamela M. Lee, "Some Kinds of Duration: The Temporality of Drawing as Process Art," in Afterimage: Drawing through Process (Los Angeles: The Museum of Contemporary Art: 1999), 31.

CATALOGUE

Entries by

Kavie Barnes · KB
Sarah Louise Eckhardt · SLE
Eun Young Jung · EYJ
Amy M. Kuhl · AMK
Jordana E. Moore · JEM
Li-Lin Tseng · LLT
Chang Wang · CW
Dawson Weber · DK
Phoebe Wolfskill · PW

Carl Andre

Born 1935, Quincy,
Massachusetts,
works in New York City

1
Untitled, 1960
Ink on board
4 3/8 × 3 inches each

These early ink drawings by Carl Andre incorporate a seemingly expressionist element of organic movement uncommon to his oeuvre. Instead, in their repetition of similar forms, their seriality (as a set of three variations) and their play between two- and three-dimensionality, they exhibit elements linked to his sculptural work.[1]

Before Andre began his career as a sculptor, he made several drawings similar to the three in *Untitled* (1960). These drawings demonstrate an important transition in Andre's career. They lead to his work as a sculptor and creator of graph-like, site-specific works composed of quadrangular forms with juxtaposing color patterns. The rectangle shape of each panel resembles other works in which Andre deals with similar forms; however, the repetition in *Untitled* differs from the way Andre usually works in that the interior patterns are organic and different from one another rather than identical. Without the same geometric precision of his wooden sculpture, the flowing colors compose a visual game; the highly contrasting hues compete to be read as figure and push the others back as the ground plane. The intensity of the red surges forward toward the viewer, but the dark mass has a weight of gravity derived from its plane on the bottom, moving it forward when its darkness might cause it to recede.

By diagonally applying the red against black ink, Andre also creates in this series the illusion of movement, depicting how liquid paint might run over the surface of a canvas. The red and black inks seem to spill over one another in each square, creating imprecise, undulating compositions. Andre balances the free-flowing effect by creating several similar panels that, when horizontally aligned as they have been in this work, give the impression of a graph. This tactic of repetition tightens an otherwise free-flowing, abstract design and makes it mathematical, which also reinforces the work's overall balance. ✤ KB

[1] Christine Mehring, "Carl Andre," in *Drawing Is Another Kind of Language: Recent American Drawings from a New York Private Collection*, eds. Pamela Lee and Christine Mehring (Cambridge: Harvard University Art Museums, 1997), 26.

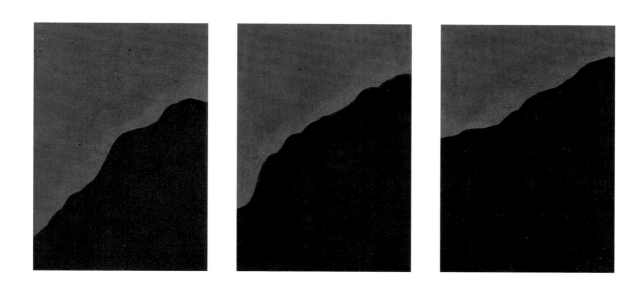

Carl Andre

In an interview with Phyllis Tuchman, Carl Andre describes the development of his career as an artist as a shift from aesthetic formalism to "structuring" or organizing forms, then to connecting structured, organized sets of objects to their "place."[1] In *PLAN* (1972) and *PERPLEX-ITIES* (1972) we can revisit this idea in an effort to understand Andre's preoccupation with bringing together two seemingly disparate entities—sculptural work and site.

In *PLAN* Andre playfully juxtaposes red and black fonts to create a visual simplification of architectural elements: The artist constructs the outline of an uneven staircase using words and phrases that refer to traditional building structures, ancient ruins and other objects associated with architectural history. The objects referred to in the "concrete poem" are connected by the dramatic influence each exercises over its setting. The staircase form is constructed of single lines of phrases such as "Mysterious Chamber" and "Sculptured Stone Table." These words have been detached from larger narrative contexts, which the viewer is prompted to contemplate.

In addition to the mysterious objects and places to which the words in *PLAN* allude, other expressions such as "Boiling Eggs" and "Wooden Lintels" impart a sense of smell, touch, and even sound to the work, further connecting the viewer with the subject matter. In an interview with Hollis Frampton, Andre discusses his wish to communicate on a primal level with the reader, "Our first poets were the namers, not the rhymers. Our first poets were the men who first associated the sounds they could make in their throats with the things around them."[2] This concern with the most elementary and fundamental level of language not only mirrors the basic materiality of Andre's sculptural practice but also might have encouraged his interest in the writings of Ludwig Wittgenstein. Wittgenstein believed that by communicating only the most direct minimal ideas—"atomic facts"—

unnecessary details would not cloud a given set of information.[3] Embracing this idea, Andre in *PERPLEXITIES* uses a basic language of words with elongated syllables to evoke an immediate response from the spectator. The gap between his words and the individual reader narrows as the reader struggles to pronounce each sound as it lengthens and repeats. Unlike a narrative or descriptive poem, the individual word speaks directly to the reader, creating a bond between artwork and beholder.

The minimal arrangement of the words into simple shapes in *PLAN* and *PERPLEXITIES* also parallels Andre's explorations in sculpture, where he uses the most basic materials to render complicated concepts. In *PERPLEXITIES*, he arranges variously sized rectangular clusters of single and repeated words that can be read diagonally, vertically and horizontally. In his *Equivalents* show in 1966, he constructed rectangular shapes using two layers of lime bricks in four permutations that produced eight different works, although the overall effect was of one cohesive artwork. Similarly, in *PERPLEXITIES*, the play of color and boxy, clustered words suggests brickwork. The creative effort he implements in *PLAN* is part of a disciplined process of composing specific words and materials that speak directly to the audience. Despite the engaging aesthetic format of his arrangement of the shapes, he insists these works on paper are poetry instead of drawings. Andre has little interest in conjuring a romantic reaction from the audience; instead, his works invoke an inherent connection between words and the reader. ❖ KB

[1] Phyllis Tuchman, "Interview with Carl Andre," *Artforum* (June 1970), 55.
[2] Carl Andre, Benjamin H. Buchloch and Hollis Frampton, *12 Dialogues, 1962–1963* (New York: New York University Press, 1981), 76.
[3] Sachindranath Ganguly, *Wittgenstein's Tractatus: A Preliminary* (West Bengal, 1968).

PLAN
OPTH
ERUI
NSANEDI
FICEO
AILED
AEATZ
EEBDOO
RWA
YSAPAR
TMEN
TSOIROU
LARMA
SSOFM
ASONR
YMYSTE
RIOUS
CHAMB
ERSCULP
TURED
STONE
TABLE
TMAJESTI
CPILEOF
BUILDIN
GCALLED
THEMONJ
ASHIER
OGLY
PHIO
SRICH
ORNA
MENT
SDOORW
AYSCH
AMBER
S&CHEMAI
NSQPF
AINTI
NGTHEEG
LESIA
ORCHU
ROHORNAMCARTOCIROUL
ENTSOUCHESAREDIF
NTHEFONTHEICBCAL
ACADEFLOORLEDTHE
CARACO
LAPASTAIROA
RTMSEHAVIN
ENTGONEACH
SIDEENT
WINEDSE
RPENTSGIGA
NTIC
HEAD

@ carl andre © 1972

PERPLEXITIESHOUSEHOLDWANTSINDIANMODEOFBOILINGEGGSCLEARINGSAVALUABLE
EERPLEXITIESOOUSEHOLDAANTSNNDIANQODEFFOOILINGGGSLLEARINGSAALUABLE
RRRPLEXITIESUUUSEHOLDNNNTSDDDIANDDDEIIILINGGGSEEEARINGSLLLUABLE
PPPPLEXITIESSSSEHOLDTTTTSIIIIANEEEELLLLINGSSSSAAAARINGSUUUUABLE
LLLLLEXITIESEEEEEHOLDSSSSSAAAANIIIIINGRRRRRINGSAAAAABLE
EEEEEEXITIESHHHHHHOLDNNNNNNNNNNNNGIIIIINGSBBBBBBLE
XXXXXXXITIESOOOOOOOLDADDITIONGGGGGGGNNNNNNNGSLLLLLLLE
IIIIIIIIITIESLLLLLLLLDDDITIONDESCRIPTIONOFTHEGGGGGGGGGSEEEEEEEE
TTTTTTTTTIESDDDDDDDDDDDITIONDESCRIPTIONOFFHHESSSSSSSSSRUINS
EEEEEEEEEESAASABELIIIIITIONSSSCRIPTIONEEEGOBERNADORUUINS
SSSSSSSSSSSSSSSSALLIIIIIIONRRRRRIPTIONOOBERNADORIINS
AAAAOOOOOOONIIIIIPTIONBBBERNADORNNNS
EEBERNADORSSSS
HIEROGLYPHIOSNNNNNNNNPPPPPPTIONRRRRNADORORNAMENTSOVERTHE
IIEROGLYPHIOSDOORWAYSGROUNDTTTTTTTTIONPLANNNNNNADORRNAMENTSVVERHHE
EEEROGLYPHIOSOOORWAYSRROUNDIIIIIIIIONLLANAAAAAAAADORNNAMENTSEEEBREE
RRRROGLYPHIOSOOORWAYSOOOUNDOOOOOOOOOONAAANDDDDDDDDDORAAAAMENTSRRRR
OOOOOGLYPHIOSRRRHWAYSUUUUNDNNNNNNNNNNNNNNN.OOOOOOOORMMMMMENTS
GGGGGGLYPHIOSWWWWAYSNNNNNDDOORWAYSRRRRRRRRRREEEEEENTS
LLLLLLLYPHIOSAAAAAAYSDDDDDDDOORWAYSAPARTMENTSGREATNNNNNNNTSTHIOKNESS
YYYYYYYYPHIOSTYYYYYSOFTHEOOORWAYSPPARTMENTSRREATTTTTTTTSHHIOKNESS
PPPPPPPPPHIOSSSSSSSSSSFFHHERRRRWAYSAAARTMENTSEEEATSSSSSSSSSIIICKNESS
HHHHHHHHHIOSBACKWALLAEEEWWWWWAYSRRRRRTMENTSAAAATBREACHMADEINOOOOKNESS
IIIIIIIIIIIIOSAAOKAALLTHEWALLAAAAAAYSTTTTTTMENTSTTTTTBREACHAADENKKKKNESS
OOOOOOOOOOOSSSSOOOKLLLHHEAALLYYYYYYYSMMMMMENTSEEEACHDDDENNNNNESS
SSSSSSSSSSSSKKKLLLLEELLLLSSSSSSSSEEEEEENTSAAAAOHEEEEEEEEESS
PRINTSOFAREDHANDLLLLNNNNNNNNTSCCCCOHSSSSSSSSSS
RRINTSFFEEDAANDSCULPTUREDBEAMOFTTTTTTTTTSHHHHHHSSSSSSSSSS
IIINTSDDNNNNDCULPTUREDEEAMFFSSSSSSSSSSSHIEROGLYPHIOSWOODENLINTELS
TTTTTSOOSSFFLLLLPTUREDMMMNNTIQUITIESYYIHHEEEROGLYPHIOSOOODENNNNTELS
SSSSSSSSSSSSPPPPPTUREDTTTIQUITIESEEERRROGLYPHIOSDDDDENTTTTELS
SSSSTTTTTTUREDIIIIQUITIESEEELLLLLLLYPHIOSSSSSSS
BURNINGOFMRUUUUUUUREDQQQQQUITIESGGGGGGLYPHIOSEEEEEENEEEEELS
UURNINGFFRRRRRHRRRREDUUUUUUITIESLLLLLLLLYPHIOSSSSSSS
RRNINGEEEEEEEEDIIIIIIITIESYYYYYYYPHIOSGOATHERWOODS
NNNNNGPANORAMADDDDDDDDDDTTTTTTTIESFFFPPPPPPPHIOSAATHERWOODS
IIIINGAANORAMATERRAGESAIIIIIIIIOSTTTHERWOODS
NNNNNNNNGNNORAMASEERRAGESCURIOUSEEEEEEEEESSTONEIIIIIIIIIIOSHHHHERWOODS
GGGGGGGOOORAMARRRRAGESUURIOUSSSSSSSSSSSSTONECCCCCCCCCCGSEEERWOODS
RRRRRAMAAAAAACESRRRIOUSCIROULAROOONESSSSSSSSSSGSRRRRRRWOODS
MOUNDAAAAAAMGOOOOOSIIIIOUSIIROULARNNNNEDISOOVERTOFAWWWWWWOODS
OOUNDMMMMMMAEEEEEESOOOOOOURRROULAREEEEEIISOOVERTFFOOOOOOOOODS
UUUNDAAAAAAAASSSSSSSSUUUUUUSGOGOULARSSSOOVERYOOOOOOOOODDS
NNNNDSCULPTUREDMONUMENTSSSSSSSSUUUULARSQUAREOOOOOVERYSTONEDDDDDDDDDDS
DDDDDCULPTUREDMONUMENTLLLLLARQQUAREOOOOVERYTTONESSSSSSSSSS
UUULPTUREDNNNUMENTAAAAAAARUUUAREVVVVVVVOOONESTRUCTURE
LLLLPTUREDUUUUMENTRRRRRRRRAAAARERRRRRRRRYEEEEBRRRUCTURE
PPPPPTUREDIMMMMMENTSCULPTUREDHEADSRRRRRERRRRRRRRYEEEEBRRRUCTURE
TTTTTTUREDEEEEEENTCULPTUREDEEADSEEEEEEYYYYYYYYUUUUCTURE
UUUUUUUREDNNNMNTUUULPTUREDAAADSTAIRCASEHOUSEOPTHECOCCOCTURE
RRRRRRRREDTTTTTTTTLLLLPTUREDDDDDSTTAIRCASEOOUSEFFHHETTTTTTURE
EEEEEEEEEDTURTLEFPPPPTUREDSSSSSAAAIRCASEUUUSEEEEUUUUUUURE
DDDDDDDDDDDUURTLETTTTTTUREDIIIIRCASESSSSSERRRRRRRE
RRRTLEUUUUUUUREDRRRRCASEEEEEEEEEE
TTTTLERRRRRRRREDOOOOCASE
IDLLLEEEEEEEEEEDAAAAAASE
EEEEEEDDDDDDDDDDSSSSSSSSSE
EEEEEEEEE

@ carl andre © 1972

Jill Baroff

Born 1954, Summit,
New Jersey, works
in Brooklyn, New York

4, below
Stacked Pair 1:6, 1999
Graphite on gampi
mounted on kozo
47 ½ × 83 inches

5, opposite
Reduction, 1999
Graphite on gampi
mounted on kozo; portfolio of four drawings
14 × 10 ½ inches each

Jill Baroff's drawings elicit a sense of stillness, spaciousness and reflectiveness. Then ideas of light and architecture emerge. The unique surface of these drawings, which can change depending on lighting, relates both to the outline of a window and the delineation of a floor plan. Throughout her career, Baroff has made reference to architectural spaces. In a 1995 show at the Stark Gallery in New York, Baroff carved lines and shapes into the walls with a utility knife, outlined them with graphite, and reshaped the gallery layout by building an additional wall into it.[1]

Since the late 1990s, Baroff has traveled between the United States and Japan. According to Lilly Wei,

> She was impressed by [Japan's] "floor-based" architecture which she contrasted to the "wall-based" structure of the West. She described the placement of the tatami on her bedroom floor…how each mat was meticulously placed next to the other and how light, traversing the weave, created a constantly changing pattern. [2]

The work immediately following this first trip was *Monochrome in Blue* (1997), which consisted of a series of corrugated boxes arranged next to one another on the floor, mirroring the placement of tatami. As the viewer moved around the boxes, the light reflecting off their surface changed due to the corrugation of the material.

These two drawings in particular help to explain the wall-to-floor relationship in Baroff's drawings. Her decision to refer to these works as "built drawings" immediately echoes this notion of architecture.[3]

Stacked Pair 1:6 (1999) and *Reduction* (1999) both utilize papers Baroff first encountered in 1996, gampi and kozo. Gampi, which is thin and delicate-looking but strong, is soaked and mounted onto unbleached kozo. Because of the sensitive appearance of the gampi, it is illuminated by the kozo behind it, giving off a soft yellow tone.[4] She then highlights the edge of the gampi by outlining each piece with a single graphite line. As in *Monochrome in Blue*, as the light or the viewer's position shifts, so does the look of the gampi on the kozo.

In *Reduction*, a portfolio of four drawings, all four sheets are treated to the same process. In each she has either placed two pieces of gampi next to each other or allowed a small edge of one sheet slightly to fold. The graphite line then accentuates these areas when the line diverges from the perfect rectangle. *Stacked Pair 1:6* follows a similar technical regimen as *Reduction* except that Baroff here has decided to layer sheets of gampi over each other. The ratio of 1:6 in *Stacked Pair 1:6* is Baroff's own notation for the number of gampi sheets stacked atop each other on either side.[5] On the side stacked with six sheets, she has accented the elements of time, material, architecture and color. The stacked sheets create a subtle build-up of color, while the transparency of the gampi mutes the outlines of the underlying sheets just slightly, leaving a visible record of their construction. ✥ DW

[1] Barry Schwabsky, *Jill Baroff* (New York: Stark Gallery, 1995), 4.
[2] Lilly Wei, "Goose Skin and Chicken Child," in *Jill Baroff: Stacked Drawings* (New York: Fifth Floor Foundation, 2000), unpaginated.
[3] Ibid.
[4] Ibid.
[5] Ibid.

James Bishop

Born 1927, Neosho,
Montana, works in
Blévy, France

6, top
Untitled, ca. 1968
Oil and graphite on paper
9 ½ × 10 ½ inches

7, bottom
Untitled, 1993
Oil and graphite on paper
9 × 11 ¾ inches

James Bishop, who has fallen through the cracks of abstract expressionism, Greenbergian color field painting and minimalism, has referred to himself as an "Abstract Expressionist of the quieter branch."[1] During the mid-1950s, he spent his time studying art and art history in New York, St. Louis and at Black Mountain College. In 1957, he embarked on a nine-month trip to Paris that was to last nine years. In 1961, in Paris, he had his first gallery show. Bishop kept up with the other Americans in Paris and visited the traveling exhibitions of new American art. It was during the 1960s that he embraced the neutral form of the square. "From then on there were no more rectangles," he stated.[2] Both of these untitled drawings, although very different and separated by thirty-some years, perform the same role in Bishop's working process. In an interview with Dieter Schwarz, Bishop explained,

> Sometimes I started [a drawing] and did not see what it needed for several weeks....I went on making little works on paper but it was simply because I was more interested in what I could do with this size, writing with the hand rather than with the arm. I think mostly it was that I could make something that seemed to me much more personal, subjective, and possibly original, and that just interests me more.[3]

For Bishop, his drawings are "the continuation of the paintings."[4] However, as distinct from his painting process, he notes that, "I knew more beforehand with a large painting what it was supposed to be. The small [drawings] often surprised me; mostly they are more complex."[5] Bishop's painting process, begun in the 1960s, involves painting flat on the floor. He would pour the paint onto the canvas and then move and lift the sides of the canvas to push the paint around. The color fields he created were rooted in the work of Helen Frankenthaler, whose work keenly interested Bishop.

Both of these drawings refer to a language of "working flat"— moving paint around on the picture plane. Due to their scale, it is likely they were worked out with thin paint and brushes. *Untitled* (ca. 1968) merges color fields with the beams. As his work progressed, Bishop used the structural beams increasingly both to add stability to his compositions and to make decisions as to where the poured paint should and should not go; in some works the beams almost functioned as borders. They not only call to mind the works of Barnett Newman and Ad Reinhardt but also give the work undertones of minimalist geometry. Such undertones echo Bishop's earlier formal interest in dividing the square into four equal parts: A method he deviated from to impose his own presence and complicate the space.

In reading *Untitled* (1993) it is important also to understand Bishop's color choices. The bright colors of his 1960s paintings gave way to browns and warm grays, which slowly became lighter in the 1970s. He worked briefly with white but quickly returned to the grays and browns. Bishop found white to be too theoretical and removed, "as if one did not commit oneself, didn't put emotions out in a certain way....[The drawings] began to fade out and become gray, which does not at all have the associations that the brown once had."[6] ✤ DW

[1] Dieter Schwarz, *James Bishop: Paintings and Works on Paper* (Düsseldorf: Richter Verlag, 1993), 121.
[2] Ibid., 34.
[3] Ibid., 36.
[4] Ibid.
[5] Ibid.
[6] Ibid.

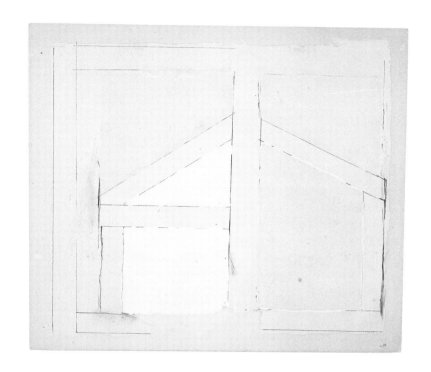

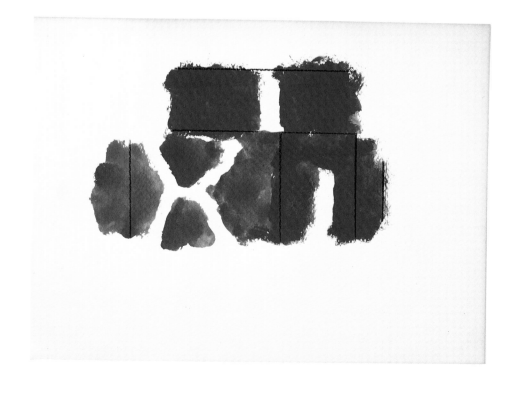

Louise Bourgeois

Born 1911, Paris, France, works in New York City

8

Untitled, 1948–1951
Ink and charcoal on wove paper (two sides)
19 ½ × 14 ½ inches

ouise Bourgeois remarked that *Untitled* (1948–1951) "might be grapes or fruit or hanging garlic."[1] She alludes to real objects, yet re-creates them abstractly. The artist also tells us that the images spring from memories of her childhood in France; nevertheless, the organic pods and lines in this image represent not reality but the essence of an experience, which comes to her as a personal revelation embodied in an abstract visual form. Bourgeois's drawings often represent her first musings on a subject, before they are generated into sculpture. But this eccentric drawing stands altogether independent of sculpture, and indeed Bourgeois's work does not require a three-dimensional incarnation to evoke the artist's personal reveries of youth—the underlying subject matter in everything she makes.

"All my work in the past fifty years, all my subjects, have found their inspiration in my childhood. My childhood has never lost its magic, it has never lost its mystery, and it has never lost its drama."[2] For Bourgeois, drawings function as her diaries, allowing her access to memories, anxieties and other powerful emotions. The allusion to plants, she said, recalls her childhood in the Creuse region of central France, where her parents hung vegetables to dry in the attic during the winter months.[3] The formal suggestiveness of the hanging pods intrigued her. The wavy background lines evoke the artist's long hair as a young woman, a motif repeated in many of her drawings.

With the influx of European artists into America during World War II, Bourgeois found herself in frequent contact with the surrealists and became interested in their exploration of the unconscious. But Bourgeois was unaffiliated with the European surrealists in exile, and her recourse to unconscious material in her art was both more overtly personal and more direct—in greater consonance with the American abstract expressionists.[4] In the late 1940s, Bourgeois moved from a style associated with surrealist automatism, in which she paired and arranged a variety of disparate subjects within an overall grid format, to this more personal, eccentric type of abstract image.

Bourgeois arranges the cluster of pods in the center of this composition and encloses them with soft organic lines that flow all around and behind the bulbs. The bulging vesicles are a familiar motif in the artist's oeuvre. Her repetition of engulfing linear webs and these sac-like shapes express her obsession with organic forms and their associations. The overlapping and hints of shading in the drawing give it depth; the background lines remain flat while the fully rounded pods press forward.

Bourgeois composed this drawing on both the recto and verso of the paper with a similar motif of bulbous forms on each side. But instead of the recto's arrangement of vesicles, she drew on the verso a single, large bulb constructed of solid, black lines. The dense lines flatten the structure, preventing the assertion of volume achieved on the recto. Repeating the alignment of forms from the front, the bulging form hangs vertically and centrally. Perhaps this larger object encloses the vesicles that are exposed on the opposite side, so that the drawing reveals the pods on one side while protecting and concealing them on the other.

According to Bourgeois, "We are not talking here about the recording of events, the recording of emotions, the recording of motives. What we are talking about is a recording of lines and shapes; that is everything."[5] To Bourgeois, past events and emotions cannot simply be transferred onto paper. Instead, the essence of past experience is revealed by evocative forms—forms that offer the possibility of altogether new associations. ❖ PW

[1] Louise Bourgeois with Lawrence Rinder, *Louise Bourgeois: Drawings and Observations* (Boston: Little, Brown, and Company, 1999), 89.

[2] Louise Bourgeois, *Destruction of the Father, Reconstruction of the Father: Writings and Interviews 1923–97* (Cambridge: The MIT Press, 1998), 277.

[3] Ibid., 16–17.

[4] Deborah Wye, *Louise Bourgeois* (New York: The Museum of Modern Art, 1982), 17.

[5] Ibid., 21.

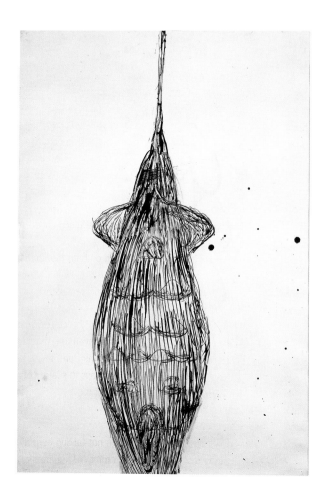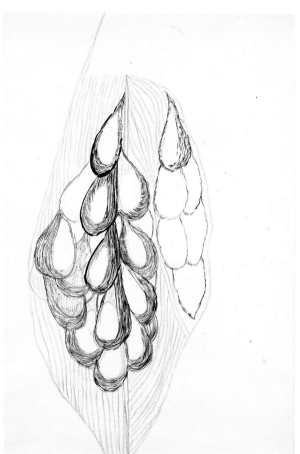

Louise Bourgeois

9
Untitled, 1950
Ink and pencil on paper
9 1/2 × 15 3/8 inches

According to Louise Bourgeois, her drawings represent an urgent need to express "the void of anxiety"[1] and channel the creative energy that precedes sculptural creation. She refers to her drawings as *pensées plumes* (thought quills), or thoughts plucked from the air, to signal the immediacy of emotion and thought they convey.[2] The artist began to focus on sculpture in 1947, but her drawings continue her exploration of formal concepts. Even after she abandoned painting for sculpture, she continued to draw.

Bourgeois's compositions from the late 1940s and early 1950s consist of amorphous, abstractedly defined forms evocative of imagery from her past. In *Untitled* (1950), numerous overlapping lines coalesce into three horizontal shapes layered one over the other and overflowing both sides of the page. In the lower and middle registers, the obsessive, fragmented lines form dense patches toward the center of the composition, but in the uppermost shape they heavily overlap at the endpoints. This creates a dynamic formal balance, as each segment appears to undulate. Where the dense fibers add gravity to the lowest and middle forms, the uppermost form is sheer and feels airy and light.

The horizontal extension of lines beyond the confines of the page suggests landscape, while the intense accumulation of the lines gives the microcosmic impression of vital muscle fibers. The eccentric forms in these drawings have many associative possibilities, nearly always layered with powerful recollections from the artist's childhood: landscapes, soft organic objects, flowing hair. As Bourgeois explains, "hair is a symbol of power. It represents beauty. It's a gift you're born with."[3] The work also bears the influence of the seventeenth-century tapestries she viewed as a child;[4] Bourgeois's parents repaired tapestries at Gobelins Tapestry Manufactory in Choisy-le-Roi, outside of Paris, and the delicate threads and intricate patterns of the tapestries intrigued her.

The swellings in *Untitled* (1950) bring to mind the formal properties of Bourgeois's sculpture; the individual hatchings suggest wood grain, a material she used exclusively at the time. Bourgeois's eloquent vocabulary of organic and linear shapes is deliberately layered, like dreams, with many simultaneous trajectories of unconscious association. At one moment, the horizontal bands seem to unite the earth and the sky, reaching upward and downward in a landscape. At the next moment, we see skeins that both embrace and entrap us in alternating patterns of hatched lines.[5] Her work does not aspire to conscious iconographic schemes; nor does it seek transcendence. Instead it serves as a therapeutic release for Bourgeois, allowing her to liberate repressed anxieties. Her drawings explore her past, focusing on events that are human and flawed. Giving form to these emotions, she purges herself of them, if only for a brief, triumphal moment; the process remains a crucial parameter of Bourgeois's artistic practice.[6] ❖ PW

[1] Deborah Wye, *Louise Bourgeois* (New York: The Museum of Modern Art, 1982), 20.
[2] Marie-Laure Bernadac, *Louise Bourgeois* (Paris: Flammarion, 1996), 14.
[3] Ibid., 29–32.
[4] Wye, *Louise Bourgeois*, 20.
[5] Bernadac, *Louise Bourgeois*, 29.
[6] Louise Bourgeois with Lawrence Rinder, *Louise Bourgeois: Drawings and Observations* (Boston: Little, Brown, and Company, 1999), 16.

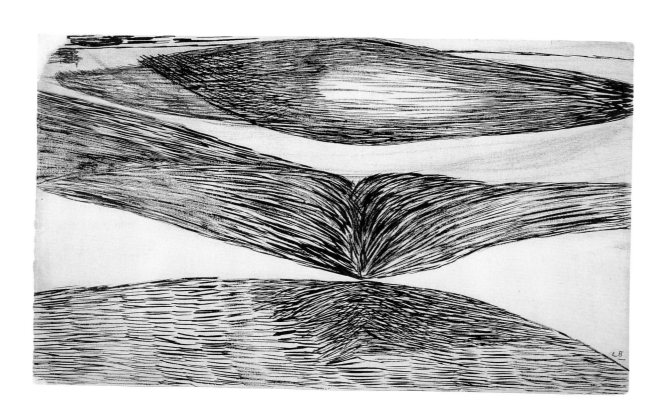

Trisha Brown

Born 1936, Aberdeen, Washington, works with her dance company in New York City

10, top
Drawing for Pyramid, 1975
Pen and ink on graph paper
6 ¾ × 7 ½ inches

By the end of the 1960s, conventional barriers between artistic disciplines such as dance, music and the visual arts began to disintegrate. As artists crossed the traditional boundaries between mediums, Trisha Brown began to develop drawing as a medium in parallel to her choreography. After all, if visual artists untrained in dance could now become dancers, dancers could become two-dimensional artists as well. In fact, Brown was not the only choreographer to explore movement through drawing; Merce Cunningham made graphic notations corresponding to his choreography that have also been treated as drawings in their own right.

Nonetheless, Brown has insisted that, although important, drawing remains a secondary endeavor for her: "It seems that whatever flows into my mind about dancing flows into my mind about drawing.…And drawing is subsidiary to the choreography."[1] Drawing became a means by which to communicate ideas to her dancers. As Roger Durbin writes,

> Brown works out her dance ideas on paper.…They reflect both the processes of how she creates and the ideas behind those processes. Drawings, she has said, are what are between herself and her dancers—until she sees them danced out. The seemingly random lines embody her notion of the unexpected…both in dance and in life.[2]

Many drawings relate to specific dance works, as is the case with *Drawing for Pyramid* (1975), which corresponds to a 1975 dance entitled *Pyramid*. When asked about the relationship between her drawings and dance in a 1998 interview, she specifically referenced the 1975 drawing, "The pyramid on graph paper…was a dance for three people, and I wanted them to be able to understand the notion of accumulating and de-accumulating."[3] According to

Marianne Goldberg, "From 1971 to 1975, Brown invented eight dances in a new 'accumulation' genre.…She pared movement down to sparse gestures played out serially, following mathematical dictates."[4] Brown's *Drawing for Pyramid* displays her concern for precision and mathematics in her lines, in her careful measurement and in her use of graph paper. Meticulous horizontal lines zigzag across the chart, occasionally overlapping to create triangles of a darker value. The numbers on the vertical axis seem to correspond to the movements that are added and subtracted in the dancer's process of "accumulating" and "de-accumulating" gestures. When speaking about Brown's dance *Locus*, also from 1975, Goldberg explains that "dance, freed from connotation, became animated by a structural language of grids, angles, and semaphore-like moves."[5] Likewise in *Pyramid*, movement is literally graphed onto a grid in a highly structured way.

By planning her dances in drawings, Brown leaves a legacy for contemporary artists such as Bruce Nauman, who thinks with drawing in a similar way. As Corinne Diserens pointed out, Brown's drawings "prolong choreographic work, or precede it;" they are "diagrams whose simple line expresses the thought of movement."[6] ✤ AMK

1 Trisha Brown, "Dancing and Drawing," interview by Hendel Teicher, in *Trisha Brown: Danse, précis de liberté* (Marseille: Musées de Marseille, 1998), 24.
2 Roger Durbin, untitled review, http://www.akron.com/20010920/SPOT/dance.htm (20 September 2001). Durbin is a member of the Dance Critics Association.
3 Brown, *Trisha Brown*, 14.
4 Marianne Goldberg, "Trisha Brown," in *Fifty Contemporary Choreographers*, ed. Martha Bremser (London: Routledge, 1999), 38.
5 Ibid., 39.
6 Corinne Diserens, "Tracé brownien," in *Trisha Brown: Danse, précis de liberté* (Marseille: Musées de Marseille, 1998), 11.

11, bottom
Untitled (diptych), 1986
Pencil on paper
2 ½ × 2 ½ inches each

A full decade before the creation of *Untitled (diptych)* (1986), dances such as *Line-up* of 1976 already were centered on the coming into being and then dissolution of lines.[1] Dance involves creating lines through directed action in space. In Trisha Brown's mid-1980s dances, according to Marianne Goldberg, "The entire group became a mechanism to heave individuals airborne, so that partnering became a sort of acrobatic cantilevering as bodies hurled, thrusted, swung, and rebounded, building and dispersing architectural forms, constantly changing plane, direction, and dimension."[2] As her dancers are flung, lines crisscross the stage in a manner that she seems to explore in drawings such as *Untitled (diptych)*, where in the square on the left many straight pencil lines intersect at a variety of angles. The right box encloses fewer lines, seemingly oriented from left to right, but all the marks are straight lines and indicate direction in space as well.

When compared to Trisha Brown's other works on paper, such as *Drawing for Pyramid*, *Footwork #13* and *Footwork #14*, which display a clear connection with either a specific dance or the body itself, *Untitled (diptych)* might at first seem minimalist with little connection to dancers or choreography. But Brown infuses the rectilinear vocabulary with an implied body motion, much as Eva Hesse subverts the minimalist grid with a bodily eccentricity of form and texture. ✤ AMK

1 Marianne Goldberg, "Trisha Brown," in *Fifty Contemporary Choreographers*, ed. Martha Bremser (London: Routledge, 1999), 39.
2 Ibid., 40.

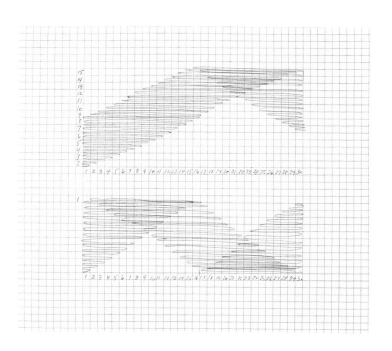

Trisha Brown

12, top
Footwork #13, 1995
Pen on paper
17 3/8 × 22 1/4 inches

13, bottom
Footwork #14, 1995
Pen on paper
17 3/8 × 22 1/4 inches

Whereas Trisha Brown's *Drawing for Pyramid* and *Untitled (diptych)* relate more to specific dances or to concepts explored within dance, later works such as *Footwork #13* (1995) and *Footwork #14* (1995) seem to refer more broadly to the body itself. In contrast to the mathematical, geometric and rectilinear character of *Drawing for Pyramid* and *Untitled (diptych)* softer, figural forms begin to appear in later drawings like *Footwork #13* and *Footwork #14*. The curvilinear lines of the feet and other body parts recall the sensory exploration of surroundings that characterized Brown's work with dance artist Anna Halprin in 1959.[1]

Like blind contour drawings, Brown's drawings of feet appear clumsy; indeed, the title of one of Brown's 1980 drawings of hands specifically tells us it is the *Left hand drawn by right hand*. According to Brown, *Footwork #13* and *Footwork #14* relate to these drawings of hands created over a decade earlier.[2] *Footwork #13* and *Footwork #14* belong to a series of thirty-six drawings of Brown's feet executed in a single day.[3] According to Brown, "It was time to have my right foot draw my left foot, and my left foot draw my right foot. I have very educated feet: they can open mail, they can turn doorknobs. I'm marsupial."[4] Brown described her process in this way:

> I purposely take it one step out of my control by using something other than my hand to draw it. I find it more interesting than my amateurish hand making, or trying to make, a Titian....When it comes to drawing ...I don't know how to make phrases....So generally there is an idea—to try foot drawings, let's say—and I have to figure out the technology.[5]

As a dancer, Brown's feet are both a natural subject and instrument. The deliberate subversion of control also inserts a dance element that resonates with the use of chance in the works of John Cage and Merce Cunningham in the 1950s and 1960s.

Brown's choreography has much in common with *Footwork #13* and *Footwork #14*. In Brown's dances of the early 1990s, movement shifts abruptly back and forth between suggestion of metaphor and formal geometry; the dancers at one moment seem to stand for nothing more than what they are and then unexpectedly elicit emotion.[6] In a similar way, the feet in these drawings dissolve from simple representation into expressive, gestural form. They also oscillate interestingly between two- and three-dimensionality as the overlapping lines obscure and flatten the drawn contours of three-dimensional objects. This ambiguity in the forms of the two feet in *Footwork #13* and *Footwork #14* parallels Trisha Brown's description of her dancers as having a "suspended identity;"[7] they escape a choreographic function, and, as Corinne Diserens writes, they gain "their own autonomy where the full power of line is expressed."[8] ❖ AMK

[1] Marianne Goldberg, "Trisha Brown," in *Fifty Contemporary Choreographers*, ed. Martha Bremser (London: Routledge, 1999), 37, 41.
[2] Trisha Brown, "Dancing and Drawing," interview by Hendel Teicher, in *Trisha Brown: Danse, précis de liberté* (Marseille: Musées de Marseille, 1998), 27.
[3] Ibid., 26.
[4] Ibid., 26.
[5] Ibid., 27, 29.
[6] Goldberg, "Trisha Brown," 41.
[7] Trisha Brown, quoted in Corinne Diserens, "Tracé brownien," in *Trisha Brown: Danse, précis de liberté* (Marseille: Musées de Marseille, 1998), 11.
[8] Ibid.

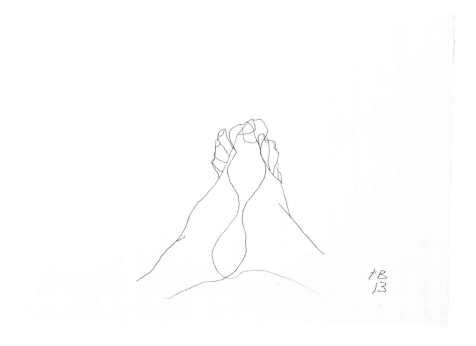

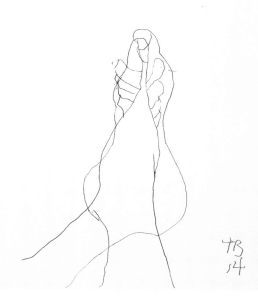

John Cage

Born 1912, Los
Angeles, California,
died 1992

14
*(2 R/1) (Where
R=Ryoanji) 7/83*, 1983
Pencil on handmade
Japanese paper
10 × 19 inches

Like his musical aesthetic, John Cage's visual art is deeply engaged with Eastern philosophy, especially Zen Buddhism. In it, Cage found a nonhierarchical worldview in which all things and beings are inter-related. Blurred boundaries are a familiar hallmark of his work. And from 1978 until his death in 1992, Cage blurred the boundaries of intention and accident by employing chance operations derived from Eastern philosophy to create drawings, watercolors and prints.

This work belongs to a series inspired by the fifteenth-century Ryoanji Garden in Kyoto, Japan, which Cage visited in the fall of 1962.[1] Ryoanji is the defining example of the Zen dry landscape garden. Its composition of fifteen rocks set into gravel raked to symbolize water represents nature in miniature.[2] In these drawings, Cage obtained images by tracing irregular circles around fifteen stones that corresponded to the fifteen rocks at Ryoanji Garden. The drawing's title, *(2R/1) (Where R=Ryoanji) 7/83*, is the formula of its composition: "2R" indicates that Cage multiplied by two the number of rocks at Ryoanji to derive the number of lines (thirty) with which he encircled the stones in the composition.[3] The symbol "/1" means that all of the drawing's lines are produced by a single type of line formation.[4]

Cage's attraction to chance operations dates back to the mid-1940s or earlier, but it wasn't until 1951, when Christian Wolff gave him the English edition of the *I-Ching* or *Book of Changes*, that Cage had a system for using chance.[5] In the *I-Ching*, the ancient, oracular Chinese text, images were selected at random from a set of sixty-four hexagrams by means of tossing yarrow sticks or coins. The *I-Ching* arrangement of hexagrams gave Cage the idea to use coin-tossing as a way of selecting pitches and other compositional features from his musical charts. He composed his 1951 *Music of Changes* in this way. Similarly, in his Ryoanji drawings, Cage used the *I-Ching*'s coin-tossing oracle as a way of selecting what stones he would use in each drawing. He also positioned the shapes, decided the number of shapes to be drawn, what types of pencils to use and so on by this method.[6] He determined the shapes of seventy-five small copper templates for a Ryoanji print series by a similar operation.[7] These chance methods shifted Cage's role as an artist from one of creating images to one of accepting them. Nevertheless, the selection of materials, the planning of the structure and the overall perspective in Cage's works are still shaped by the artist's stylistic predilections.

As a non-objective abstraction, this Ryoanji drawing shows no identifiable image, only intertwined lines and repetitively irregular circles that record the process of construction. Ranging from thin to solid lines, the delicately penciled contours only lightly reveal a stone's trace and assert its absence. This last point is important, because the emptiness evoked signifies the core of meditation in Zen, in which one contemplates the void while awaiting enlightenment. ✦ LLT

[1] Richard Fleming and William Duckworth, eds., *John Cage at Seventy-Five, Bucknell Review* 32, no. 2 (London and Toronto: Associated University Presses, 1989), 96–97.

[2] David Bernstein and Christopher Hatch, eds., *Writing through John Cage's Music, Poetry and Art* (Chicago: University of Chicago Press, 2001), 236.

[3] Joan Retallack, ed., *Musicage: Cage Muses on Words, Art, Music: John Cage in Conversation with Joan Retallack* (Hanover and London: Wesleyan University Press, 1996), 280.

[4] Ibid., 281.

[5] Jonathan Fineberg, *Art Since 1940: Strategies of Being*, 2nd ed. (New Jersey: Englewood Cliffs, 2000), 175.

[6] Retallack, *Musicage*, 240.

[7] Bernstein and Hatch, *Writing*, 236.

John Cage

15

River Rock and Smoke, 4/13/90, #12, 1990
Watercolor on paper prepared with smoke
52 ½ × 15 inches

For at least two weeks every year from 1978 to 1992, John Cage worked at Crown Point Press in San Francisco making drawings and etchings. He had given up painting for music in the late 1920s and early 1930s, but this experience reopened the world of visual art for him.[1] In 1985, he developed with the printers at Crown Point a technique called "smoking" the plate.[2] In this technique, the printers ignited a wad of newspapers and suffocated the flames with dampened printing paper. The entire ensemble, still smoldering, was then gathered up in a wool blanket and quickly run through the press. The gray essence of the smoke, along with ghostly traces of newsprint, was impressed into the paper.[3] Since the size and area of the burn marks were uncontrolled, the technique created unpredictable atmospheric effects, consistent with Cage's aesthetic of indeterminacy.

In *River Rock and Smoke 4/13/90 #12* (1990), Cage complicated the smoking technique by combining it with watercolor. In 1988 and again in 1990 he accepted an invitation to work at the Mountain Lake Workshop at the Virginia Tech Foundation in Blacksburg.[4] This drawing was made there, using the technique that Cage developed at Crown Point. In this work, the yellowish and irregularly smoked residue scatters across two-thirds of the picture with an impressive array of burn patterns. In the lower right-hand section, Cage brushed watercolor around the contour of a rock. The composition shows an interesting counterpoint between the yellowish smoky areas produced by the fire and the light calligraphic brushstrokes of the water-based color. In the *I-Ching*, fire and water are two of the five earthly elements that sustain nature and drive the universe.[5] Cage's use of smoke (fire) and watercolor (water) suggests he learned from the *I-Ching* more than just its divinatory methods.

Although Cage earlier had resisted using a brush on the grounds that brushwork too strongly reflects the agency of the artist, he devised a way consistent with his aesthetic to brush watercolor into this drawing. "This is a very circumscribed gesture," he explained, "because it has the support of the stone."[6] Tracing around a rock selected by chance operations, Cage believed that the rock, more than the hand of the artist, determined the calligraphic line of the watercolor.

Cage used a randomizing process to make this drawing because he viewed art as an exploration of nature, whose fundamental principle is chance. He sought to open the mind and spirit to the beauty of life in a way minimally affected by the artist's expression or interpretation. Cage preferred that viewers provide their own meaning according to their individual personality and life experience. This open-ended or non-intentional strategy is a guiding principle of Cage's aesthetics, and *River Rock and Smoke 4/13/90 #12* is a microcosm of that attitude. ❖ LLT

[1] Joan Retallack, ed., *Musicage: Cage Muses on Words, Art, Music: John Cage in Conversation with Joan Retallack* (Hanover and London: Wesleyan University Press, 1996), 83.

[2] Ibid., 239.

[3] Ibid., 244.

[4] David Bernstein and Christopher Hatch, eds., *Writing through John Cage's Music, Poetry and Art* (Chicago: University of Chicago Press, 2001), 238.

[5] Most scholars note Cage's technical application of *I-Ching* methods. But this juxtaposition of fire and water suggest he also understood its philosophy of the natural world. The five earthly elements in the *I-Ching* are metal, wood, water, fire and earth.

[6] John Cage, interview by Vincent Katz, *Print Collectors Newsletter* 20 (January/February 1990): 109.

Anne Chu

Born 1959, New York, New York, works in New York City

16, top
Listen, 1994
Acrylic, pigment, pencil and embroidery on paper
28 1/4 × 24 1/4 inches

As an artist, Anne Chu's interests lie in abstraction. She explores the exclusively physical qualities of form through a variety of mediums, frequently creating drawings to complement her sculptures. *Listen* (1994) is an investigation in which Chu isolates particular forms and materials from previously completed sculptures and organizes them into a fresh design.

On a thick and grainy surface, a symmetrical, pink acrylic floral form dangles from a black square embroidered into the paper. Chu relegates these two shapes to their own space on the paper and restricts them to the left third of the sheet. This isolation allows the artist to explore the shapes and mediums without reference to narrative or relative space, in keeping with her own interpretation of abstraction, which demands a focus on isolated form.[1]

Chu achieves this focus by stressing the unique characters of her forms. The artist has brushed layer upon layer of acrylic onto the paper, drawing attention to the shiny, thick surface that characterizes the paint. The bright pink color and sheen of the floral form contrasts with the texture of the embroidered thread and the matte paper onto which Chu

paints it. While the thickness of the acrylic establishes a separate plane from the paper's surface, the black square incorporates the paper into its stitch. Chu clearly regulates these forms: Traces of graphite inside each pink petal accentuate the deliberate planning of both form and composition, as does the tight and even spacing of machine-stitched thread.

A faint greenish watercolor stains the other section of the paper. It covers a rather large area of the page and appears poured rather than brushed onto the surface. It flows into the two shapes on the left, breaking the isolation of the forms. In contrast to the stable solidity of the acrylic and sewn forms, which assert such strong identities as a result of Chu's heavy manipulation of their materials, the spread of the watercolor feels uncontrolled. Chu's shapes exist apart from one another in color and medium, as well as in the process of their creation. This opposition allows Chu to bring out the particularity of all her forms, as well as the complexity with which they compose a whole. ✤ JEM

[1] Anne Chu, telephone conversation with author, 13 March 2002.

17, bottom
Landscape, 1999
Watercolor on paper
23 1/2 × 31 inches

Landscape paintings as a genre customarily contain a visual representation of land and sky. Anne Chu's *Landscape* (1999) depicts a view of the natural world but one that exists as an amalgamation of abstract relationships and challenges received notions of landscape painting.[1] For Chu, a true landscape is not mimetic of a panoramic scene but rather an abstracted system of shapes and colors.

Chu works with watercolor because of its transparency and the way paper grain absorbs its color and allows uncontrolled figuration to seep into a composition.[2] The haphazardly placed brushstrokes of *Landscape* enable the artist to maintain this level of uncertainty through the changing character of the stains. At times, an underlying color retains its original tone and remains visible beneath faint overlapping

strokes. At other times, the pressure of Chu's brush and the concentration of her water-pigment mixture might mix hues or even eliminate colors altogether. The splotches may also change shape, spreading outward with the addition of more water. This fundamental unpredictability of color and form is *Landscape*'s defining characteristic. Color, in particular, Chu has said, is "not part of the substance of things at all, and somehow corrosive of our ability to make out that substance."[3] ✤ JEM

[1] Anne Chu, telephone conversation with author, 13 March 2002.
[2] Chu, telephone conversation.
[3] Barry Schwabsky, "Anne Chu," *On Paper* 2, no. 1 (September/October 1997): 21.

Marsha Cottrell

Born 1964, Philadelphia,
Pennsylvania, works in
Brooklyn, New York

18, left
Untitled, 1998
Toner on paper
11 × 8 ½ inches

19, right
Untitled, 1998
Toner on paper
11 × 8 ½ inches

Marsha Cottrell's computer-assisted works on paper broaden the notion of drawing by introducing new materials and processes to the medium.[1] Understood as a manual rendering of thought processes, drawing can function as a projection of the artist's conceptual plan for a final work. As a stylistic language it also distinguishes the individual artist's hand. However, Cottrell's delicate drawings stand as independent formal explorations not adjunct to painting or sculpture. They are self-sufficient visual objects made by modest means. In the *Untitled* works (1998), Cottrell manipulated the punctuation marks in a word-processing program and laser-printed them in toner (plastic iron oxide) onto yellowish Japanese paper in standard 11 × 8 ½-inch format. The tiny, crisp black marks are dispersed around the center of the paper surface, creating a faint illusion of space. Cottrell doubly separates the marks from their conventional origin: First, by the act of typing and laser printing she disengages the activity of mark-making from the existential gesture of the hand. Second, she estranges the keyboard marks from their customary function, inverting these neutral and banal marks into personal, expressive gestures.

Around 1997 Cottrell started to use the computer as a drawing tool instead of such conventional materials as graphite, ink and gouache,

> It was really exciting to me that I could have the freedom to organize these tiny, sharp and very black particles independent of a conventional typewriter/word-processing grid. It was an intuitive decision to use typewritten information....I wanted most to see how far I could go staying as close to the most straightforward application of the computer as possible.[2]

Cottrell estranges familiar marks and signs by misusing or abusing their functions. It is this creative misuse of the computer that characterizes her mechanical drawings as an alternative mode of expression.[3] Despite removing the hand's trace from her work, she does not negate the manual process of drawing in a specific time and space. Instead, her artistic appropriation of word-processing technology humanizes the mechanical nature of the medium.

Cottrell's typed drawings exist somewhere between writing and drawing. She draws with punctuation marks, "the pauses within speech."[4] Neither discursive nor figurative, the tiny marks look like vestigial hieroglyphs that seek verbalization. Using the machine as a "poetic device," Cottrell's work pushes the ever-expanding boundaries of drawing.[5] ❖ EYJ

[1] Using the term "computer-assisted" instead of "computer-generated" for her work, Cottrell emphasizes artistic interventions involved in her drawings. "They are," she remarks, "derived from a very human, improvisational process." Marsha Cottrell, electronic correspondence with author, 6 May 2002.

[2] Marsha Cottrell, electronic correspondence with author, 12 March 2002.

[3] "Cyber Drawings," press release for the exhibition *Cyber Drawings*, Cristinerose Gallery, January 6–February 12, 2000, unpaginated.

[4] Sarah Schmerler, exhibition review of *Cyber Drawings*, *Art on Paper* (May–June 2000): 81.

[5] Ibid.

Walter De Maria

Born 1935, Albany, California, works in New York City

20
Nine Mountains and the Sun, 1964
Graphite and colored pencil on paper
23 × 35 inches

Walter De Maria received a bachelor's degree in history and a master's degree in art from the University of California, Berkeley. After arriving in New York in 1960, De Maria participated in the Judson Dance Theater, interacted with Fluxus artists and performed with a rock band; in 1968, he began making site-specific work in real landscapes. A difficult artist to classify, De Maria has played an integral part in minimalism, land art and conceptual art. Unlike most of De Maria's drawings, his whimsical graphite and colored pencil drawing *Nine Mountains and the Sun* (1964) does not appear to be preparatory for sculpture.

He made the drawing a few years after his arrival in New York and nearly a decade before some of his best-known site-specific work. A simple line drawing of a mountainous island surrounded by sea and sun, the work seems almost naïve. The light lines of the mountains seem to disappear at a distance of ten feet and elicit a sense of timelessness, similar to De Maria's *Lightning Field* (1977). A visitor to *Lightning Field* is catapulted into a space without history, a space that isolates the viewer. When describing the work in 1980, De Maria stated, "Isolation is the essence of Land Art."[1] Likewise, De Maria's *Nine Mountains and the Sun* isolates its viewer by a lack of context. The drawing's yellowed edges and fanciful subject matter seem nostalgic, without reference to an actual place. It evokes an otherworldly landscape in the same way as does De Maria's *5 Kontinente Skulptur* (1987).

Contemporary with this drawing, De Maria was fabricating minimalist objects in polished aluminum and stainless steel—works like *Cage* (1961–1966), *Cross* (1965–1966) and *Death Wall* (1965)—which related in their simplicity to contemporary works by Donald Judd but sometimes had menacing titles and suggestive forms. *Museum Piece* (1966–1967), for example, has the form of a glistening swastika. Landscape drawings also exist from the mid-1960s in the form of a single word such as "sky," "mountain" or "river" lettered across a sheet—highly conceptual drawings that recall such earlier works as Jasper Johns's *Out the Window* (1959), in which Johns lettered the title over his canvas to signal a view onto nature. But *Nine Mountains and the Sun* seems like an aberration in De Maria's work of the period. Perhaps its closest parallel is in the contemporary drawings of Robert Smithson or Robert Morris's *Untitled* (1965), which evokes a romantic landscape via the description of a mound of earth (see page 117). ❖ AMK

1 Walter De Maria, "The Lightning Field," *Artforum* 18 (April 1980): 58.

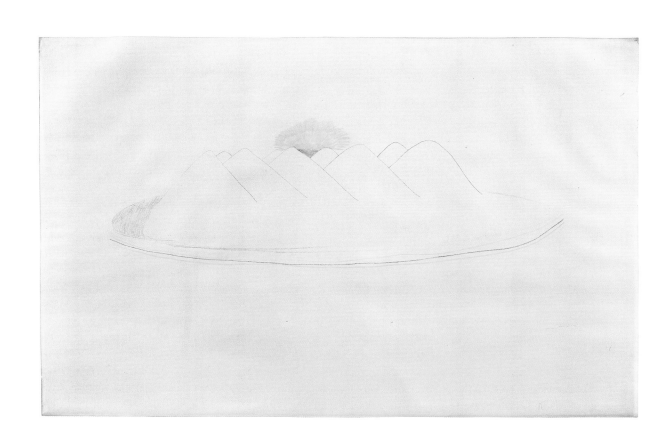

Dan Flavin

Born 1933, New York,
New York, died 1996

21
*Jill's Red Red and
Gold of December 9,
1965*, 1965
Colored pencils on paper
19 3/4 × 12 3/4 inches

Since 1963 Dan Flavin has focused on a single medium —the fluorescent tube. For over three decades he experimented with the limited vocabularies of commercially available light units: nine colors, four sizes and two shapes of fixtures.[1] His light work developed toward architectural installations that "combine traditions of painting and sculpture in architecture with acts of electric light defining space."[2] In the middle to late 1960s, Flavin also made a number of schematic drawings on white, gray or black paper in graphite and colored pencils. Distinguished from his graph paper diagrams, notebook sketches and architectural floor plans, Flavin drew most of these drawings, like *Jill's Red Red and Gold of December 9, 1965*, with fine lines in geometric composition.

The organization of colored tubes in this drawing is simple and almost stark. The relative proportion of the tubes suggests that the artist might have wanted to use a two-foot lamp in the middle and six- or eight-foot tubes on either side. Yet, Flavin here seems more concerned with capturing the immediate experience of light than with the exact size of the tubes. He creates a tension-filled space in the dialectic between the austere lines of color and the total space of the paper. By eliminating the depiction of the rectangular fixtures he reinforces an intense light effect of contrasting colors.

Flavin wrote, "I intend rapid comprehensions—get in and get out situations. I think that one has explicit moments with such particular light-space."[3]

The three colored lines of this symmetrical composition recall the *Monument for David* series that the artist made in the mid-1960s. In this series of drawings dedicated to his twin brother, who had died in 1962, Flavin composed on black paper, showing a shorter vertical tube framed by two longer tubes of light. Flavin characteristically referred to his finished installations in current compositions and further developed earlier ideas in his drawings. In addition, qualities associated with painting, such as color and composition, persistently engaged Flavin even as he focused on the systematic arrangement of light fixtures. "I aim constantly for clarity and distinction first in the pattern of the tubes and then with that of the supporting pans," he wrote. "But, with or without color, I never neglect the design."[4] ❖ EYJ

[1] The nine colors were blue, green, pink, red, yellow and four variations of white. The straight light tubes came in two, four, six and eight feet, but toward the late 1960s six-foot lamps became increasingly obsolete. The circular light fixtures, uniformly in one foot, were first used in 1972.
[2] Dan Flavin, "…In Daylight or Cool White," *Artforum* 4 (December 1965): 24.
[3] Dan Flavin, "Some Other Comments…," *Artforum* 6 (December 1967): 23.
[4] Ibid., 21.

Dan Flavin
(Sonja Flavin)

22
Untitled (to Barnett Newman) One and Three, 1971
Black ink, colored pencils and graphite on graph paper
16 × 22 inches

n December 1971, Flavin submitted two pairs of rectangular corner installations for an exhibition in the Dwan Gallery.[1] These four corner installations developed from a single installation Flavin exhibited in the Leo Castelli Gallery a year earlier using the same primary colors. Each of the four assemblages consisted of four-foot yellow lamps at the top and bottom and combinations of four- and eight-foot red and blue light tubes arranged vertically to form a rectangle. The installations paid homage to Barnett Newman, who had died in 1970. Flavin selected red, yellow and blue to refer to a series of late paintings by Newman entitled *Who's Afraid of Red Yellow and Blue*; Flavin saw number IV in the series in the artist's studio shortly after his death.

Untitled (to Barnett Newman) One and Three (1971) diagrams installations one and three of the Dwan Gallery set of four. Like many of the graph paper diagrams executed under Flavin's supervision by his wife Sonja, the drawing factually records the components and colors of the installations. The red and blue lines on either side suggest the back projection of light. Flavin explored back projection in his corner pieces and some corridor installations by facing the supporting pans to the front and the lights to the back. For instance, in the "barrier" pieces that he continued to explore after 1966, Flavin installed a series of vertical fixtures in corridors, blocking the viewer's passage and thereby using the gallery space in a more overtly physical way.

The schematic drawing in the bottom center of the page shows the placement of the piece in a corner. Flavin's active use of corners reveals his interest in the Russian constructivists who placed work in more unstable relations to their exhibition spaces, frequently using corners to accentuate a revolutionary dynamism. Flavin explicitly expressed his admiration for the Russian avant-garde of the early twentieth century in the series *"Monuments" for V. Tatlin*. The title of the series refers to Vladimir Tatlin's unrealized project of 1919, *The Monument to the Third International*, a symbol of the utopian social ambition of the Russian avant-garde. Flavin noted in 1965 that his work "has been founded in the young tradition of a plastic revolution which gripped Russian art only forty years ago."[2] He dedicated thirty-six light installations to Tatlin between 1964 and 1982.

This drawing shows that the artist's deployment of industrial products involves an additive process of color and shape. Flavin's projects present permutations of basic modules, but they are not as systematic or exhaustive as those by Donald Judd or Sol LeWitt. In 1966 Flavin remarked with a hint of pessimism, "I sense no stylistic or structural development of any significance within my proposal—only shifts in partitive emphasis.... It is curious to feel self-denied of a progressing development, if only for a few years."[3] However, for all the apparent constraints of standardized industrial materials, he found new possibilities in the medium of fluorescent light for more than thirty-five years, until his death in 1996. Flavin's light installations transformed space and architecture, probing the unlimited possibilities of light permeating space. ❖ EYJ

1 The diagram of the four assemblages is reproduced in *Drawings and Diagrams by Dan Flavin, 1963–1972* (St. Louis: St. Louis Art Museum, 1973), 77.
2 Dan Flavin, "On the *Monuments*," in *"Monuments" for V. Tatlin from Dan Flavin, 1964–1982* (Los Angeles: Donald Young Gallery and Leo Castelli Gallery for the Museum of Contemporary Art, 1989), unpaginated.
3 Flavin, "Some Remarks...," *Artforum* 5 (December 1966): 27. Flavin added, "The lamps will go out (as they should, no doubt). Somehow I believe that the changing standard lighting system should support my idea within it. I will try to maintain myself this way."

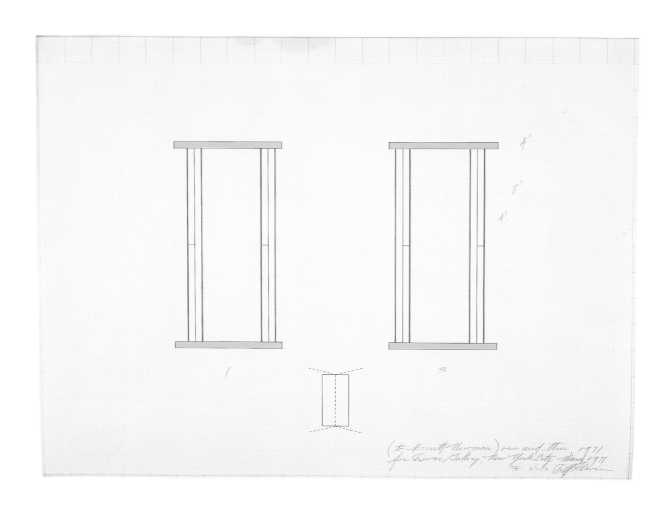

1 3

(to Barnett Newman) one and three 1971
for Dwan Gallery, New York City, March 1971

Dan Flavin
(Sonja Flavin)

23
*Alternate Diagonals
of March 2, 1964
(to Don Judd)*, 1971
Pen and black ink
and colored pencils
on graph paper
17 ¼ × 22 ½ inches

Alternate Diagonals of March 2, 1964 (to Don Judd) (1971) represents an assemblage of light tubes arranged at an angle of forty-five degrees. The eight-foot tube issues from a base of four four-foot strips. A bluish-white tint has been added to the tubes to suggest color and set them off from the ground. Dan Flavin repeatedly altered tube colors and positions throughout this work's exhibition history. When he first exhibited it in the Kaymar Gallery in New York in 1964, he used a gold eight-foot tube and red four-foot tubes in a downwardly angled composition. When installing the piece in the Green Gallery later that year, he made the eight-foot tube cool white and the four-foot tubes daylight and angled them as indicated in this drawing. The initial drawing for the piece indicates "all red" for the tube color.[1]

These variations of color and arrangement demonstrate the ongoing importance of drawing in Flavin's installations. "All my diagrams," Flavin wrote, "even the oldest, seem applicable again and continually. It is as though my system synonymizes its past, present and future states without incurring a loss of relevance."[2] A few years later he added, "I have come to understand that, for me, drawing and diagramming are mainly what little it takes to keep a record of thought….Within my reciprocating system for fluorescent light such continuous retention is constantly required….The system is as active as I can think within and for it."[3]

Flavin believed that the diagonal placement of a fluorescent light tube would create a dynamic equilibrium between fluorescent light as image and the light tube as a physical object. In his seminal work of 1963, *the diagonal of May 25, 1963,* he diagonally arranged on a wall a common eight-foot light tube and fixture. Flavin stated, "The radiant tube and the shadow cast by the supporting pan seemed ironic enough to hold alone.…It seemed to sustain itself directly, dynamically, dramatically in my workroom wall—a buoyant and insistent gaseous image which, through brilliance, somewhat betrayed its physical presence into approximate invisibility."[4]

Against critics' reading of the gaseous fluorescent light as spiritual and mystical, Flavin adamantly defined his light work as a simple and direct statement based on an interchangeable system of parts.[5] The modules of each work are prefabricated industrial products with variable limits of color, size, shape and duration. Executed under his supervision by his wife Sonja, this work demonstrates the role of drawing as a systematic record of Flavin's oeuvre. Whereas the lines and notes are more spontaneous in Flavin's sketches on notebook pages, the use of color and line in this diagram is highly precise and restrained to document the installation and record the factual components of the work. ❖ EYJ

1 *Fluorescent Light, Etc. from Dan Flavin* (Ottawa: National Gallery of Canada, 1969), entry no. 87.

2 Dan Flavin, "Some Remarks…," *Artforum* 5 (December 1966): 27.

3 Dan Flavin, *Drawings and Diagrams by Dan Flavin, 1963–1972,* (St. Louis: St. Louis Art Museum, 1973), 4.

4 Dan Flavin, "…In Daylight or Cool White," *Artforum* 4 (December 1965): 24.

5 The artist emphatically said, "My fluorescent tubes never 'burn out' desiring a god." Dan Flavin, "Some Other Comments…," *Artforum* 6 (December 1967): 21.

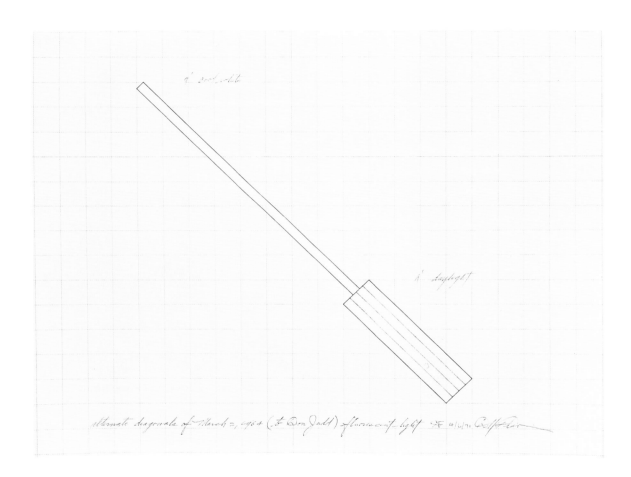

Suzan Frecon

Born 1941, Mexico, Pennsylvania, works in New York City

24, top
strokes then turn, 1999
Watercolor on agate-burnished old Indian ledger paper
17 1/4 × 13 3/8 inches

25, bottom
Untitled, 1994
Watercolor on Indian paper
12 5/8 × 17 3/4 inches

As if to give the viewer gentle instructions, Suzan Frecon strategically placed a meditation on the practice of looking, written by Gervaise of Canterbury in 1174, on the penultimate page of an exhibition catalogue: "A work of art can only be comprehended by looking at it—and no description is a substitute for this."[1] These words speak to the subtle yet expansive force of Frecon's work, which grows more intense through concentrated looking. While most art critics attempt to sum up this power by describing the associations the work might conjure, such as memory, architecture or calligraphy, Frecon instead speaks of it in terms of pure abstraction. She concerns herself primarily with the formal and technical challenges of color, value, balance and composition.

While her watercolor drawings like *Untitled* (1994) and *strokes then turn* (1999) are often exhibited autonomously, they only represent one aspect of her work. Frecon also produces large-scale abstract oil paintings, using deep hues of red, green and blue that are similar to the colors in her drawings. Although her watercolors are not usually studies for her oil paintings, she does often work on drawings and paintings simultaneously. For example, as a layer of paint dries on an oil painting, she may turn to a watercolor and continue to work on an aspect of a formal problem. The two mediums create an important balance in her body of work: Frecon maintains rigorous control over the preconceived, tight, geometric compositions of her oil paintings, but prefers in her watercolors to collaborate with the materials, so to speak, allowing for accidental effects. For example, she might predetermine how many strokes she will use in a watercolor or the direction she wishes the composition to take, but she will leave room for the watercolor to bleed into the paper, creating irregular edges and often wrinkling the delicate papers she frequently selects.

In *Untitled* and *strokes then turn* Frecon uses an Indian paper that often comes already creased and sometimes with writing on it. *strokes then turn* has been creased into four even quadrants, and a thin section creased along the bottom also has been divided into four equal squares. The creases register almost like thin, precise pencil lines creating a grid. The fluidity of the thick, flowing brushstrokes contrasts strikingly with the regularity of the creases. The four small squares at the bottom of the drawing emphasize the emptiness of the space beneath the brushstrokes at the same time that they bring the ground forward. The relationship between the paper and the paint is further emphasized by the bleeding on the edge of the brush strokes, especially in the creases of the paper.

The thick lines in *Untitled* also bleed into the paper, giving the impression that the lines almost organically grow from one another. This tangle of lines crowds the page and creates an expansive energy from which the viewer can imagine the lines reaching beyond the paper's edge. Although more intensely packed than *strokes then turn*, the thick red lines in *Untitled* also maintain a strong relationship with the paper. Rather than overpowering the delicate balance of the composition, the energetic lines enclose organic areas of the paper, turning negative space into positive shapes.

By following Frecon's instructions simply to look at her work, the viewer will find that the material and formal aspects of her drawings—the texture of the paper, the composition of the bleeding brushstrokes—open up the work to the associations of which critics have written, such as memory, transformation and change. Yet, trying to describe how her work visually expresses these themes merely undermines each drawing's own visual uniqueness. As Gervaise's quote suggests, looking at the work allows its meaning to expand while trying to tie down its immaterial meaning through language only sets limits. ❖ SLE

[1] Printed in *Suzan Frecon* (Wien: Wiener Secession, 1994) unpaginated.

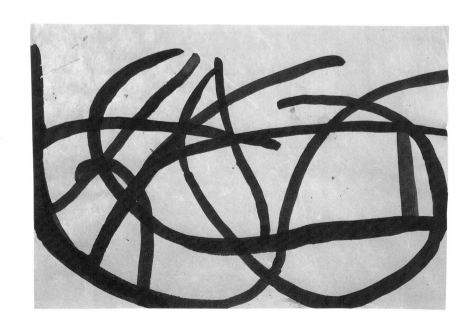

Simon Frost

Born 1962, Woodham,
Surrey, England, works
in Brooklyn, New York

26, left
Untitled, 1993
Graphite on paper
20 3/8 × 9 3/8 inches

Artist after artist has taken up the grid as the medium within which to work, always taking it up as though he were just discovering it, as though the origin he had found by peeling back layer after layer of representation to come at last to this schematized reduction, this graph paper ground, were *his* origin, and his finding it an act of originality.[1]

For *Untitled* (1993) Simon Frost went to the rudimentary origins of drawing, using graphite, paper and the grid. Although Frost describes his materials simply—"a piece of paper and a stick to draw with"—his subject is more complex.[2] The use of the grid carries with it many loaded references both to a modernist vocabulary and minimalism, as well as to the rhetoric of objectivity with which Frost concerns himself. While playing into this rhetoric and exploiting the foundational quality of the grid, the artist attempts to break free from its repetitive limitations.

Frost painstakingly drew by hand the grid in the background of this piece. An edge of the grid, with alternating lengths of line, is visible along the top. At the starting points of each line, one can detect the marks made by the pressure of the pencil, which assert the human presence behind this creation. In addition, Frost drew the grid squares on the left larger than to those on the right in a play against the austerity of the grid, which most often is precisely and mathematically constructed. All of these imperfections restate the proximity of the artist and challenge the mechanization of repetitious form. *Untitled* thus questions the concept of the grid by emphasizing the subtleties of individual human impact.

Several other elements of this deceptively simple drawing further confuse its objectivity and highlight the artist's subjective motivations. The graphite Frost uses encourages a tactile connection to the drawing—as the fingers would wrap around the angular wood of a pencil to draw these lines—and graphite's uncertain, powdery edge gives the grid a soft quality. Set against the background of the grid, swarms of waxy, black dots introduce a level of optical subjectivity, barely allowing through the space between them a glimpse of the paper beneath. As one stares at the overall pattern, the black dots converge into a uniform haze that seems to rise from the grid and into the viewer's space. ✣ JEM

[1] Rosalind Krauss, "The Originality of the Avant-Garde," in *Art after Modernism: Rethinking Representation*, ed. Brian Wallis (Boston: David R. Godine Publisher, Inc., 1984), 19.
[2] Simon Frost, telephone conversation with author, 10 March 2002.

27, right
Untitled, 1993
Graphite on paper
16 15/16 × 10 inches

Simon Frost describes the repetitious wave design in *Untitled* (1993) as architectural. He likens its construction to the building of towers with a foundation on the bottom and layers consecutively added on top.[1] However, despite this architectural metaphor, Frost's drawing promotes a more humanized experience of the cool structure. The ripple of the layers creates an illusion of movement as the viewer's eyes undulate along the crests and troughs, lifting and sinking with their changing tonality. Then, as the eye moves farther down the page, the spaces between the lines appear to contract and compress. The tonal gradations within the drawing, from the lightness of upper lines to the progressively deeper darkness near the bottom, are so subtle that it is difficult to discern where the drawing begins and ends. Frost leads the viewer on a futile search for a point of origin that is implicit, never directly evident. All these elements involve the viewer within the drawing and make the viewing process more subjective. Subtleties of light, shade and contour lead the eye around the page, forcibly engaging viewers in the act of seeing. ✣ JEM

[1] Simon Frost, telephone conversation with author, 10 March 2002.

Cheryl Goldsleger

Born 1951, Philadelphia, Pennsylvania, works in Athens, Georgia

28, top
Untitled, 1999
Wax, oil and
pigment on paper
22 1/2 × 22 5/8 inches

29, bottom
Untitled from the Circuitous Series, 1997
Wax, pigment
and oil on paper
40 × 40 inches

Cheryl Goldsleger uses wax in her drawings in order to make her work more penetrable. She exploits its texture and transparency, pouring the viscous medium so that it appears soft and rubbery when dry and permits a view of what lies beneath. Wax allows Goldsleger to challenge the unstable boundaries of two-dimensional work. It dematerializes the painting with its simultaneous presence both on top of and within the paper as it covers and seeps into the porous grain of its surface. In *Untitled* (1999), the artist experiments with this medium and its characteristic penetrability. The color and thick surface of a white maze overlaying a grid causes the maze visually to separate from the darker background. The artist has poured the wax so that it not only penetrates the grain of the paper but also enters the space of the viewer as it thickens in layers atop the paper's surface. Goldsleger addresses the space of the viewer in a work like *Untitled from the Circuitous Series* (1997) as well. Instead of the picture merely entering the viewer's vision, Goldsleger invites the viewer to enter the picture's space in return.

In this *Circuitous Series* drawing, Goldsleger depicts an identical maze from multiple perspectives with each maze positioned at a different angle to the picture plane and layered one on top of the other. In an architectural space devoid of people, the drawing suggests an amphitheater or English maze garden. Goldsleger tries "to create structures that invite one to physically move through and be surrounded by the space in a tactile way."[1] The artist inserts a human presence by encouraging the viewer visually to wander the space. In this complex system of perspectives, views from above reveal the intricacies of the maze's organization, while other perspectives engulf the viewer within its structure, suggesting the anxiety of being trapped in a labyrinth. The drawing thus incorporates a sense both of order and disorder, allowing simultaneously a view from without that is schematic and a view from within that is subjective. The experience is at once fascinating and disorienting, as the strangely linear and cyclical nature of the pattern repeatedly doubles back on itself but preserves an external appearance of order.

The subjective experience with which Goldsleger infuses her geometric forms is echoed in the marks she leaves in her drawings: the ragged edges of the paper, the variations in surface densities, even impressions of her fingers in the wax. Her drawings are unique in "their use of elementary spatial gestalts to generate a supposedly universal language—the climax of the century's rationalist non-objective art."[2] She uses the grid and the maze as her foundation and imbues these geometric and repetitive patterns with both her own and her viewers' presence, creating a unique spatial experience. ✤ JEM

[1] Cheryl Goldsleger, "Artist's Statement," in *Large Drawings* (New York: Bertha Urdang Gallery, 1993), unpaginated.
[2] Donald B. Kuspit, "Cheryl Goldsleger at Bertha Urdang," *Art in America* 73, no. 3 (March 1985): 151.

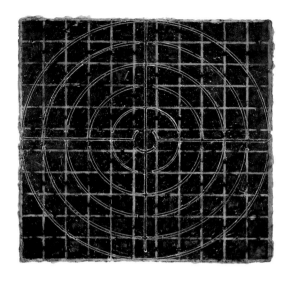

Robert Grosvenor

Born 1937, New York, New York, works in East Patchogue, New York

30, top
Untitled, 1973
Pencil and masking tape on paper
22 ½ × 28 ¼ inches

31, bottom
Untitled, 1974
Masking tape and pencil on paper
29 ½ × 49 ¼ inches

Throughout his career, sculptor Robert Grosvenor has tested the limits of his materials, always attempting to draw something unexpected out of them. *Untitled* (1973) is a sketched experience of such an attempt in which the artist forcibly bent and broke two static poles, making them soft and malleable.[1]

In the lower right corner of the page, the artist has written, "2 telephone poles implanted in the ground upside down, broken off at ground level / Fresno, California 1973." However, the drawing is not merely a study for this sculpture. It is not subordinate but equivalent to the three-dimensional work in both its form and its relationship to the viewer. Accordingly, the straightforward materials and simple arrangement of the drawing deny a schematic reading of the project. There are no measurements on the page. There is no marker of scale. Only a faint graphite line stretched across the surface places the forms in any specific relationship to each other. The beams exist only in their final state, without reference to their mass or process.

This is an experience similar to that which the viewer would have with the finished sculpture, where one does not witness the force of Grosvenor's fracturing process. Instead, the artist exhibits only the final product of his actions, so as to accentuate the material form of the objects. *Untitled* reflects the same attempt to allow the two broken beams to rest in nonreferential space. In this drawing, it appears as though Grosvenor has carefully isolated these beams in order to promote a new way of seeing the telephone pole. The faint line sketched across the page appears too fragile to support the mass of thick masking tape intended to represent the poles. There are no extraneous markers of the surrounding environment. Instead, the L-shaped beams appear to contradict their mass and float freely in space. ✤ JEM

[1] Robert Grosvenor, telephone conversation with author, 13 April 2002.

Untitled (1974), like *Untitled* (1973), relates to a wooden beam sculpture executed at an outdoor site. Robert Grosvenor described making the sculpture by cutting the beam through its center, breaking it to the left and right of the cut and later excavating earth from beneath the center break. He then applied downward force to the center of the beam, causing the two pieces of the pole to dip in a shallow v-shape and recede into the earth. By thus connecting the beam to the ground beneath it, the artist symbolically restores its original connection to the earth, almost redeeming it from its function as a telephone pole. In Grosvenor's view, by breaking the pole and forcing these ends to lie down into the earth, he has taken the stress out of the pole and returned the material to a state of structural calm.[1]

Grosvenor's drawing makes visual references to this untitled sculpture, which was later lost. A central indentation in the length of tape indicates where the pieces of the pole have sunk into the earth. The graphite ground line turns darker in certain areas underneath the tape to suggest where the

earth would yield to the weight of the depressed end of the pole.[2] Despite these physical correspondences, however, *Untitled* evokes a much different experience than the sculpture. Since all references to the sculpture or the process of its creation (e.g., any recorded measurements or calculations) are absent, the drawing operates in an independent way. On this large sheet of paper, the pieces of tape seem too fragile and thin to signify wooden beams. Likewise, the tears in the tape are almost delicate in their intricacies. Grosvenor has even gone so far as to overlap the tears along the length of the tape, disguising their fractures. This drawing promotes more delicacy than Grosvenor's own sculpting would allow and suggests a gentleness that is extraordinary when compared to the actual brute forces of the sculpture. ✤ JEM

[1] Robert Grosvenor, telephone conversation with author, 13 April 2002.
[2] Christine Mehring, "Robert Grosvenor," in *Drawing Is Another Kind of Language: Recent American Drawings from a New York Private Collection*, eds. Pamela Lee and Christine Mehring (Cambridge: Harvard University Art Museums, 1997), 59.

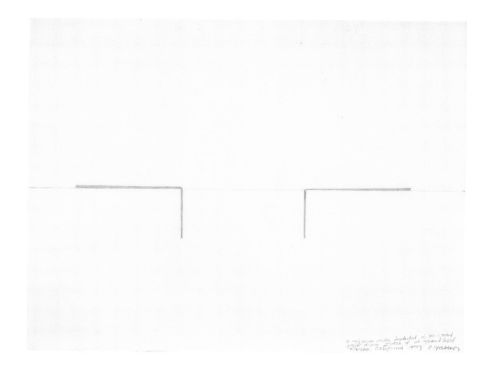

Nancy Haynes

Born 1947, Waterbury, Connecticut, works in Brooklyn, New York

32, top
Untitled, June 1995
Monotype
printed in black
10 3/4 × 12 3/4 inches

Nancy Haynes insists that her work "is severely, intentionally non-objective, truly not grounded in anything. My paintings are not abstractions of landscapes, still lifes, figures, or anything we know. They are detached fragments of the unknowable."[1] *Untitled* (June 1995) belongs to the "dissolving grid series," created using a ground of graphite etching ink under an oil paint grid. Haynes traced around a plastic waffle from a light fixture, then removed parts of the painted grid with a sponge brush. Because of the viscosity of the paint, she could actually move the grid more or less intact, "deconstructing the architecture of the composition."[2]

The artist herself suggested a feminist reading of this deconstruction in which she, like Eva Hesse, softens the strict geometry of the minimalist grid into something at once lyrical and almost bodily. In *Untitled*, a black grid overlies a rich gray background; ink bleeds where horizontal and vertical lines meet. The grid seems to be a recurrent theme. As Barbara MacAdam remarked, Haynes's monotypes are "constructs,

palimpsests, built layer upon layer."[3] Yet, parts of the grid are missing. Like interference on a television screen, the black grid fades out intermittently, and the absences are as expressive as any visible marks. The ink in this drawing soaks into the paper to create a surface absence like a solarized photograph. Jeremy Gilbert-Rolfe notes an "intensification of one's sense of the surface" in Haynes's work "where modulation replaces construction, which is to say, where (phenomenal) concepts of appearing and disappearing displace (ethical) ones of revealing and concealing."[4] As Nancy Haynes has said, she aspires *not* "to make beautiful paintings…[but] silent poetry."[5] ❖ AMK

1 Nancy Haynes, interview by Trinkett Clark, in *Parameters: Nancy Haynes* (Norfolk: Chrysler Museum, 1992), unpaginated.
2 Nancy Haynes, telephone conversation with author, 26 March 2002.
3 Barbara A. MacAdam, "Something to Glow On," *ARTnews* 98 (summer 1999): 94.
4 Jeremy Gilbert-Rolfe, "Endspace: From a Real to an Absolute: Nancy Haynes' Paintings, 1974–1998," *Nancy Haynes* (Fondation Leschot, 1998), 5.
5 Haynes, *Parameters*, unpaginated.

33, bottom
Untitled (TC/NH 1/94 #A07), 1994
Monotype
32 × 45 inches
Museum of Modern Art, New York

Most of the critical attention paid to Nancy Haynes's work has been directed toward her colorful—sometimes even fluorescent—paintings, works in which she applies paint to a number of different supports, from linen to slate. But the casual fluidity of Haynes's monotypes—the fact that she makes them quickly and can easily discard unsuccessful attempts—allows an experimental freedom to inform the work.[1]

As Christine Mehring explains, Haynes creates her monotypes by a variety of means: by applying ink, graphite, pigment or paint thinner and using such tools as steel wool, scrapers, brushes and asphalt spreaders. *Untitled (TC/NH 1/94 #A07)* (1994) seems, at first, predominantly white. Mehring contextualizes Haynes's monotypes in a lineage of abstract experiments with white by Kasimir Malevich, Ellsworth Kelly, Robert Rauschenberg and Robert Ryman.[2] And, indeed, Haynes acknowledges the impact of seeing the works of Malevich and Jackson Pollock and Barnett Newman's *Stations of the Cross*. In particular, she spoke of a sense of infinity expressed through void: "Openness, expanse, absence: those are the things that interest me the most."[3] Elsewhere Haynes noted that "my paintings have become more and more about erasure and emptying out."[4] But her untitled monotypes also address this issue—a void that is not black but white, that is "emptied out" and yet charged with possibility. It is not a minimalist aesthetic but one closer to Russian constructivism or suprematism. Absence allows memory to flow in and hints at the "absence of inherent existence."[5]

"The sensation of light" is also important, and Haynes compares her process to that of Georges Seurat, who created light in his drawings through an absence of marks.[6] In variations of white, gray and black, with occasional hints of green in her monotypes, Haynes uses a limited palette. She renders a center of subtle grays, shading the drawing darker around the edges. She vertically interrupts the surface of the composition at regular intervals with rhythmic striations of ink. These streaks of gray extend from the top edge of the paper, gradually fading as they progress downward. Horizontal streaks also appear. As Ann Wilson Lloyd notes, these blurred striations in Haynes's work recall Gerhard Richter and create "a sense of graphic motion, like rapid panning with the camera."[7] On the right side of the paper, the ink flows more freely, contrasting with the regular striations of the center. This contrast reveals much about Haynes's process and the dialogue between control and freedom in her monotypes. ❖ AMK

1 Nancy Haynes, telephone conversation with author, 26 March 2002.
2 Christine Mehring, *Drawing Is Another Kind of Language: Recent American Drawings from a New York Private Collection*, eds. Pamela Lee and Christine Mehring (Cambridge: Harvard University Art Museums, 1997), 60–62.
3 Haynes, telephone conversation.
4 Nancy Haynes, interview by Trinkett Clark, in *Parameters: Nancy Haynes* (Norfolk: Chrysler Museum, 1992), unpaginated.
6 Haynes, telephone conversation.
6 Ibid.
7 Ann Wilson Lloyd, "Nancy Haynes at John Good," *Art in America* 82 (May 1994): 121.

Eva Hesse

Born 1936, Hamburg,
Germany, died 1970

34, top
*Untitled (Vertical
Abstraction)*, 1960
Ink and wash on paper
13 1/2 × 10 inches

35, bottom
Untitled, 1960
Casein and ink on paper
11 × 13 5/8 inches

While attending Yale University, Eva Hesse noted in her diary that she was making "a series of drawings in ink with my main tool a crudely shaped wrong side of a small brush. The drawings can best be described as imagined organic and natural forms of 'growth.' They are essentially quite free in feeling and handling of medium, 'ultra alive.'"[1] Using predominantly ink and translucent washes in orange, black and brown, Hesse combines color and line in these two drawings to create whimsical forms that seem to wiggle and grow as we look at them. This early vocabulary of intertwined and unruly gestures anticipates her future sculpture, with its eccentrically hanging and interlacing elements. The undulating line and color of these drawings beg to be freed from the confines of the page. As Christine Mehring notes, these complex drawings of entanglements predict *Right After* (1969), a huge construction of tangled rope suspended from a gallery ceiling.[2] The surging lines stretch beyond the paper, suggesting an expansive sculpture, but their small scale as drawings also brings to mind the intimacy of works such as *Inside I* (1967), in which Hesse commits a tactile construction of tangled rope to a small box. Here, strings of varying width are confined within their protective box, contrary to the dramatic freedom of *Right After*.

The freely expressionistic technique of these drawings differs from Hesse's later, more constrained geometric formats. She employs broad and narrow brushes, pens and the "wrong" end of the paintbrush in composing these works. Fine lines mix with soft washes of color; splotches of opaque paint combine freely with translucent passages. Hesse unites clearly defined lines with indeterminate areas of color so that the deeply defined contours emerge from watery splashes of pigment. Tension exists between the disorder of color and line and the ultimate control and unity of the overall form.

According to Lucy Lippard, "The drawings from 1960–61 are among the most beautiful in Hesse's oeuvre…she could always draw, even when she was having trouble with painting, and the drawings expressed her deepest feelings."[3] These drawings fall early in Hesse's short career. They spring out of an interest in abstract expressionism but exhibit more control than a quick gesture—in several places in both compositions the line appears quite deliberate. Hesse's method varies, however, as in *Untitled (Vertical Abstraction)* (1960), in which the artist allows paint to dribble freely on the paper, letting gravity dominate the composition in these areas. Its organic lines appear bodily, suggesting a disintegrating torso whose legs are all that remain. *Untitled* (1960) appears less figurative but presents a similar stringiness and mixing of dense and controlled line with daubs of translucent color. Both drawings concentrate at their centers, from which lines and colors radiate. The drawing's effortless sense of freedom and release contrasts with the intensive wrapping and winding in Hesse's sculpture and reliefs of the mid-1960s but anticipate the freer spontaneity of her last works. Both drawings bring to the fore Hesse's early interest in organic forms that later generated tactile, bodily sculptures of grand scale. ❖ PW

[1] Lucy Lippard, *Eva Hesse* (New York: Da Capo Press, 1992), 12–13.
[2] Christine Mehring, "Eva Hesse," in *Drawing Is Another Kind of Language: Recent American Drawings from a New York Private Collection*, eds. Pamela Lee and Christine Mehring (Cambridge: Harvard University Art Museums, 1997), 64.
[3] Ibid, 15.

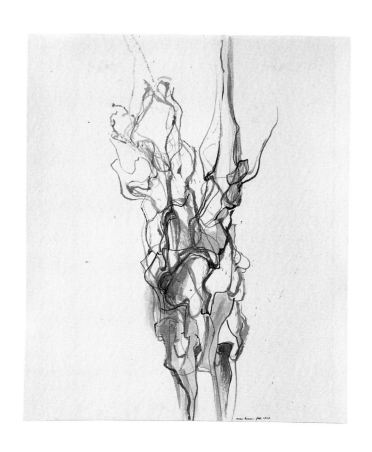

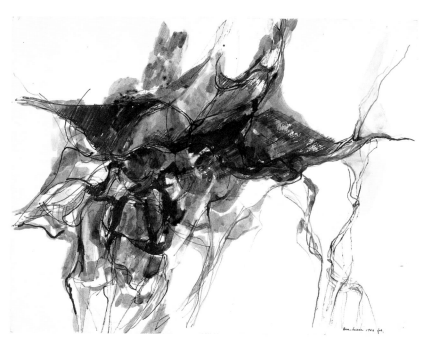

Christine Hiebert

Born 1960, Basel, Switzerland, works in Brooklyn, New York

36
Untitled (L.37), 1995
Charcoal on paper prepared with rabbit skin glue
47 ¾ × 106 inches

Christine Hiebert's drawing, *Untitled (L.37)* (1995), consists of layers of "all-over" mark-making. The convoluted lines lead the viewer's eye around the large-scale composition in hectic paths. The surface of *Untitled (L.37)* is heavily worked, pulling the viewer in closely and, as the artist explained, encouraging "the viewer to engage with the drawing at close range, then to walk along the piece in order to see the whole thing progressively, instead of standing back and seeing the work only all at once, from a distance."[1] While some lines appear sensitive and even tentative, the overall effect of the work is bold in size and surface activity.

Mark Daniel Cohen described the intricacy of Hiebert's working process,

> She creates with a slow and pains-taking care, to follow out an assembling necessity—every mark as it enters the tentative and self-formulating composition, upon consideration, demands and decides the next mark....She spoke of reaching a resolution of tension, a feeling of balance and palpable completion. It is by a feeling that she knows.[2]

Whereas some of Hiebert's lines seem sensitively to evolve in response to those that surround them, others evoke a sense of the artist's physical gesture. In this drawing, the artist prepared the surface of the paper with rabbit skin glue; multiple erasures bruise this cream-colored skin, leaving occasional faint bands of gray. The process is interactive and spontaneous. "I have no idea what the final product might be," Hiebert stated, "I can't see it. I can only see what's on the paper at any given time and I have to respond to it by making new marks and erasures. I am searching for something and that search is important but the final piece has to feel resolved in some way. Open but resolved."[3]

To some writers, the sheer size of Hiebert's work has suggested landscape, but that overlooks her intuitive technique of mark-making. "These drawings have nothing to do with observation," Hiebert explained, "they have to do with the experience of space and movement and habitation....Rather than try to look like nature, the drawings (I hope) elicit feelings and experiences from us in the way that nature does."[4] According to Hiebert, her marks have a human quality,

> The articulateness of single lines in a vast array of lines or marks…signifies to me the struggle of individuals in a complex, unstable world. I really love it when someone looks at a drawing for a while and then all of a sudden starts laughing because he or she saw a comical mark or passage. The marks can be tragic or painful, too. I like when a single mark can create an experience.[5]

✢ AMK

1 Christine Hiebert, artist's unpublished statement, 3 September 2000.
2 Mark Daniel Cohen, "Christine Hiebert: Large and Small Drawings," http://www.reviewny.com/current/00_01/november_1/review2.html (1 November 2000).
3 Christine Hiebert, letter to author, 27 March 2002.
4 Ibid.
5 Ibid.

Christine Hiebert

37
Untitled (L.01.2), 2001
Charcoal on paper
prepared with
rabbit skin glue
45 ¾ × 63 ¾ inches

nstead of the "all-over" energy and large scale of *Untitled (L.37)*, Christine Hiebert's *Untitled (L.01.2)* (2001) consists of isolated clusters of mark-making. In general, Hiebert's drawing practice centers on the expressive character of each individual line. In *Untitled (L.01.2)*, Hiebert developed clusters of marks independently of one another and focused less attention on layering and integration than in previous works.[1] Hiebert metaphorically compares her process to urban development,

> I sometimes think of the field of the paper as the area of a city, in which a range of very separate, local activities arise simultaneously, and their connection is often an afterthought; similarly, the long, reaching lines in the drawing that connect the smaller areas, came second. The erasures in this piece, too, are sometimes long and reaching and while they obliterate, are also used to connect.[2]

While retaining some variation in line where occasional dark marks emerge from a tangled web of pale lines, the subtractive marks are much more apparent in this work, which postdates *Untitled (L.37)* by six years.

In *Untitled (L.01.2)*, Hiebert moves beyond mere erasing to literally sanding her marks off the surface of her paper. The subtraction is evident; the sanding produces thick, broad gestures of white that contrast with the more delicate black charcoal lines. Erasing and sanding become significant forms of mark-making; while the charcoal lines and the erasures rest on top of the coating of rabbit skin glue, the sanding cuts through the surface to the white paper, making these gestures whiter than the rest of the drawing. Hiebert has compared the result of sanding on her paper to an abrasion on one's skin. Where the glue is removed, the surface of the paper is actually raised just as the skin is raised when scraped. Hiebert explains,

> I sometimes like the association with "welt" of something harsh, not that I intend that the whiteness always signify something harsh (maybe hard-won, yes), but the act of producing this beautiful soft whiteness is quite aggressive, especially when I use the electric sander....It is not my goal to produce a beautiful surface. My goal in making the drawing is to slow myself down [and] make myself look very hard at what's in front of me.[3]

✢ AMK

[1] Christine Hiebert, letter to author, 5 May 2002.
[2] Ibid.
[3] Christine Hiebert, letter to author, 27 March 2002.

Jasper Johns

Born 1930, Augusta,
Georgia, works in
Connecticut and
St. Martin

38, top
0–9, 1960
Graphite and wash
on ivory-colored paper
8 × 13 inches

39, bottom
Numbers, 1996
Acrylic, graphite and
collage on paper
24 1/2 × 19 9/16 inches

I n the sweeping success of his first solo exhibition in 1958, Jasper Johns represented banal objects such as American flags and targets in a distinctively individual style that focused on its artistic production rather than its ordinary image. Johns was interested in how our mind structures the sights that we experience in daily life and attempted to destabilize the fixed meaning of mundane objects. This is the intention of Johns's idea of a "rotating point of view": to represent common objects in unexpected ways.[1] His *0–9* (1960) and *Numbers* (1996) prominently demonstrate this concept.

0–9 displays ten numbers broken into two rows of zero to four and five to nine. It is an exhibition of banal symbols routinely used but seldom examined. By using the encaustic technique that mixes heated wax with pigment, Johns preserves sensuous, gestural brush strokes on the surface of the paper to create a highly individualized style of drawing. This achieves an expressive individuality that sharply contrasts with the generality of the found imagery of numbers. Executing mundane subject matter in a highly expressive way creates a tension within the work: The artist seems simultaneously to inject a painting with feeling and to reject the expression of emotion. *0–9* demonstrates a conflicted relationship between engagement and disengagement, personality and impersonality. This tension between banal image and unique execution destabilizes the conventional notion of subject matter in art.

Numbers raises similar issues. The organizing feature of the composition is a grid filled with eleven rows of eleven digits sequenced from zero to nine. At first sight the composition seems quite straightforward. The first row begins with a blank space, and subsequent rows follow the pattern of Johns's previous works on this subject, with each beginning one number further along in the sequence so that reading both across rows and down columns produces sequences of zero to nine. In each sequence but the first, however, the final number repeats the first number of the sequence. If one were to see each line as a loop in a perpetually repeating pattern (as in Johns's other works on this subject) this breaks the pattern by repeating a different number in each sequence. This type of subtle shift, a sort of test of whether the viewer is paying attention, is typical of the perception of Johns's aesthetic. Executed in thick black acrylic mixed with graphite, the drawing has a distinctively sensuous surface that resembles *0–9* as well as most other encaustic paintings and drawings by Johns.

By turning an integer series into an art subject in these two drawings, Johns dislocates numbers from their usual function as mathematical notation. This change in focus provides a more flexible relationship between the object and the viewer, which is the essence of Johns's idea of art. As Johns explained in 1965: "I mean it in the sense of undefined, or what I consider an undecided situation, one that offers more possibilities to examine a situation. I think an undecided situation—something conditional—leads to a broader spectrum of facts."[2] Seeking to promote a more open-ended way of thinking, Johns is attempting to present an ordinary image in an extraordinary way, stirring in viewers' minds an uncertainty that disrupts habits of seeing. This form of indeterminacy not only changes our perception of things but also gives a fresh sense to the time and space we occupy. ❖ LLT

[1] Kirk Varnedoe and Roberta Bernstein, *Jasper Johns: A Retrospective* (New York: The Museum of Modern Art, 1996), 17.
[2] Ibid., 18.

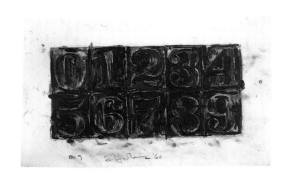

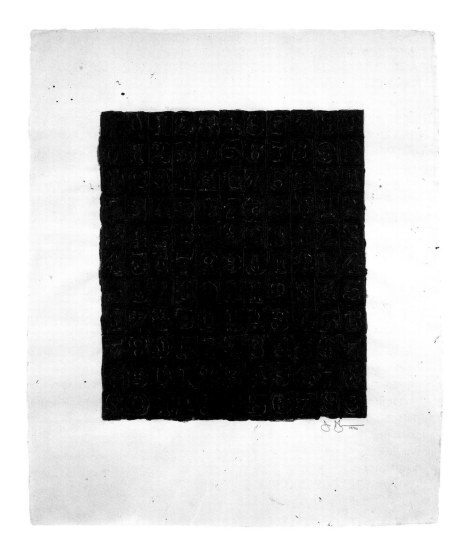

Jasper Johns

40

Flag, 1972/1994
Acrylic and graphite (1994)
over lithograph (1972)
19 ⅝ × 25 ⅞ inches

Jasper Johns does not generally make drawings as preparatory studies for his paintings and sculptures. To the contrary, he usually makes drawings after motifs in his art. After executing his first *Flag* in 1954, for example, Johns over the next thirty-three years made thirty-seven drawings and twenty-one paintings of the subject.[1] Johns's drawing practice reflects the perpetually changing yet constant state of his thinking. *Flag* (1972/1994) was first executed as a lithograph and then, after twenty-two years, retouched with graphite and a sensuously handled acrylic. The drawing simply shows an American flag on a yellowish ground—a different motif than his many other flag drawings and paintings. But with Johns the explicit motif is never simply the subject. Johns said of his decision to paint the American flag, "Using this design took care of a great deal for me because I didn't have to design it. So I went on to similar things like targets—things the mind already knows. That gave me room to work on other levels."[2]

As with all of Johns's painted targets and flags, this depiction is so intractably literal that it remains an actual flag despite its painterly brushwork and its status as art. A flag is an inherently flat subject, based on a formal scheme rather than a reference to a unique physical object that exists in the world. This also can be said of the numbers and letters that Johns frequently used; we cannot talk of them as referential because a number or a flag by definition is a concept with no unique material identity. At the same time, the handling of the paint on the surface of *Flag* asserts its identity as an object, further accentuating the epistemological ambiguity. The viewer questions what about the work stands in for the identity of the artist: Is it the flag? The abstraction of the flag? Or the brushwork and signatory style? *Flag* also raises a philosophical dilemma concerning the language of art and the perception of reality in that it cannot help but refer to the well-known history in Johns's oeuvre of its particular imagery. That is, the appropriated image of the flag not only ties art to mass production and civic consumerism but also engages in a form of pastiche of the artist's previous work. These are merely a few of the "other levels" to which Johns refers. ❖ LLT

[1] Nan Rosenthal and Ruth Fine, *The Drawings of Jasper Johns* (Washington, D.C.: National Gallery of Art, 1990), 94.
[2] Jasper Johns, *Jasper Johns: Writings, Sketchbook Notes, Interviews* (New York: The Museum of Modern Art, 1996), 82.

Jasper Johns

41
Untitled, 1980–1984
Acrylic, graphite and
collage on plastic
16 2/5 × 14 1/2 inches

Untitled (1980–1984) features a primary color motif that has recurred in the work of Jasper Johns since the late 1950s. In *False Start* (1959), Johns stenciled names of primary and other colors over color patches that pointedly were not those named by the stenciling. The effect is a cognitive dissonance that affects the nature and speed at which information is processed. The epistemology of vision—the issue of how we see—has been a core theme throughout Johns's career. For more than forty years he employed in his work visual tricks such as reversing images or presenting them in negative space. In part, *False Start* and the other works in which the artist experimented with mismatched colors and color names reflect Johns's longstanding interest in the psychology of perception.

In *Highway* (1959) Johns painted three blocks of primary colors across the bottom of the canvas; we also see these in *Diver* (1962), *Arrive/Depart* (1963–1964), the right panel of the landmark *According To What* (1964) and any number of other works. Primary colors are, of course, important to painters as the building blocks of the standard palette. In this drawing, *Untitled* (1980–1984), Johns included three acrylic rectangles of primary colors deeply obscured with a graphite wash that blended into the acrylic and changed the clarity of the hues. Johns handled the motif of the color chart in this way in, among other places, the well-known *Watchman* (1964) and in drawings of the same title from 1966.

We can also see in the margins of this work evidence of the tracings Johns began to make around this time. The forms on the right margin resemble elements of Duchamp's *Bride Machine*. Johns owned a reproduction of *Bride Machine* by Duchamp's brother Jacques Villon, which he used for his *Tracing* (1978).[1] The lines at the bottom margin of this drawing appear to be taken from the steam shovel featured in an advertisement for Drainz (a plumbing product), which Johns traced into *Untitled* (1983–1984).[2]

It was in 1982 that Johns abandoned his series of cross-hatch paintings in favor of works loaded with personal imagery and new and old motifs, some traceable back to the beginning of his career. He remarked in 1978, "In my early work I tried to hide my personality, my psychological state, my emotions…but eventually it seemed like a losing battle. Finally one must simply drop the reserve."[3] And yet, the effort to obscure the primary colors in this drawing seems to head in an opposite direction.

"Much of my early work was concerned with what I considered 'pure' color. [But with red, for instance], the recognition of it is generally just red, even though it's not just red," Johns told Amei Wallach in 1991.

> My work is gradually moving in a slightly different direction.…I was concerned with…a kind of rigid idea of purity, and that's perfectly normal. And now, an off color seems to me just as pure as the central color in the spectrum, within limitations—there is not a huge range of possibilities presented in this way, but still, while working I am not concerned to keep something in the purest representation of itself, of the name red or the name yellow.[4]

For an artist so sensitive to the way in which language relates to the apprehension of things, his treatment of the blocks of primary colors in this drawing may offer a fertile metaphor for the growing complexity of Johns's thinking about how we see. ❖ LLT

1 Nan Rosenthal and Ruth Fine, *The Drawings of Jasper Johns* (Washington, D. C.: National Gallery of Art, 1990), 278.

2 Ibid., 274–278.

3 Peter Fuller, "Jasper Johns Interviewed: II," *Art Monthly*, no. 19, London (September 1987): 7; cited in Mark Rosenthal, *Jasper Johns: Work Since 1974* (Philadelphia: Philadelphia Museum of Art, 1988), 60.

4 Jasper Johns, interview by Amei Wallach, in *Jasper Johns: Writings, Sketchbook Notes, Interviews* (New York: The Museum of Modern Art, 1996), 264.

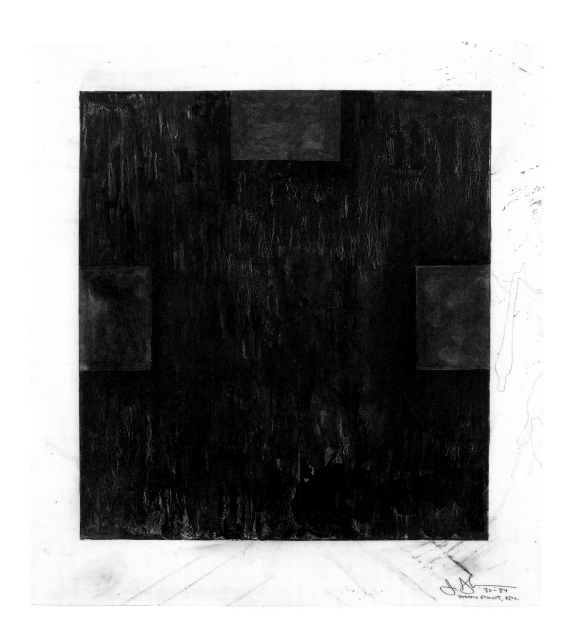

Jasper Johns

42
Untitled, 1991
Ink on mylar
34 × 45 inches

haracterized by its uncommonly fluid handling of ink on plastic, Jasper Johns's *Untitled* (1991) presents a multiplicity of themes. In the lower left corner, a porcelain vase creates a figure and ground reversal of the profiles of England's Queen Elizabeth and Prince Philip (the profiles are shown in the negative space around the vase). Above the vase are tracings from Matthias Grünewald's early-sixteenth-century Isenheim altarpiece depicting a Roman soldier at the resurrection. Johns has turned the Grünewald image on its side and all but dissolved it in the way he handles the flowing ink. Two Barnett Newman drawings enter this picture from the top edge, reversed as though in a mirror, then softened by their rendering in liquid ink.[1] A representation of the wood grain in Johns's house in Stony Point, New York, appears at the right. On the right bottom, he depicts the bottom of a large black canvas—with name and date—reversed and upside-down. The wood, the Newman drawings, the vase and the Grünewald tracing all began to appear in Johns's work in the early 1980s, in paintings like *Perilous Night* (1982) and *Racing Thoughts* (1983).

The profiles hidden in the negative spaces on either side of the porcelain vase reflect Johns's interest in Danish psychologist Edgar Rubin's perception studies of the ability to reverse negative and positive forms.[2] Such perceptual alternations between figure and ground, Rubin noted, confuse short-term memory and force closer examination of an image. Johns incorporates this "Rubin's figure" into the drawing to alert the viewer to the complexities of visual perception. It is like a *vanitas* symbol for an age in which the semiotic sign has all but replaced the experience of nature.

In this drawing, Johns expresses his interest in the complexities of how we see—and how we know what we see—by tracing reproductions of paintings he admires, a technique he employed in drawings throughout the 1970s and 1980s. With it, he overwhelms the narrative function of Grünewald's religious painting by reducing it to nearly unidentifiable markings and undermining its historical meanings. Likewise, the transcendence of Newman's original work is lost; the image instead appears as a familiar iconic element, shifting the emphasis to issues of language. ❖ LLT

[1] Pamela Lee, "Jasper Johns," in *Drawing Is Another Kind of Language: Recent Drawings from a New York Private Collection*, eds., Pamela Lee and Christine Mehring (Cambridge: Harvard University Art Museums, 1997), 92. Johns had acquired the original drawings from Newman's widow in exchange for two works of his own.

[2] Nan Rosenthal and Ruth Fine, *The Drawings of Jasper Johns* (Washington, D. C.: National Gallery of Art, 1990), 286.

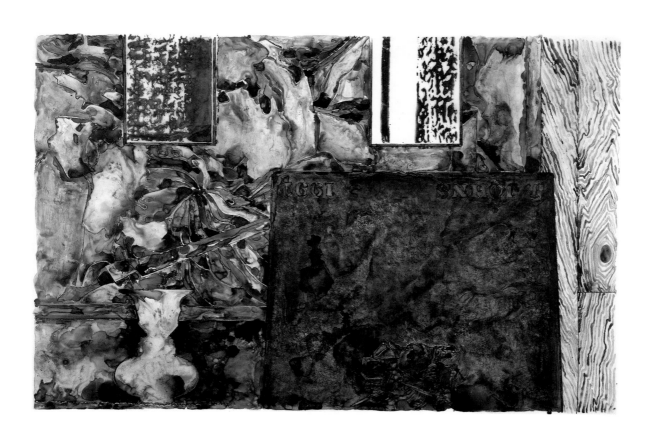

Donald Judd

Born 1928, Excelsior Springs, Missouri, died 1994

43
Drawing for Untitled 1973 Structure, 1972
Brown ink on yellow paper
17 1/4 × 22 1/4 inches
Museum of Modern Art, New York

In his 1965 essay "Specific Objects," Donald Judd referred to his and several of his friends' new three-dimensional work as "particular forms…producing fairly definite qualities." Judd asserted that the new work, "neither painting nor sculpture," challenged the insufficiencies of the two traditional mediums and ultimately would undermine both. In earlier art, parts and elements were composed according to a hierarchical composition that stressed some components over others. In the new work, Judd argued, the pictorial or sculptural elements involving new industrial materials and actual three-dimensional space were arranged by a simple order, "like that of continuity, one thing after another." He wrote that "the thing as a whole, its quality as a whole" would be more specific and actual, thus more intense and powerful. Although the essay became a seminal statement on his own work and on minimal art in general, Judd himself never regarded the new tendency as a movement or a homogenous style.[1]

Judd admired the scale and wholeness of abstract expressionist work, especially that of Jackson Pollock and Barnett Newman. He acknowledged the influence on his own holistic structure of the monumental, overall composition of Pollock's paintings, in which all parts of the surface are equally apparent and physical.[2] He also found in abstract expressionism a defense against the charge of compositional simplicity and impersonal matter-of-factness: "A painting by Newman is finally no simpler than one by Cézanne. In the [new] three-dimensional work the whole thing is made according to complex purposes, and these are…asserted by one form."[3] Whether in a single form or a series, Judd envisioned a total unity where parts and elements neither subordinate nor dominate each other, where form and materials refer to themselves with maximum clarity and directness.

Drawing for Untitled 1973 Structure (1972) contains a conspicuous order of mathematical progression. In the drawing, the sculptural parts and spatial intervals are treated as equal elements generated by systematic permutation. Starting in the mid-1960s, Judd employed serial methods as a means of circumventing the practice of balancing major and minor parts. The mathematical system provided him with a predetermined formula that undermined artistic decisions and supported an infinitely mutable system of combining materials, colors and dimensions. The nonrelational arrangement of equal parts is manifest in Judd's stacks and wall progressions in which identical box-like forms are repeated, as in this drawing, vertically or horizontally along a wall. Judd predetermined elements and intervals in his work using one of four mathematical progressions: arithmetic, geometric, inverse natural numbers and the Fibonacci series.[4] This particular drawing shows the use of an inverse natural number progression, in which the underlying order is the least readable since the elements are slightly and erratically varied.

Judd's sculptures, however, are not literal illustrations of philosophical or mathematical propositions. He deems the terms "order" and "structure" inappropriate to his work. "One or four boxes in a row, any single thing or such a series, is local order, just an arrangement, barely order at all," Judd explained. "The series…has nothing to do with either order or disorder in general….The series of four or six doesn't change the galvanized iron or steel or whatever the boxes are made of."[5]

The surrounding notes and the rough diagram of the box beneath the numerical progression in this drawing indicate a construction of thin metal with an open interior; it was constructed in 1973 of galvanized iron. When installing the piece at the National Gallery of Canada in Ottawa in 1975, he cantilevered seven shell-like boxes horizontally along the wall in reverse order of the drawing (see below). The installation demonstrates that Judd envisioned the progression running both left to right and right to left. Until 1994, when he died at the age of 65, Judd remade the same objects in different materials, colors and dimensions. Each was a "specific object," he declared. "Things that exist exist. They're here, which is pretty puzzling. Nothing can be said of things that don't exist….Everything is equal, just existing, and the values and interests they have are only adventitious."[6] ✦ EYJ

[1] Donald Judd, "Specific Objects," in *Complete Writings, 1959–1975* (New York: New York University Press, 1975), 181–189.
[2] Donald Judd, "Jackson Pollock," in *Complete Writings*, 195.
[3] Judd, "Specific Objects," 184–185.
[4] Roberta Smith, "Donald Judd," *Donald Judd* (Ottawa: The National Gallery of Canada, 1975), 24–25.
[5] Donald Judd, "Statement," in *Complete Writings*, 196.
[6] Donald Judd, "Black, White and Gray," in *Complete Writings*, 117.

Galvanized Iron, 21 May 1973, 7 3/4 x 118 x 12 1/2 inches.

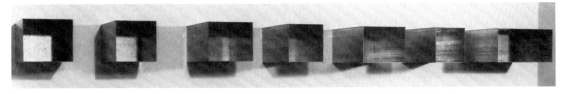

M.B.B.

Projects 12.5
Complete rear
Stainless or galvanized

144.750

142.216

Projects 12.5
Complete rear
Stainless or galvanized

Judd 72

Ellsworth Kelly

Born 1923, Newburgh,
New York, works
in Spencertown,
New York

44
Self-Portrait, 1948
Ink and pen on paper
8 ¼ × 7 ⅛ inches

After returning from military service in France in 1945, Ellsworth Kelly attended the School of the Museum of Fine Arts in Boston (1946–1948). Ture Bengtz, his drawing instructor, emphasized contour drawing over academic shading. Kelly had already mastered illusionist drawing at the Pratt Institute in Brooklyn four years earlier, and he welcomed this looser, more spontaneous approach.[1] Bengtz's assignments encouraged Kelly to focus on the shape of an object instead of its volume. This emphasis on line and edge anticipated Kelly's lifelong penchant for flat, non-illusionistic formats, from the simplified silhouettes in his paintings of the 1950s to his later, shaped color paintings. Despite the careful attention to detail in this work, he emphasizes line and contour over volume.

Self-Portrait (1948) comes from an early period in Kelly's oeuvre. For most of his career, Kelly's drawings functioned as preliminary sketches for paintings. His early portraits, however, generally were not intended to serve in this way.[2] *Self-Portrait* is not a psychologically probing work; only the purely formal qualities of this three-quarter portrait seem to interest Kelly. Nevertheless, this particular work represents the artist's face in more detail and with more attention than most other Kelly self-portraits from this time, which tend to be more quickly drawn without erasures or corrections. Kelly often used amorphous and fluid lines, in part inspired by his study of Matisse. At the beginning of his career, he drew several pencil self-portraits that varied from expressionistic, quick sketches to cubist exercises.[3] In the 1940s, Kelly took his subjects directly from life, sketching plants, fruits and trees, as well as portraits, but by the spring of 1949, he became increasingly interested in abstraction and largely abandoned such realistic subject matter. ❖ PW

[1] E. C. Goossen, *Ellsworth Kelly* (New York: The Museum of Modern Art, 1973), 15.
[2] Diane Waldman, *Ellsworth Kelly: Drawings, Collages, Prints* (Greenwich, Conn: The New York Graphic Society, 1971), 14.
[3] Diane Upright, *Ellsworth Kelly: Works on Paper* (New York: Harry N. Abrams, Inc., 1987), 9.

Ellsworth Kelly

45
*Untitled—Green
with Red*, 1964–1965
Tempera on paper
30 × 21 inches

From 1948 to 1954, Ellsworth Kelly studied art in Paris at the Ecole des Beaux-Arts and in the city's museums. He returned to New York in 1954 after reading a review of an Ad Reinhardt exhibition at the Betty Parsons Gallery, in which he found affinities between Reinhardt's work and his own, most notably their mutual explorations with color.[1] Kelly felt alienated from such New York artists as the abstract expressionists Robert Rauschenberg and Jasper Johns. Instead of expressive gesture painting or appropriation, he sought to manipulate large blocks of solid color, abstracted from objects in everyday life.

By 1949–1950, Kelly's work had changed dramatically from his sketches of plants and figures to simple abstract objects, as in *Window, Museum of Modern Art* (1949), in which he replaced all the identifiable details of the subject with large, abstract forms. Although the flat color and large shapes anticipated his later works in pure blocks of color, he generally avoided perfect geometric forms such as circles and triangles and instead treated bulging or oddly angled forms inspired by nature. His work from the 1950s and 1960s focused on a simplified palette in bold fields of unmodulated color.[2]

Untitled—Green with Red (1964–1965) belongs to a series of seven works in this format with differing color combinations. He also used this tempera on paper as a template for one of a series of twenty-seven lithographs printed in 1964–1965.[3] The print series consists of variations of rectangular and ovoid color shapes. Kelly often based his abstract work upon observations of the natural world, a quality that distinguished him from many contemporary hard edge and minimalist artists. He frequently simplified such mundane objects as a window, a fragment of architecture or a shadow, representing their pared down essence in large forms of flat color. "I'm not interested in the texture of the rock, or that it is a rock," the artist claimed, "but in the mass of it, and its shadow."[4]

The artist's goal was to expand the possibilities of color. In *Untitled—Green with Red*, Kelly juxtaposes solid colors and eliminates line and spots of bare canvas in order to diminish any projection of space. Moreover, red and green are complementary colors, which repel one another, creating the kind of optical vibration that was popularized in the mid-1960s as op art. Kelly privileges color over space or form, composing a simple color combination that yields a complex visual result.[5] ❖ PW

[1] E. C. Goossen, *Ellsworth Kelly* (New York: The Museum of Modern Art, 1973), 49.
[2] Diane Waldman, *Ellsworth Kelly: Drawings, Collages, Prints* (Greenwich, Conn.: The New York Graphic Society, 1971), 15.
[3] Ibid.
[4] Ibid.
[5] Henry Geldzahler, *Ellsworth Kelly: The Paris Prints, 1964–65* (New York: Susan Sheehan Gallery, 1992), unpaginated.

Eve Andrée Laramée

Born 1956, Los
Angeles, California,
works in Brooklyn,
New York

46
*Major Freeway
Interchanges in
the Ohio Valley*, n.d.
Charcoal on map
20 3/8 × 27 1/4 inches

Eve Andrée Laramée's career-long interest in the melding of fact and fiction features prominently in *Major Freeway* (n.d.). Her drawings and installations examine society's ambition to explain with scientific facts an ever-evolving, information-based world. Laramée states, "Through my work I speculate on how human beings contemplate and consider nature through both art and science in a way that embraces poetry, absurdity, contradiction and metaphor."[1] Her illumination of the potential irrationality inherent in human belief systems is the theme of this charcoal drawing.

Meshing science with fantasy is nothing new for Laramée. Her site-specific piece entitled *Instrument to Communicate With Kepler's Ghost* (1994), for example, is a pseudoscientific contraption attributed with the power to contact the spirit world—at least the ghost of Johannes Kepler. An astronomer, Kepler authored the modern laws of planetary motion.[2] Like his radical scientific works, which in their day were considered fantastical, Laramée embraces the idea of taking a conceptual leap, in this case the leap necessary to conceiving a machine to communicate with the dead. At the heart of her project is an examination of how we collect evidence to constitute fact; a glass bell jar "containing hair, skin cells, clothing lint, and other clues to our identity" is the core of the *Instrument*.[3] From these facts of human detritus, viewers are invited to make the conceptual leap to believing in a machine to speak with ghosts.

New theoretical boundaries are broken in the mysteriously beautiful drawing, *Major Freeway*. In it the viewer encounters a rectangular web of delicate lines set against a black background. The closed organic shape that seems to glow from the center of the dark page is in fact a line erased through a charcoal layer that Laramée applied to the surface of a roadmap. The subtle creases in the paper evoke the machine-folds of a map designed to fit in the glove box of a car. Roadmaps are generally accepted as reliable forms of guidance for everyday travel and command an authority grounded in the scientific certainty of cartography. Laramée's blacking out of geographical fact with dark charcoal forces the audience to imagine giving up their trust in the map as a source of direction. Her process of literally obliterating the map may connote hostility or perhaps simply a playful disparagement of our faith in scientific certitude. Laramée interrupts the blackness with an erased drawing of stars linked together on a stringy rectangle. These lines themselves suggest a hand-drawn map of freeway interchanges. But this new, fanciful map edges toward the absurd: A driver who follows its route would end up right back where they began.

Laramée challenges spectators to question their relationship to so-called factual data and mocks our dependence on them. She cautions the audience to analyze the notion of a map of the world—as though one could find a stable truth there—by presenting us with visually mystical ways of conceiving geographic space. ❖ KB

1 "Eve Andrée Laramée," http://home.earthlink.net/~wander (14 January 2002).
2 Jennifer Riddell, "Parallel Histories: Eve Andrée Laramée's *A Permutational Unfolding*," in *A Permutational Unfolding / Eve Andrée Laramée*, (Cambridge: MIT List Visual Arts Center, 1997), 17.
3 Ibid, 17.

Sol LeWitt

Born 1928, Hartford,
Connecticut, works in
Hartford, Connecticut

47, top
*6 Variations/
1, 2, 3, (1)*, 1967
Ink on paper
12 × 10 inches

48, bottom
Variations 3–1–3,
1967/1968
Pen and pencil on paper
11 ¾ × 23 ¾ inches

Sol LeWitt's famous 1967 essay, "Paragraphs on Conceptual Art," made clear his philosophy that the idea behind a work of art is more important than the end product. De-emphasizing the art object, LeWitt instead emphasized the process of planning the work. He explained,

> The idea itself, even if not made visual, is as much a work of art as any finished product. All intervening steps—scribbles, sketches, drawings, failed works, models, studies, thoughts, conversations—are of interest. Those that show the thought process of the artist are sometimes more interesting than the final product.[1]

As evidence of his thought process, then, LeWitt's drawings hold a privileged place in his body of work. To illustrate the predetermined nature of his structures and wall drawings, LeWitt would hang his drawings next to the finished piece as a part of the work. Clean, precise and ordered, these drawings made explicit the idea that had produced the final work.

Both *6 Variations* (1967) and *Variation 3–1–3* (1967–1968) are drawings for a series of three-dimensional structures. Like *47 Three-Part Variations on Three Different Kinds of Cubes*, they explore different variations of cube constructions of three or two different kinds of cubes. In *6 Variations* LeWitt created a two-layer drawing consisting of an opaque sheet of paper covered by a translucent sheet of mylar. On the bottom layer he drew two separate levels of vertical rectangles in sets of four. In both the top level labeled "6 Variations" and the bottom level labeled "5 Variations," each rectangle represents one side of a stack of three types of cubes: Cube type one is completely closed, type two's front and back sides are open (2FB), and type three has only one side open. (Theoretically type three could have any side open, but for these variations LeWitt appears to have set a limitation that type three may only have the front [3F] or right side [3R] open.) The openings are marked with an "X". On the top layer of mylar LeWitt has written all of the labels and numbers that explain the components of his systematic variations.

Pragmatically this division of layers does not seem necessary—none of the writing overlaps the rectangular figures in a way that necessitates a second layer. Rather, this material divide reinforces how the two parts of the drawing, language

and figure, are different yet work together. Although visually the rectangles and "X"s illustrate the system of variations, and linguistically the labels explain the variations, neither alone would make the system as clear to the viewer as both do together. Furthermore, just as the words and figures work together, the drawing and the final structure were displayed together, supporting LeWitt's claim that the thought process of the artist remains as important if not more important than the final product.

Similar to *6 Variations*, LeWitt's *Variation 3–1–3* is another set of variations on the three-cube structure; although in these structures one cube type, type three, is predominant: The top cube is always type three, open on one side; the middle cube is always type one, closed on all sides; and the bottom is again type three. While the top cubes remain in the same position in all three structures, the bottom cube rotates to the right, with its opening facing front, then facing right and finally facing back. Unlike *6 Variations*, which remains flat, these structures are drawn in isometric perspective on a light grid pattern. The grid emphasizes the uniformity and rationale of the cubes—each cube is two-grid-squares tall and two-grid-squares wide, and the top and sides of the structures are one-grid-square deep.

While the grid gives the appearance of a completely rational system, its limitless potential for variation also underlines the arbitrariness with which the rules for these particular variations were chosen. For example, why has LeWitt chosen three-cube structures instead of four-cube structures? Why does he explore only three variations in *3–1–3* instead of four variations for the four sides? The inevitability of these kinds of questions negates the rationality of the system. LeWitt's systems, which appear simple and objective on the surface, also emphasize the subjectivity of the decisions that order them. LeWitt summed up this paradoxical balance between procedural order and subjective or arbitrary expression in sentence five of "Sentences on Conceptual Art": "Irrational thoughts should be followed absolutely and logically."[2] ❖ SLE

[1] Sol LeWitt, "Paragraphs on Conceptual Art," in *Sol LeWitt: Critical Texts*, ed. Adachiara Zevi (Rome: I Libri Di AEIUO, 1994), 80.
[2] Sol LeWitt. "Sentences on Conceptual Art," in *Sol LeWitt*, 88.

6 Variations in which there are one each of cubes 1, 2 & 3

5 Variations in which cube no. 1 is predominant

X = openings in sides. FB&L = FRONT, BACK, RIGHT and LEFT

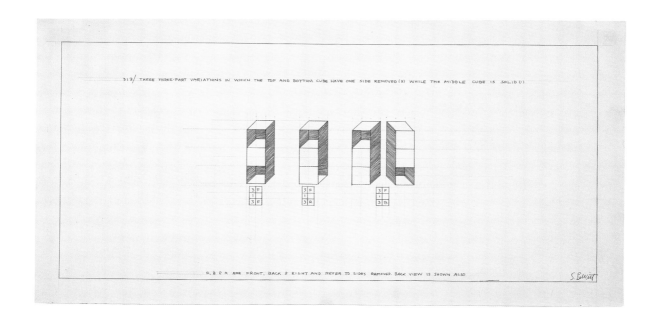

313/ THREE THREE-PART VARIATIONS IN WHICH THE TOP AND BOTTOM CUBE HAVE ONE SIDE REMOVED (3) WHILE THE MIDDLE CUBE IS SOLID (1)

F, B & R ARE FRONT, BACK & RIGHT AND REFER TO SIDES REMOVED. BACK VIEW IS SHOWN ALSO

Sol LeWitt

49
*Three Asymmetrical
Pyramids*, 1986
Watercolor on paper
22 1/2 × 30 1/4 inches

Sol LeWitt's gouache and watercolor drawings of the late 1970s and early 1980s perform a different function than do his earlier drawings for structures like *Variations 3–1–3*. Instead of working as an explicit guide for the assistants who execute LeWitt's designs (or the viewers trying to understand the finished structure), these drawings on paper allow LeWitt to freely explore new themes and directions for his work. Jan Howard, curator of The Baltimore Museum of Art's *Drawing Now: Sol LeWitt*, describes his watercolors and gouaches as "the daily studio activity that keeps LeWitt's work evolving."[1] Drawings like *Three Asymmetrical Pyramids* (1986) illustrate LeWitt's exploration of new forms and colors in the late 1970s and early to mid-1980s. As LeWitt moved away from a strict adherence to predetermined systems, he began to introduce more varied geometric and three-dimensional shapes, like those in *Three Asymmetrical Pyramids*. The three-dimensionality of LeWitt's isometric cubes and pyramidal figures were a surprise to many viewers because they seemed to contradict LeWitt's interest in two-dimensional forms that did not disrupt the two dimensional surfaces on which they were drawn. However, rather than contradicting his previous interest in two-dimensional surfaces, works like *Three Asymmetrical Pyramids* engage flat surfaces in a new way. The undulating geometric forms do not create a stable sense of depth; the solid planes of color advance and recede against their black background, playing with the viewer's sense of two- and three-dimensionality.

This use of muted colors is also an example of LeWitt's continued exploration of color that began in the 1980s. While LeWitt in his previous series had used as variables the primary colors of red, blue, yellow and black (the four basic colors used by commercial printers), he did not begin to layer washes of ink over one another (which is what created the rich variety of colors) until 1983.[2] The uneven surface of *Three Asymmetrical Pyramids* provides physical evidence of LeWitt's experimentation with shades of color, and the careful variation of muted complementary and primary colors makes clear his studied contemplation of color balance. In his introduction to LeWitt's 2000 retrospective, Gary Garrels describes LeWitt's increased attention to material and color in his works on paper: "Whereas he would be happy to have his own presence and hand absent in the structures and wall drawings, in works on paper his attentiveness and delight in materials, form, and color are amply evident."[3] ❖ SLE

[1] Jan Howard, artist's statement in exhibition brochure, *Drawing Now: Sol LeWitt*, October 6–December 6, 1987, Baltimore Museum of Art.
[2] Brenda Richardson, "Unexpected Directons: Sol LeWitt's Wall Drawings," in *Sol LeWitt: A Retrospective*, ed., Gary Garrels (New Haven: Yale University Press, 2000), 44.
[3] Gary Garrels, "Introduction" in *Sol LeWitt: A Retrospective*, 29.

Sol LeWitt

50
*Bands of Lines in
4 Directions*, 1991
Gouache on paper
11 × 30 inches

n October of 1968, Sol LeWitt made his first wall drawing as part of a group show at the Paula Cooper Gallery in SoHo. *Drawing Series II 18 (A & B)* was drawn with pencil directly onto the gallery wall and consisted of two four-by-four-foot squares, each composed of four one-by-one-foot squares. Each one-foot square was filled in with straight lines that were horizontal, vertical or diagonal from the upper right corner or upper left corner. These four squares, with their four directions of lines, were the basic elements for a series in which he explored all possible combinations of the lines. The full series had been published earlier that year in Seth Siegelaub's *The Xerox Book*. Twenty-three years after both *The Xerox Book* and the first wall drawing, LeWitt's gouache drawing *Bands of Lines in 4 Directions* (1991) continues to illustrate these four basic components of lines in four directions. However, the thin pencil lines have evolved into thick bands of color.

While *Bands of Lines in 4 Directions* shares the same basic components of LeWitt's first series of lines in four directions, the vibrancy of these later bands significantly alters the drawing's meaning. The rich and varied colors of the thick brush strokes produce a bold aesthetic effect whose energy underlines the dynamic contrasts between the lines. This energy overshadows the objectivity of LeWitt's basic components, and the color variations follow no predetermined order. According to LeWitt, however, his use of color still works with his original intent to systematically explore all possibilities within a given set of determinants (i.e. lines in four directions). Asked why in the 1980s he introduced to his works such vibrant colors—colors that appeared to operate in a perceptual rather than conceptual way—LeWitt replied, "To be truly objective one cannot rule anything out. All possibilities include all possibilities without pre-judgment or post-judgment."[1] Yet, even if the vibrant colors are only another objective variable, the shift in emphasis is undeniable: The astounding beauty of LeWitt's vibrant colors provoke the viewer to respond more to the work as an aesthetic object in its own right and less as a product produced by the machine of the idea. ❖ SLE

[1] Sol LeWitt to Andrea Miller-Keller, "Excerpts from a Correspondance, 1981–1983," in *Sol LeWitt Wall Drawings, 1968–1984* (Amsterdam: Stedelijk Museum, 1984), 19.

Sol LeWitt

51
*Bordered Rectangles
Within Bordered
Rectangles*, 1992
Gouache on paper
11 ½ × 9 ½ inches each

The gouache drawing on paper *Bordered Rectangles Within Bordered Rectangles* (1992) synthesizes Sol LeWitt's early concern with seriality and his later experimentation with bold colors and loose, "not straight" brushstrokes. In these two sets of three rectangles, each rectangle consists of three different borders. While the borders in the first two rectangles are different colors—black, yellow and red—the last rectangle consists only of two colors—red and yellow. The order of the colored borders changes in each rectangle, much like the combination of open and closed cubes changes order in *6 Variations*. However, unlike the almost sterile "X"s that marked these changing combinations in the cubes of the 1960s, these rectangles pulsate with a visual dynamism created by the juxtaposition of the border color and size. As the eye follows a single color across the series, the rectangles appear to grow and shrink.

Although this system is no less rational than *6 Variations*, the sensuality of the colors and the loose quality of the brushstrokes render the series less cold and objective. The set of rules that guide the variations is subsumed by the aesthetic effect. In the more than twenty years since LeWitt created *6 Variations*, the tension in his work between rational/irrational, objective/subjective, and perceptual/conceptual has shifted in opposite directions. In the cube series of the late 1960s the extreme order and systemization of the variations are what first strike the viewer, who then realizes that these finite variations are indeed based on subjective decisions. Twenty years later in *Bordered Rectangles*, the intensity of the rectangles' color is what stands out and only a persistent or informed viewer recognizes the quiet order that underlies the structure of the perceptually intense series. ❖ SLE

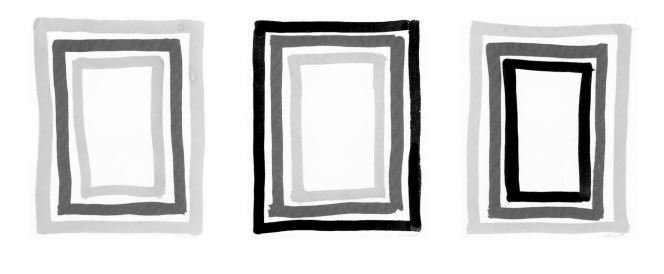
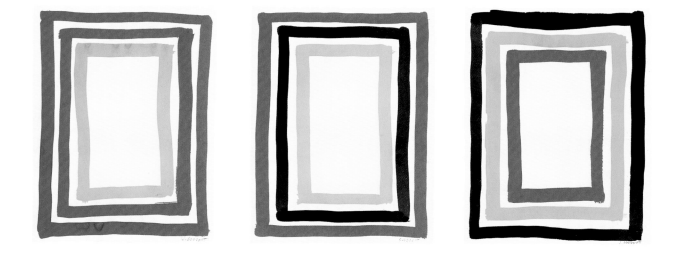

Glenn Ligon

Born 1960, Bronx,
New York, works in
Brooklyn, New York

52

*Untitled (Stranger in the
Village/Crowd #1)*, 2000
Silkscreen, coal dust,
oilstick and glue on paper
40 × 54 inches

The blackness of the surface is immediately striking in Glenn Ligon's *Untitled* (2000). The drawing belongs to a body of elusive, poetic works that present seemingly disjointed ideas on the surface of the paper. Ligon borrows the title from a 1953 essay by James Baldwin entitled "Stranger in the Village," which describes the winter months of the writer's sojourn in a small Swiss town where he was the first black person the townspeople had ever seen. Ligon's appropriation of the text reintroduces and reconnects issues of race and marginality to himself and his audience. He challenges the audience to read the blotchy, difficult work, to examine more closely the powerful text and to resist a simple, celebratory interaction with the iconic status of Baldwin's words.

Ligon constructs this large work in three layers. The first and most difficult to perceive is a white silkscreen print. It barely shows through here, but in other works in the series, one can make out several bodies forming the crowd alluded to in the title. For the second layer, Ligon has covered most of the silkscreen with black oilstick. In the third layer, the artist has stenciled words to the surface with glue and covered them with coal dust, creating a rough, tactile and sparkling collection of words. The coarsely ground coal glistens on the surface of the letters, but in some passages the concentration of the glue and coal obliterates entire chunks of text and makes them illegible. Rather than diminish their importance, however, this fragmented perception of the text emphasizes the profundity of the words by forcing the viewer to examine them one by one, and the black typewriter font against the subtly white background becomes reminiscent of an old novel or a tattered newspaper—barely readable but no less important to its owner. The blotchy rendering of the letters draws the viewer in closer, questioning to what the text refers in spite of the difficulty one might encounter trying to decipher it.

Ligon's appropriation of the forty-seven-year-old text reminds us that history is constantly recycling itself through the subjectivities of both the artistic producer and the audience. Ligon, an admirer of black writers and historical icons of the 1950s and 1960s, keeps race and politics at the forefront of his work. In *Untitled*, he returns audience attention to Baldwin's text, emphasizing seemingly autobiographical phrases. However, because these personal phrases have been partially obliterated by the crowded nature of the composition, it is unclear whether the words belong to Ligon or Baldwin, especially because Ligon often incorporates the word "I." *Untitled* highlights a section in "Stranger in the Village" in which Baldwin tells of feeling isolated in the town because of his blackness. Blotches of phrases like: "The time

has come…" and "looking at me as strange…" hint at a simmering paranoia as Baldwin becomes aware of the town's peculiar interactions with him as a black man. In addition, the crowded, multilayered nature of the work's arrangement, which causes parts of his words to disappear, implies the artist's struggle to function in a society that would rather not recognize him:

> There are days when I cannot pause and smile, when, indeed, I mutter sourly to myself, exactly as I muttered on the streets of a city these children have never seen, when I was no bigger than these children are now: Your mother was a nigger. Joyce is right about *history being a nightmare*—but it may be the nightmare from which no one can awaken. People are trapped in history and history is trapped in them. [*emphasis added*][1]

For Baldwin, his childhood history of racism in America becomes a nightmare that extends to his feelings of marginalization in the foreign town. This quote recalls his discomfort with the children in the town who, whenever they saw him, pointed in pure wonderment and screamed *"Neger!"* unaware of its uncanny similarity to the racist English word "nigger." Here, Baldwin makes a connection between two countries: Swiss culture, a people ignorant of black identity, and American culture, which he understood as one of blatant racist hatred. As Ligon explains in a conversation about the work, Baldwin had used his experience as an alien in a Swiss town to examine his ostracism at home.[2] The racism he confronted in America consumes him in his interactions with the Swiss strangers.

Ligon emphasizes that *Untitled* is not a simple rereading of Baldwin's text. Rather he presents the words as an interrogation of the way the public digests the writer's now classic works. Ligon states, "I didn't want my paintings just to be re-presenting the text, saying 'Baldwin is important, here's the text, read it again.'"[3] Instead of assigning Baldwin's ideas to a distant past, Ligon's assimilation of autobiography into his tribute to Baldwin's text asserts an empathy with the writer's struggle. Readers often visit Baldwin's words as a site of literary genius that documents a struggle long bygone. In appropriating Baldwin's text in the first person Ligon creates a shared identity with the author that connotes Ligon's own struggle to assimilate and yet maintain a distinct voice in America. ❖ KB

1 James Baldwin, "Stranger in the Village" in *Notes of a Native Son*, (Boston: Beacon Press, 1955), 162.
2 Thelma Golden, moderator, "A Conversation," in *Glenn Ligon, Stranger* (New York: The Studio Museum in Harlem, 2001), 11.
3 Ibid., 28.

Sharon Louden

Born 1964, Philadelphia, Pennsylvania, works in New York City

53, left
Pinch #4 (from the "Pinching Series"), 1995
Powdered graphite and acrylic matte medium on vellum
29 ½ × 21 ½ inches

54, right
Flaps, 1998
Gel medium on gridded mylar
24 × 18 inches

Sharon Louden describes her early works as abstractions of sexually engaged body parts.[1] In *Pinch #4* (1995) and *Flaps* (1998), Louden creates overlapping abstracted bodily forms that incite the viewer to feel physically connected to them. The delicate translucent forms in both works resemble cellular and bodily structures. If they evoke a sense of aggressive movement, they do so in slight, shivering motions like the gestures of nervous fingers or excited sexual organs.

Frenetic movement is a key aspect of Louden's work. In a 2000 installation entitled *Swells and Extensions* Louden shaped overlapping glowing strings into a large biomorphic cluster that seemed to "quiver" in what Alice Winn describes as, "dance dramas frozen in midair."[2] Similarly, in *Pinch #4* and *Flaps* the tight bunch of strokes overlap and press against each other. Their multidirectional positioning combined with their multilayered format gives the clusters the impression of frantic motion.

In *Flaps*, Louden complicates the viewer's perception of the drawing's two-dimensionality. The artist applies transparent black gel to translucent mylar graph paper, making the viewer aware of every stroke. Brushstrokes become darker and more opaque as they overlap. Because each subtle nuance is apparent, an illusion of shallow depth complicates our notion of dimensionality. The transparency of the medium against the translucent mylar makes the paper barely visible. Because the dense bunch of strokes appears uniform behind the framed glass, the delicate cluster seems to float toward the upper left edge of the paper in three-dimensional space. The faint blue lines of the graph paper bring the viewer's attention back to the work's two-dimensionality.

Pinch #4 incorporates a similar cluster of forms that shift between two- and three-dimensionality in their exploration of more overtly bodily forms. The work is composed of several smudges of graphite on vellum that resemble vaginal forms. As in *Flaps*, the tiny strokes of paint seem to press against each other, forming a tight cluster that appears caught in a shivering frenzy of movement. In this work, too, the cluster seems to sustain itself without the interposition of the paper. However, subtle creases become apparent; the tension created by the application of numerous short strokes with the wet ink against the delicate paper causes the paper to gather slightly at the site of the cluster, creating the effect of a single contracting vaginal form. In these highly abstract works, Louden creates organic illusions that obscure the boundaries between lines on paper and living forms. ❖ KB

[1] Sharon Louden, artist's statement in exhibition brochure, *56th Exhibition of Central New York Artists*, (Utica, N.Y.: Museum of Modern Art, New York, 1995), 25.

[2] Alice Winn, "Taking Journeys at a New Gallery," *Pittsburgh City Paper*, 2–9 February 2000.

Robert Mangold

Born 1937, North Tonawanda, New York, works in Washingtonville, New York

55

Untitled Drawing #1, #2, and #3, 1968
Graphite on paper
13 7/8 × 8 1/2 inches

Since the early 1960s Robert Mangold has produced an oeuvre devoted to rigorous investigation of the two-dimensional surface plane of painting. Dividing shaped canvases and exploring the relations of parts to the whole, he has dealt with the affective power of the painted surface as an immediate physical presence. His systematic exploration of the picture plane by drawing lines over the divisions or sectioning them into various forms often elicited for his work the label of geometric abstraction. Defying this categorization, Mangold stated, "Geometric art always makes me nervous, I don't think of my work in that way. I think all of my works are about things fitting or not fitting together, with the structural shape either dictating the terms of the interior structure or setting up a framework the interior structure plays off of."[1]

The notion of sections or parts has been central to Mangold's work since 1964. In the series *Walls and Areas* (1964–1966), he investigated the interplay of parts and wholes in painting by variously dissecting the shaped planes. He underscored the material quality of the flat panels with irregular outlines and joints cut into their centers. The curved line at the bottom edge of the *Areas* paintings conveyed the form of a segmented circle. Mangold first introduced curved outlines in *Cool Gray Area with Curved Diagonal* (1966), which was an extension of the *Areas* series. In addition, the artist made his curved lines with a compass to "avoid the organic natural line."[2] His experiments with the underlying interrelationships between fragmented and whole shapes culminated in his series *V, W, and X* (1968–1969). He made sixteen models of the *V, W, and X* series in green, ochre and blue respectively. *Untitled Drawing #1, #2, and #3* (1968) are variants of the series.

In preparatory drawings for this series, Mangold divided three semicircles into four sections by three vertical lines equidistantly spaced across the composition. He added diagonal lines connecting the ends of different verticals to form variants corresponding to the letters "V," "W" and "X." The set of three drawings presented here contains the left half of a semicircle, the semicircle with the outer segments removed and the center section of a semicircle. Subtracting sections or edges further complicates the basic serial method of sectioning and dividing the semicircle. However, the lines are perceived with clarity, at once dividing the planes into multiple smaller fragments and containing the segments as a whole. More importantly, the lines dividing the ground do not create illusionistic space but present the segmented elements as flat surface. The shaped outer edges and the internal parts are intricately related to constitute an integral whole. While the dividing lines in the interior are determined by the outside shape, they simultaneously configure the exterior shape of each drawing. "The division of panels…keeps reinforcing the edge," Mangold remarked. "The division… [puts] a certain kind of pressure on the edge…the edge would constantly be reasserting itself."[3]

In the finished paintings, Mangold gave a uniform color to each of the three series to underscore the individual groups' serial character. He applied a rather subdued acrylic paint with a roller to masonite panels to integrate the variously odd shapes and the physical surface of color. Mangold explained, "Color plays an important but controlled role in the works and gives the surface an assertive presence. In most cases, the color is kept somewhat subdued to prevent it from dominating the piece, since I want the work to be a total unity of color-line-shape."[4]

In opposition to such contemporaries as Donald Judd and Sol LeWitt, who had assistants or industrial craftsmen execute their work, Mangold believes that the artist must execute the work of art himself. The idea of art-making as intimate personal experience is central to his work, "I believe that making art has to do with a relationship of one—me and the work. My most important audience is me, while I'm working, this is where the pleasure, struggle and excitement of art lies."[5] The introspective quality of his painting process reflects how abstract expressionism affected his work. As he remarked, "The legacy of abstract expressionism was not something I wanted to rebel against but to extend somehow."[6] ❖ EYJ

[1] Robert White, "Interview with Robert Mangold," *View* (December 1978): 12.
[2] Although initially stimulated by the curved silhouette of a mountain in the country where he spent the summer of 1966, Mangold used a compass to delineate curved lines and arcs to "avoid the organic natural line." Maurice Poirier and Jane Necol, "The '60s in Abstract: 13 Statements and an Essay," *Art in America* (October 1983): 130.
[3] White, "Interview," 12, 16.
[4] Robert Mangold, interview by Rosalind Krauss, *Artforum* (March 1974): 37.
[5] White, "Interview," 22.
[6] Mangold emphasized the influence of Barnett Newman's work in particular: "The strongest influence was Barnett Newman's work. It presented me a kind of serious monumentality, mental expressiveness and emotional tenseness that was to be a model for me of what great art should be." Poirier and Necol, "The '60s in Abstract,"130.

Robert Mangold

56

Plane/Figure Variant (Double Panel), 1993
Acrylic and colored
pencil on paper
30 × 44 inches

n the mid-1970s Robert Mangold moved toward a broader range of colors and larger painting formats to accentuate a tension between pictorial and structural elements. In 1977–1978 he began to apply colors with a brush instead of a roller to concentrate on the interplay of color and surface. He also began to execute preparatory works with sheets of paper instead of masonite models. Mangold said of this shift to more painterly visual effects, "There was a need for the surface of the paintings themselves to be more tangible, more tactile, more there."[1] He continued his experiment of the previous decade in the tense relations between line and format. Yet, along with luminous colors, the basic geometric units of lines and forms became more dynamic and nuanced.

Plane/Figure Variant (Double Panel) (1993) exemplifies Mangold's continuing exploration of the interplay between drawn lines and colored shape. The shift in his approach can be seen by comparing this work to the three preparatory drawings for the *V, W, and X* series of 1968. In the earlier work, the precisely drawn sectioning lines and interior subdivisions are firmly contained as equal pictorial elements within a unified whole. In the finished work, the color functions as a way of identifying individual series and presenting the serial character within each group. In the 1993 drawing, the vertical line dividing the color fields in the center is slightly mismatched with the ovals' axis of symmetry. This mismatch orchestrates a tension that negates static geometry. The tension is reinforced by the way the left panel's oblique edge undermines the stability of the geometric composition. The balance is maintained, however, among outlines, interior forms and colors. The radiant hues of lilac and yellow create a soft, atmospheric space. The gently curved ovals that abut each other float over the translucent space of color, engendering a sense of equilibrium that checks a visual slippage. The interrelated yet independent pictorial elements of color, line and format combine to unfold with clarity the immanent planar surface.

The practice of drawing has been integral to Mangold's work. His works on paper concern the entire working process. Mangold states:

> I work out my thoughts in sketchbooks and drawing pads....After the idea is worked on as a sketch, I then make a large paper work in acrylic paint and pencil, using the same materials that I will use in the finished work....The works on paper are where the ideas are worked out and most of the important decisions are made, the momentum from them carry me into the painting.[2]

❖ EYJ

[1] John Gruen, "Robert Mangold: A Maker of Images—Nothing More and Nothing Less," *Art News* (summer 1987): 137.
[2] Robert Mangold, "Works on Paper," in *Robert Mangold: Works on Paper* (Zurich: Annemarie Verna Galerie, 1988), vii.

Brice Marden

Born 1938, Bronxville,
New York, works in
New York City

57, top

not titled, 1970
Powdered graphite and
wax on handmade paper
27 ½ × 40 ⅞ inches

B rice Marden in an interview with Janie C. Lee describes himself as an intermediary for the image, "I think if there's a real working idea for me it's letting the image come up out of the unknown rather than taking some known thing and applying it to the plane and defining it." This working process is evident in his paintings as well as his drawings from the mid-1960s and 1970s. Even Marden's materials—colored pencil, graphite, inks, charcoal, beeswax and sticks—transcend their substances.[1] By 1970, Marden's blocks of black had grown more worked-over than those in earlier drawings, such as *Untitled* (1965). Marden described his process at this time as "turning a piece of white paper into black."[2] His layering technique demanded that he fill in every hole in the paper.

> You're also mixing the graphite with the beeswax, so that in a way the graphite is like a paint pigment with the wax as the binder. And then you have to make sure that it is even. You have to work at it. I would have a hard edge, like a metal ruler, and I would work out to the edge of the rectangle with that.[3]

Marden's process in the early 1970s combines building and removal. In a work such as *not titled* (1970), he rubbed the beeswax into the paper and then scraped it away, working toward the smooth surface apparent in this drawing. In addi-

tion, he cut a grid into the black surface, where deviations in the thickness and depth of the cuts are revealed.

The grid for Marden has two distinct sources. There was a period in the early 1970s in which he would go to the Museum of Modern Art once a week to look at Piet Mondrian's painting *Broadway Boogie Woogie* (1942–1943). At this time, Marden had done some drawings in which he would inset a postcard reproduction of the Mondrian painting and work around it. This was his response to the collage efforts of Jasper Johns and Robert Rauschenberg.[4] Before this, Marden recollects, "When I got to Paris in 1964, I couldn't paint because I did not have a studio, so I worked on drawings....I felt I wanted to break the gray area down to make it tighter and have the surface be more taut, and so I started using a grid. The grid actually began as a frottage I did of the tiles in our kitchen."[5] For Marden, the grid contains not only art historical references but also citations of his surroundings. ❖ DW

1 Janie C. Lee, *Brice Marden Drawings: The Whitney Museum of American Art Collection* (New York: Whitney Museum of American Art, 1998), 15–16.
2 Ibid.
3 Ibid., 14.
4 Ibid., 15.
5 Ibid., 13.

58, bottom

Untitled, 1965
Charcoal, colored pencil
and graphite over
silkscreen on paper
14 × 18 ½ inches

L ike Brice Marden's monochromatic paintings of the mid-1960s, in which he would cover ninety percent of the surface of the canvas but leave a vacant strip at the bottom to catch drips and splatters, this mid-1960s drawing includes prominent traces of its process. Marden drew the work over a silkscreen image, blocking out a majority of the white printed underneath. Yet his blocked out areas do not completely mask the print; one can clearly see the marks left by his hand. And he lets the white show through completely at the bottom of both blocks. Marden's process recalls those of Jackson Pollock and Willem de Kooning, in which the complexity of their built-up surfaces revealed the act of painting.[1]

> The process is really about feeling and trying to understand what's out there and how you're responding to it and getting it down so it can be communicated. The plane at one point is chaos or the miasma,

and you work it up just so that there's an image. The chaos becomes understandable, or you can see it in some way that isn't necessarily understandable, but it's plausible.[2]

The stacking of two black masses in *Untitled* (1965) also anticipates the horizontal stacking of canvases in Marden's paintings of the late 1960s and 1970s. Meanwhile, Marden's controlled, laborious and repetitive graphite, colored pencil and charcoal marks give a consistent feel to the entire colored area, despite the fact that these materials do not generate this kind of surface easily. A constant working and reworking is necessary to obtain such an even coloring. ❖ DW

1 Klaus Kertess, *Brice Marden: Paintings and Drawings* (New York: Harry N. Abrams, Inc., 1992), 12.
2 Janie C. Lee, *Brice Marden Drawings: The Whitney Museum of American Art Collection* (New York: Whitney Museum of American Art, 1998), 15.

Brice Marden

59
*Masking Drawing
No. 20*, 1983–1986
Oil, ink and gouache
on paper
14 × 32 ⅞ inches

*M*asking Drawing No. 20 (1983–1986) comes from a series of drawings and paintings that originated from a stained glass window project Brice Marden began for the Basel cathedral.[1] Marden made studies that were based on the grid structure of the existing windows and additional studies that were much more experimental in layout. Drawing on alchemical color themes, he used red, green, yellow and blue; the Book of Revelations, with its "visions of bejeweled translucence" and its "repetitive use of numbers" also influenced the conception of this project.[2] The drawings for this project are among his most experimental.

Although he eventually left the cathedral project, Marden exhibits in these drawings his interest in a different kind of spontaneity and interaction with the picture plane. He curiously juxtaposed bands and splatters of color with a grid of black beams. The openness of the grid, allowing a fair amount of the paper to show through, suggests the luminescence of large, stained glass windows. This working process allowed Marden to get closer on paper to the working ideas of Jackson Pollock. The colorful stripes and splashes of oil paint (including "oil rings," in which oil has soaked in the paper surrounding a spot of color) demonstrate a direct and intuitive method that is absent in the overworked drawings of his earlier career. They even differ from the *Window Paintings* (1983–1986), where he superimposes a more even grid on a patterned arrangement of horizontal, vertical and diagonal lines, creating a less indulgent feeling.

In *Masking Drawing No. 20*, Marden has revealed the painting process as well as the process of the gridded bands. For this series, he began looking at the sheets of paper he used to mask the edges of his paintings to keep colors separate from each other. Taking these sheets, he cut them up to reconfigure the space of their color blotches. Then he went back into the drawings and superimposed his own grid work, loosely mimicking that of stained glass windows.[3] The varying thickness and line quality of the grid also point to a more intuitive drawing manner. In relation to his earlier drawings, the number of gridded lines in conjunction with the extensive whiting-out and overworking demonstrate the perseverance required by this labor-intensive process. ✤ DW

[1] Klaus Kertess, *Brice Marden: Paintings and Drawings* (New York: Harry N. Abrams, Inc., 1992), 33.
[2] Ibid.
[3] Ibid., 40.

Brice Marden

60
Small Corpus, 1989–1994
Oil on natural vellum
stretched over plywood
25 1/4 × 19 7/16 inches

I n 1988, Brice Marden began painting his *Cold Mountain* series. These works marked a shift in his practice, inspired by a 1984 visit to the exhibition *Masters of Japanese Calligraphy, Eighth to Nineteenth Century* at the Asia Society and Japan House galleries in New York.[1] A 1984 trip to Thailand with his wife, Helen Marden, and their two daughters further stimulated this change.[2] And in addition to his continuing fascination with Jackson Pollock's work, Marden began studying Chinese calligraphy and observing the gesture-like markings on seashells. "The only Western art I've been investigating has been Pollock," he said in 1991. "I used to not want to have anything to do with Oriental art or Asian art. I thought, I'm Western, I just can't understand a different philosophy. I guess that's one of the things about coming through middle age. You don't feel like you have to restrict yourself anymore."[3]

The freedom he felt in calligraphy turned Marden toward nature and he continued to use sticks as a replacement for pens and pencils. "By getting farther away with a delicate instrument…in a way it becomes closer: the slightest move is reflected. There's also accident, and I use it. That's an Abstract Expressionist thing."[4] The *Cold Mountain* paintings refer to the Chinese poet Cold Mountain, whose name derived from the poet's place of retreat, the sacred Cold Rock Mountain.[5]

Small Corpus (1989–1994), with ties to both painting and drawing, resembles the transparency and gestures of the *Cold Mountain* paintings. This drawing on natural vellum stretched over plywood reveals Marden's entire process. Building on the ideas of luminosity from the *Masking* drawings, Marden used the vellum to illuminate the thin washes of oil. He allowed the natural grain of the wood ground to leave a colored impression on the paper. And over this light gray he interwove bands of muted color that curve like Chinese calligraphy.

Downplaying this calligraphic reference, Yve-Alain Bois, however, emphasizes a different reading and offers that Marden's work after 1986 refers more to the body and, in particular, to the lungs.

> It is not enough for a painting to look like [lungs], it must also pulsate; it is not enough to pulsate, it must also draw you into its tangles; it is yet not enough if it does that, for it must also permit the circulation of air between its discrete but similar elements: it must be woven in space.[6]

Marden adds, "It's not a form of writing. I'm *not* trying to make a language. I think of Chinese calligraphy as simply the way I see it, not knowing the language."[7] For Marden, "one of the things about the work…is it's more directly involved in the act of drawing and the automatic. They start out with observation and the automatic reaction, and then break off, so there's layering of different ways of drawing."[8] ❖ DW

1 Klaus Kertess, *Brice Marden: Paintings and Drawings* (New York: Harry N. Abrams, Inc., 1992), 41.
2 Pat Steir, *Brice Marden: Recent Drawings and Etchings* (New York: Matthew Marks Gallery, 1991), unpaginated.
3 Ibid.
4 Ibid.
5 Kertess, *Brice Marden*, 47.
6 Yve-Alain Bois, "Marden's Doubt," in *Brice Marden: Paintings, 1985–1993* (Bern: Kunsthalle Bern, 1993), 51.
7 Steir, *Brice Marden*, unpaginated.
8 Ibid.

Tom Marioni

Born 1937, Cincinnati, Ohio, works in San Francisco, California

61

Tree-Bird-Man, 1990
Pencil on paper
44 5/8 × 86 inches

Tom Marioni's *Tree, Drawing a Line as Far as I Can Reach* (1972) established a theme that has persevered in his work for three decades and underlies *Tree-Bird-Man* (1990). Integrating drawing and performance, all of Marioni's *Tree* and *Bird* drawings result from repetitive and concentrated, performance-based activities. As he did with most of his *Tree* and *Bird* works, to draw *Tree-Bird-Man* Marioni hung a sheet of paper on a wall, sat before it and drew vertical pencil lines that he shaded until the pencil ran out of lead. There are hundreds of such drawings of different sizes, with only minor variations.

For Chinese and Japanese calligraphers, who have long-interested Marioni, writing or drawing is deeply integrated with physical exercise. The artistic activity is ritualistic and symbolic, since writing and drawing are seen as an approach to self-realization and self-improvement. The simplicity, elegance and reflectivity of Marioni's works have an enigmatic Zen quality.[1]

"All of this work is body measurement," Marioni says, "but each drawing has associations: tree, bird, man or—in the calligraphic works—picture writing."[2] In Marioni's work, we literally can watch the creation of meaning through the repetitive activity of generating the work. They are, Marioni has said, "sculpture evolved into the fourth dimension."[3] The work is highly conceptual; the materials reflect the ideas, the generative process and the artist's way of approaching life. ✤ CW

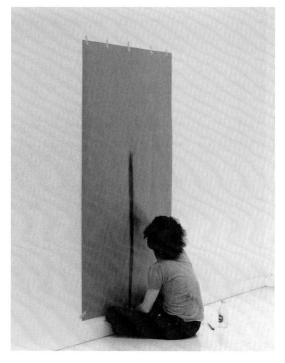

Tom Marioni drawing *Tree, Drawing a Line as Far as I Can Reach*, Reese Palley Gallery, San Francisco, 1972.

[1] Marioni titled one of his books *Zen Stories*.
[2] "Tom Marioni," *Crown Press Newsletter* (November 1994): 1.
[3] Marcia Tanner, ed., *Tom Marioni: Trees and Birds, 1969–1999* (Oakland: Mills College Museum, 1999), 10.

Agnes Martin

Born 1912, Maklin,
Saskatchewan,
Canada, works in
Taos, New Mexico

62
Wood I, 1963
Watercolor and
graphite on paper
15 × 15 ½ inches

Born in the far west of Canada in 1912, the same year as Jackson Pollock, Agnes Martin belonged to the generation of the abstract expressionists. She admired Mark Rothko and Barnett Newman, particularly for their use of geometry to represent transcendental experiences. Martin constructed her philosophical views from a variety of sources, among them the writings of Chuang Tzu and Lao Tzu (the two principal philosophers of Taoism). The notion of quieting or emptying the mind to achieve clarity of vision has been central to Martin's artistic practice.

The many repetitions of parallel lines forming the grid in *Wood I* (1963) recall the sacred geometry of Tantric art, in which a recitative-style repetition relates the work to meditation and concentration. Below the grid of black graphite, Martin laid an equally dense pattern of delicate white gossamer lines. While preserving wholeness and symmetry, the geometric field is full of subtle movement. The small irregularities and wavering undulations of the gridded lines suggest the trembling of the artist's hand and variations in pressure applied to the pencils. The effect is at once clear and elusive, tranquil and fluctuating. Radiating intensity and concentration at different moments in the drawing, the process points toward the conceptual clarity of the whole. The art critic Hilton Kramer remarked, Martin's art is "like a religious utterance, almost a form of prayer."[1]

Although Martin shifted her attention from the biomorphic shapes of natural motifs to abstract geometry in the late 1950s, the evocation of nature persisted in her drawings and paintings of the 1960s. Titles such as *Wood I* continued to suggest a reference to nature. However, Martin sought not a representation of nature but a visual correlative for the feeling of exultation that nature elicits. For Martin, the grid functioned as a vehicle for expressing an unrestricted vision of nature, as a means for rendering in concrete forms what is inherently incapable of being objectified. In a letter to Barbara England attached to the back of the drawing, Martin wrote: "All great artwork attempts to represent our joy in moments of clarity of mind and vision....Please study your response to art very carefully (and to everything else) as it is the road to self knowledge and the truth about life."[2] ❖ EYJ

[1] Hilton Kramer, "An Art That's Almost Prayer," *The New York Times*, 16 May 1976, sec. 2, p. 31.
[2] Agnes Martin to Barbara England, letter enclosed with the drawing.

Agnes Martin

63
Untitled, 1963
Ink, pencil and
crayon on paper
9 × 9 ¼ inches

Beginning with her inclusion in the Guggenheim Museum's *Systemic Painting* show in 1966, Agnes Martin's work has been associated with minimalism. Indeed, since the early 1960s, a geometric grid structure has prevailed in her paintings and drawings. She composed holistically rather than with compositions of balanced parts to suggest that we apprehend her work as single, complex images. Despite these formal affinities, however, Martin's goals differed from those of other minimalist artists. She sought to embody a personal and transcendent vision through the infinite, nonreferential space of a geometric order. In consequence, despite formal similarities to minimalism, Martin infused her work with an expressive touch that sets it apart. She called herself an expressionist and declared, "I paint my pictures in response to something."[1]

In *Untitled* (1963), the geometric structure creates a format in which all compositional units are equal and independent. Martin drew eight elliptical lines bent upward and downward in a repeated pattern across a square frame. The arcing lines create an illusion of an oscillating string, pegged at both ends. The vertical line in the center stabilizes the oscillation by symmetrically dividing the composition. Yet a number of subtle details destabilize the overall geometry. The colored dots along the vertical lines do not always match the elliptical lines. The lines and dots reveal a process of adjusted measurements and lapses in concentration, rather than a finished form of geometric perfection. Martin points out, "My formats are square, but the grids are never absolutely square, they are rectangles a little bit off the square, making a sort of contradiction, a dissonance, though I didn't set out to do it that way. When I cover the square surface with rectangles, it lightens the weight of the square, destroys its power."[2]

It was around 1957 that Martin began to employ grid structures and geometry as a vehicle for spiritual contemplation. She had come to New York in 1957 and lived until 1967 on Coentis Slip, the downtown Manhattan waterfront district. Among her immediate neighbors on the Slip were Ellsworth Kelly and Jack Youngerman, who painted hard-edge geometric forms. Martin had shifted from representational imagery to biomorphic abstractions in the mid-1950s, but by the late 1950s biomorphism gave way to more abstract geometric patterns. By 1963, when Martin made this drawing, her canvases echoed the modular layout of grids. By limiting her forms and deploying motifs at equidistant intervals along parallel lines, she gives her work equilibrium and quietude. "[Geometry] is a means of getting to a content in ourselves; a plane of attention and awareness, a plane of self-understanding," Martin remarks. "I use geometry because it allows a frontal and direct experience and when handled in a certain way is intimate and tranquil."[3] ✤ EYJ

[1] Barbara Haskell, "Agnes Martin: The Awareness of Perfection," in *Agnes Martin* (New York: Whitney Museum of American Art, 1992), 108.
[2] Lucy R. Lippard, "Homage to the Square," *Art in America* (July/August 1967): 55.
[3] Michael Auping, *Abstraction, Geometry, and Painting: Selected Geometric Abstract Painting in America Since 1945* (Buffalo: Albright-Knox Gallery, 1989), 166.

Agnes Martin

64
Untitled, 1995
Pencil, ink and
watercolor on paper
11 × 11 inches

n October 1967, immediately following her exhibition at the Nicholas Wilder Gallery in Los Angeles, Agnes Martin left New York and abandoned painting until 1974. After seven years of a solitary and simple life, she constructed a studio in New Mexico and resumed painting at the age of sixty-two. Martin refers to the seven-year break as "the time to be awake and aware." She remarks, "'Free and easy wandering' it is called by the Chinese Sage Chuang Tzu. In free and easy wandering there is only freshness and adventure. It is really awareness of perfection within the mind."[1]

Martin's work after 1974 differs from that of the 1960s in several respects. Most noticeably, the dense lines and intricate grids of her earlier work give way to expansive color areas and broad bands. The colors are thin and translucent, producing a softer expression, an atmospheric quality. She orients the bands of pale colors either horizontally or vertically, while the compositional arrangement remains holistic and nonhierarchical. *Untitled* (1995) exemplifies this second phase of Martin's art. The wide horizontal bands of translucent washes of pink and blue exude a mystical radiance. The parallel lines drawn in pencil across the lightly painted surface sustain the almost dematerialized colors in an ordered pattern. The austere pencil lines precisely divide the field as if to compensate for the sensuality of the pale colors.

Associations with nature or the organic world disappear in this drawing. By using distilled forms and colors, it attains the equilibrium and detachment of an anti-nature art. "Nature is conquest, possession, eating, sleeping, procreation," she explains. "Nature is the wheel....You never rest with nature, it's a hungry thing....Being detached and impersonal is related to freedom. That's the answer for inspiration. The untroubled Mind."[2] The simple form and color in *Untitled* capture an ethereal perfection beyond nature: the untroubled mind. ❖ EYJ

1 Agnes Martin, "On the Perfection Underlying Life," in *Agnes Martin: Paintings and Drawings, 1974–1990* (Amsterdam: Stedelijk Museum Amsterdam, 1991), 29.
2 Agnes Martin, "The Untroubled Mind," in *Agnes Martin* (Philadelphia: Institute of Contemporary Art, 1973), 17–19.

TOP

a. martin '95

Stefana McClure

Born 1959, Lisburn, Northern Ireland, works in Brooklyn, New York

65

Nihon Keizai Shimbun, Monday, February 22, 1999 (Heisei 11), 1999
Graphite on paper mounted on kozo
23 1/4 × 34 1/2 inches

Stefana McClure discussed the importance of transnational travel, "living between places," as a key inspiration for *Nihon* (1999).[1] Despite the exclusion of an obvious sign of McClure's own hand in the finished product of the work, the series of drawings to which this work belongs is a deeply personal, romantic record of McClure's life "between cultures." McClure is a native of Northern Ireland; she works in London and Tokyo and currently lives in New York City. A commonality between all the countries where she has lived has been their shared means of communicating information through the newspaper media.

Nihon is constructed of fragmented impressions from a Japanese financial newspaper. McClure created five of these works, each with a newspaper from a different country, by mounting transfer paper face-up and adding newspaper to its back.[2] She copied one page at a time by painstakingly etching each word from the newspaper into the transfer paper with a sharp pencil. The copied information ends up on the backside of the paper, creating light impressions of words and images. Although the newspaper's content and advertisements are specific to the Japanese newspaper, the format and font of the image is recognizable as a newspaper to anyone familiar with the medium.

McClure's artistic process of tracing each word is a time-consuming effort and demands a commitment of special care to the subject matter. Indeed, the artist's appropriation of this ghost-like remnant of the well-known Japanese financial paper *Nihon Keizai Shimbun* is a self-proclaimed "ode" or souvenir that marks her travel to the country.[3] The artist includes the newspaper date as if it were a keepsake—as one would date an event in a personal journal or a photograph in an album. In an interview she explained, "I am not interested in making any kind of artist's gesture or mark." Her intention instead is to make a faithful copy of the newspaper. "I am only interested in preserving it, taking it away, rather than adding to it. This is how I want to preserve it."[4] Thus, the artist wishes her hand only to be evident in the technical sense of her careful recording of the newspaper's text. ✤ KB

1 Stefana McClure, telephone conversation with author, 29 April 2002.
2 Ibid.
3 Ibid.
4 Ibid.

Paul Mogensen

Born 1941, Los
Angeles, California,
works in New York City

66, top
no title, 1968
White acrylic and
graphite pencil on
cream-colored paper
22 × 30 inches

I n a 1967 dialogue with Brice Marden and David Novros, Paul Mogensen stated that in his work "order determines form without possibility of adjustment for visual considerations."[1] The artist uses a predetermined system of ordering, generally based on mathematical calculations, and ends with a visual statement larger than a classification of rules. Mogensen turns minimal geometric form into a powerful declaration about the beauty of mathematics. In this simple drawing, the viewer becomes immediately aware of the presence of white paint as an expressive element. Mogensen paints the white acrylic onto a darker cream-colored paper, drawing attention to the potentially dramatic qualities of a color generally deemed neutral or inexpressive. In his larger compositions, Mogensen often makes use of the gallery wall as a backdrop in dialogue with paintings, making the viewer especially aware of his or her position in space. Likewise, in this work he brings attention to the cream-colored borders of the painting as much as to the interior forms.

In this composition, Mogensen has drawn straight horizontal lines across the interior rectangle with a graphite pencil. He forms modular progressions, adding approximately an inch of space to the bottom of each tier as he ascends the composition. The effect is simple and calm. The painting thwarts illusionism and foregrounds visual sensation in an exploration of elementary geometric form.

Mogensen removes himself from subjective decisions with the mathematical concept. This move is itself a matter of choice but eliminates a subjective invention of form.[2] Freedom from the decision-making process is conducive to more spontaneous creation, and yet this work has a calming effect that draws attention away from mathematical concepts toward personal sensations. ❖ PW

[1] Carl Andre, "New in New York: Line Work," *Arts Magazine* 41 (May 1967): 49–50.
[2] Harris Rosenstein, "Paul Mogensen: An Observation on Method," in *Paul Mogensen: Paintings and Drawings 1965–1978* (Houston: The Museum of Fine Arts, 1979), 7.

67, bottom
no title, n.d.
Sumi ink on rag paper
22 × 30 inches

T his intimate ink drawing corresponds to a 128 × 310-inch canvas and was composed not as a preparatory sketch but as a later examination of the same principles that informed the earlier, larger work.[1] The harmonic progressions in this "dot dash" painting demonstrate the potential visual complexity of Paul Mogensen's geometric systems.[2] He establishes and follows rigorous mathematical rules in order to eliminate intuitive invention: Since the formula preexists the work, the execution is a visual discovery for the artist. Mogensen devotes equal attention to his materials and unmixed palette of colors. The artist refers to this technique as "rational subjectivity." His decisions of formula, material and color are made on a whim, but he strictly follows them and accepts the results.[3]

Mogensen studied the musical scores of Schönberg while attending the University of Southern California. And in this particular drawing, he translates the mathematical basis of three different harmonic progressions into a visual format. Although the painting appears flat, the viewer surmises a variety of illusionistic readings. The façade of a large building comes to mind, holding segmented offices with lights flickering off and on. The work also suggests an overhead view of a busy street, the blank spaces representing lines of traffic. Although the artist doesn't intend figuration, the work involuntarily suggests these references.

As an art student, Mogensen was fascinated by a particular black painting by Clyfford Still. Although Mogensen replaced Still's abstract suggestions of geological strata with hard-edge geometry, the effect of Still's uncompromising monochrome remains. Mogensen varies the number of coats of black paint on the canvas; one coat absorbs completely into the cloth, while three coats creates a thick reflective surface. This technique is less apparent in the drawing, which nonetheless still shows variations in paint application. Mogensen feels that a painting that is too regular or too perfect is lifeless.[4] Imperfections in the drawing, such as small smears or blobs of paint allude to the artist's touch. The artist does not date this work, because he doesn't want it read as an indicator of artistic evolution or as marking a specific time. Instead he wants the work evaluated ahistorically on its own intrinsic criteria to emphasize its timelessness.[5]

The strong opposition of black and white enhances the color of each and undermines the mathematical logic of the composition. Mogensen does not provide the viewer with conceptual information or mathematical formulas as to how the work was conceived. He provides no information through title or reference, and he gives no instructions. Instead, Mogensen allows the visual object to communicate the power of the ideas. ❖ PW

[1] Paul Mogensen, conversation with author, 21 March 2002.
[2] Harris Rosenstein, "Paul Mogensen: An Observation on Method," in *Paul Mogensen: Paintings and Drawings, 1965–1978* (Houston: The Museum of Fine Arts, 1979), 14.
[3] Mogensen, conversation.
[4] Ibid.
[5] Klaus Kertess, *Paul Mogensen* (Vienna: Wiener Secession, 1994), unpaginated.

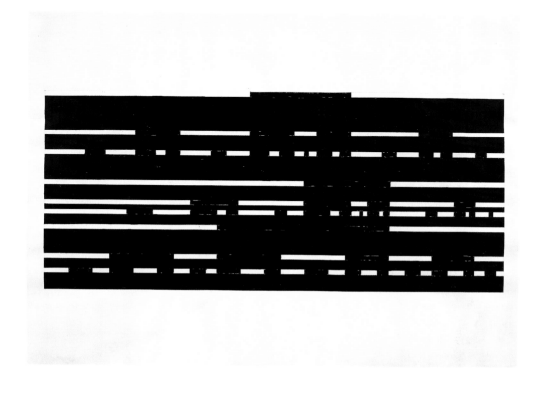

Robert Morris

Born 1931, Kansas City, Missouri, works in Gardiner, New York

68
Untitled, 1965
Pencil on gray paper
19 × 24 inches

Robert Morris's sketchbooks and preliminary drawings play a crucial role in the planning and development of his sculpture. According to the artist, "Any large project begins with drawings. Drawings and notes, an accumulation of verbal and visual signs, put down on successive pages of the notebook. Gradually the concept begins to emerge."[1] Morris's *Untitled* (1965) is a preliminary study for his first earthwork and thus represents an important foundation for his later developments in outdoor projects. J. Patrick Lanan commissioned the piece for a sculpture garden outside Miami.[2] The completed earthwork was to consist of earth and sod covered by a long stainless steel beam approximately two feet high and fifty feet long—the dimensions varying depending on the site.[3] Morris views this work as an outdoor extension of the plywood works he was constructing at the time.[4] He intended to create a sculpture that would broaden his existing vocabulary of minimal geometric form to incorporate the natural elements of earth and sod.

The artist planned numerous outdoor projects in the mid- to late 1960s and early 1970s. He felt that environmental sculptures could be liberated from the confining relationship between the art object and the restrictive museum space. Not only would the earth be a setting for the sculpture, it would be an integral component. According to Maurice Berger,

> By relocating art from the museum to the landscape, Morris's earth projects dramatically transcended the art world's institutional demands. Often assuming a labyrinthine structure and scale that would not allow the viewer to apprehend the entire work at once, such projects were neither earthworks nor sculptures; instead they existed somewhere between landscape and architecture, establishing a connection to the geological and temporal conditions of their setting.[5]

The sculpture derived from *Untitled* would be modest in comparison to the works Berger has in mind,[6] but it nonetheless communicates Morris's desire to supplant the museum environment with a natural one. The sculpture was to extend fifty feet and require that the viewer walk around the work, perceiving it over an interval of time.

In *Untitled,* a long plank veers diagonally back into the page, buttressed by an earthen mound. Morris illustrates the earth floor using discrete lines that become increasingly softer and shaded as they near ground and eventually dissolve into an undifferentiated mass. The multitude of tiny lines energetically animates the minimal beam. With this suggestion of movement, the artist turns from the static, orderly forms of minimalism to an almost animistic image. Unlike most preparatory drawings, the composition lacks any written directions, proportions or numeric guidelines, and this allows the drawing to exist independently from any particular work of sculpture. The artist also omits any indication of scale. The absent dimensions and indeterminate size of the object add a surreal ambiguity; the artist focuses solely on the object and not on its environment.

This drawing is composed and ordered by the beam placed atop a mound of earth, transforming a minimalist geometric vocabulary into an eccentric object. In terms of formal properties, the soft, fiber-like descriptions of the earth beneath the minimalist board anticipate the anti-form of Morris's felt and thread waste compositions. Relying upon earth materials as its base, however, this work appears more orderly than the anti-form pieces. The fibers do not spread across the room as in the thread waste and scatter pieces, nor do they maintain the physical integrity of the felt works.

As Morris's ideas changed over the course of the 1960s, his earlier minimalist doctrines evolved into a questioning of the nature of art. The artist developed the more organic, tactile aesthetic that characterized his outdoor projects and anti-form works, which often incorporated earth with other materials. Morris's involvement with loose and impermanent forms also expressed an interest in chaos, entropy and the psychology of vision. *Untitled* appears at a time in his work when Morris is experimenting with the dynamic union of a geometrically ordered minimalist beam with soft, palpable earth materials. He mixes opposites in this work, juxtaposing hard and soft form, order and disorder, steel and earth, geometric rigidity and organic fluidity. The organic presence of the work enlivens it, bringing together Morris's exploration of geometric form with his investigation of outdoor spaces and materials. ✤ PW

1 *Robert Morris: From Mnemosyne to Clio: The Mirror to the Labyrinth* (Lyon: Musée d'Art Contemporain, 2000), 202–203.
2 Diana Turco, electronic correspondence with author, 11 April 2002.
3 Robert Morris, electronic correspondence with author, 25 April 2002.
4 Ibid.
5 Maurice Berger, *Labyrinths: Robert Morris, Minimalism, and the 1960s* (New York: Harper and Row, 1989), 139.
6 In 1971, Morris was invited to the Netherlands to participate in the international exhibition *Sonsbeek 71.* There he executed his first outdoor composition, the colossal *Observatory* to which Berger refers.

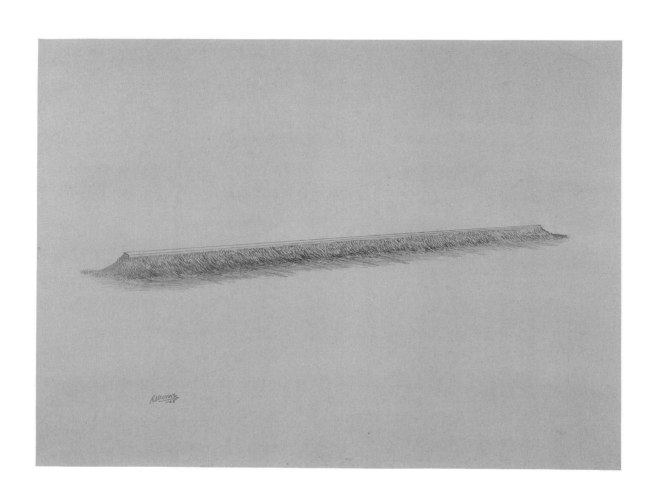

Bruce Nauman

Born 1941, Fort Wayne,
Indiana, works in
Galisteo, New Mexico

69
*Acoustic panels /
10 panels—4' × 8' each /
arranged in studio /
sept. 1969*, 1970
Pencil on paper
23 3/8 × 29 inches

Since the beginning of his career in the mid-1960s, Bruce Nauman's style has been defined more by "an aesthetic and intellectual sensibility" than by his materials, process or even continuity of appearance in the work itself.[1] Nauman's work frequently and uncomfortably infringes on the viewer's personal space or assaults the viewer's sensibilities with disturbing verbal expressions. His prints and drawings, generally studies for his sculptures and installations, explore the same themes: Disconcertingly suggestive ambiguities of word play, anti-narrativity, interest in the body and environments that manipulate the viewer.

As indicated by its inscription, Nauman's *Acoustic panels* (1970) documents a soundless arrangement of panels in his studio in September 1969. In December of 1969 he installed at the Galerie Ileana Sonnabend in Paris his first public *Acoustic Wall*, which incorporated sounds of breath, laughter, and pounding through speakers set into the wall.[2] As Pamela Lee explains, Nauman's acoustic installations are similar to his video corridors.[3] In both, Nauman transforms his viewer into a receptor who experiences his environment physically and psychologically. In *Acoustic Wall*, two walls *silently* converge.[4] According to Nauman,

> When the corridors had to do with sound damping, the wall relied on soundproofing material which altered the sound in the corridor and also caused pressure on your ears, which is what I was really interested in: pressure changes that occurred while you were passing by the material. And then one thing to do was to make a V. When you are at the open end of the V there's not too much effect, but as you walk into the V the pressure increases quite a bit, it's very claustrophobic.[5]

While *Acoustic panels* functions as a schematic record of a private installation, it also documents Nauman's continued experimentation with auditory environments in drawings and installations through the mid-1970s.[6] Its notation of ten four-by-eight-foot panels indicates the dimensions of *Acoustic*

Pressure Piece (1970), an installation in which the visitor passes through twelve- and twenty-inch spaces wherein Nauman has deadened the registration of sound (see below).[7] Like *Acoustic Wall* (1969–1970), the perception of sound (or lack of it) in *Acoustic Pressure Piece* differs according to the viewer's proximity to the panels, but the sensory experience is deliberately uncomfortable. ❖ AMK

[1] Neal Benezra and Kathy Halbreich, "Preface and Acknowledgments," in *Bruce Nauman*, ed. Joan Simon (Minneapolis: Walker Art Center, 1994), 8.

[2] Coosje van Bruggen, "Sounddance," in *Bruce Nauman* (New York: Rizzoli, 1988), 238.

[3] Pamela Lee, "Bruce Nauman," in *Drawing Is Another Kind of Language: Recent American Drawings from a New York Private Collection*, eds. Pamela Lee and Christine Mehring (Cambridge: Harvard University Art Museums, 1997), 146.

[4] van Bruggen, "Sounddance," 238.

[5] Ibid.

[6] Ibid., 279. The article includes a reproduction of Nauman's drawing, *Untitled (after Acoustic Pressure Piece)* (1975).

[7] Marcia Tucker, "pheNAUMANology," *Artforum* 9 (December 1970): 40. Tucker includes reproductions of the pencil drawing *Acoustic panels* and of the sculpture *Acoustic Pressure Piece*. Both appear with the date of 1970; however, Pamela Lee in her essay "Bruce Nauman" and Kathy Halbreich and Neal Benezra in the catalogue raisonne *Bruce Nauman* date the work to 1971 without clarifying the discrepancy.

Acoustic Pressure Piece, 1970, wallboard and acoustical material, 8 × 4 × 50 feet as captioned and reproduced in Marcia Tucker's "pheNAUMANology," *Artforum* 9 (December 1970): 40.

acoustic panels —
10 panels – 4 x 8 each –

arranged in studio
sept. 1969

20'

4' 4' 4' 4' 4' 4' 4' 4' 4' 4'

← 40' →

R. Serra Jan 70

Laurie Reid

Born 1964, Minneapolis, Minnesota, works in Oakland, California

70
In Memory of Fragrant Yellow Tea, 1996
Watercolor on paper
60 × 60 inches

Laurie Reid's watercolor drawing *In Memory of Fragrant Yellow Tea* (1996) arouses one's feelings about nature. Using faint, almost colorless brushstrokes of watercolor, Reid created simple repetitive curves that evoke gray mountains or waves, traveling horizontally over the off-white paper. The light, connecting and disconnecting curves are more water than color and seem to pucker the delicate paper. The rhythmic movements of the lines and the gray tonality produce a quiet tranquility. Reid has a passion for her materials: "As a child, I was absolutely absorbed by materials. I love the sensation of materials."[1]

The trace of water droplets along this drawing's top and bottom right edge reflect the work's spontaneity and the artist's presence. The subtlety of line, space and color manifest a minimalist formalist aesthetic but more importantly evokes the sensuality of sight and touch. The work's title makes clear the intention to capture the sensual quality of human memory—the fragrance and color of the yellow tea. In a 1998 statement, Reid said that her attention had shifted away from representational subject matter to an obsession with the way in which "water, atmosphere, gravity, paper and pigment intersect and interact with each other and with the artist."[2] For Reid, the process of making art "ultimately manifests some of the singular properties and the simple mysteries of the world we live in."[3] Through her materials Reid's art metaphorically and poetically materializes not only such elements as air, wind and water but also their human engagement by sight, touch and smell. ❖ LLT

[1] Kathan Brown, "Laurie Reid," *Crown Point Press Newsletter* (January 2001).
[2] Quotations are from Laurie Reid's 1998 application to the Society for the Encouragement of Contemporary Art (SECA).
[3] Ibid.

Dorothea Rockburne

Born 1932, Quebec, Canada, works in New York City

71

Triangle, Rectangle, Small Square, 1978
Vellum, colored pencil, glue, rag board, varnish
33 × 43 inches

Notes to Myself on Drawing:

1. How could a drawing be of itself and not about something else?

2. Construct an investigation of drawing which is based on information contained within the paper and not on any other information.

3. Thought acts upon itself.

4. It seemed reasonable that paper acting upon itself through subject imposed transitions could become a subject-object.

5. The subject-object draws on relationships which are not intrinsic to the thing itself, but rather which inform through some action imposed by the situation.[1]

By making the invisible visible, *Triangle, Rectangle, Small Square* (1978), one of eight works from the *Vellum Curve Series*, achieves Dorothea Rockburne's objective of a nonreferential drawing. This drawing is about itself as it communicates the process of its own creation through folds, material and color. It is the physical evidence of an idea, a subject-object that "draws relationships which are not intrinsic to the thing itself, but rather which inform through some action imposed by the situation."

In this series, Rockburne created vellum versions of earlier paintings made using the Golden Section. In this method, one divides a line so that the lesser of its two sections stands at the same ratio to the greater section as the greater section stands to the sum of both. It is an ancient mathematical method of arranging lines in an aesthetically pleasing way. The concept of this drawing relies on an equal coincidence of mathematical and aesthetic interests. *Triangle, Rectangle, Small Square* makes mathematics, a conceptual field normally conveyed through numbers and symbols, aesthetically evident.

Rockburne chose vellum paper because of its transparency. It simultaneously contains and reveals the process of its own creation through its folds. The artist never separates the line segments but rather layers each division atop another by folding the vellum and editing nothing. Rockburne folds to reveal rather than to conceal, and this is only possible because her chosen medium allows the viewer to see every fold as well as that over which it was folded. Thus, the artist forces contradictory lines to stand next to and on top of each other. Here, the fold both forms and informs the work, working as a material and a process.

To further illustrate the process, Rockburne inscribes bold lines and arcs of blue, copper, black and pink colored pencil within the boundaries of the composite vellum shape. Each color and each line enables the viewer logically to extract the original Golden Rectangles that the artist has formed and transformed. Rockburne states, "what the color does, in terms of identity and what it physically is, are not separate."[2] The colored outlines of the Golden Rectangles instead reveal and subsist as disclosures themselves. Each line, like each fold, supports both the structure and the process of the drawing. ❖ JEM

[1] Dorothea Rockburne in Jennifer Licht, *Eight Contemporary Artists* (New York: The Museum of Modern Art, 1974), 50.

[2] Jennifer Licht, "An Interview with Dorothea Rockburne," *Artforum* 10, no. 7 (March 1972), 35.

Winston Roeth

Born 1945, Chicago, Illinois, works in New York City

72, left
Untitled, 1988
Charcoal on handmade paper
31 1/4 × 23 inches

73, right
Circles (Light), 1996
Pastel on customized, resurfaced paper
35 3/4 × 26 inches

Unlike the minimalist emphasis on mundane materiality, Winston Roeth in the early 1980s sought a kind of romantic transcendence through materiality. One critic related his work to such current European artists as Wolfgang Laib and Gunter Umberg.[1] *Untitled* (1988) exhibits Roeth's persistent interest in geometry. Executed with charcoal on handmade paper, this drawing shows an enlarged stellar image, composed of three straight lines (an "X" bisected by a horizontal) intersecting slightly off-center. Roeth avoids dynamic composition, textured brushwork, illusionism or imagistic associations and instead deals with formal absolutes: Vertical, horizontal and diagonal lines, black and white colors and regular triangles of negative space. The work emphasizes simple forms and basic drawing materials.

Circles (Light) (1996) not only explores the formal possibilities of art but also aims to capture the intangible natural element of light. This drawing shows two colored circles: a gray circle inside a red one. The work's sole subject, the circles dominate the entire picture plane. In their interior, an empty rounded space glows with natural light, illustrating the title—*Circles (Light)*. Eschewing external reference, this composition forces on the viewer the proposition that art exists in a calm of contemplation and earthly detachment. When the flat surface seems to disappear into nothingness, it abandons materiality, seemingly shifting from conventional to metaphysical perception. The picture vibrates with the intensity of its colors, circles and light—unbounded elements with which the viewer can think, imagine and meditate.

Humans comprehend the world with symbols and images, language and sensation. Roeth's art destabilizes this convention because he presents only lines, colors and spaces rather than illusion. A viewer is given only the basic forms of a reductive geometric work and forced to find meaning on his or her own. It is a situation that raises the questions, What do we see when we look at a nonreferential form? What do we think we see? And what do we believe we know about it? ✤ LLT

[1] Stephen Westfall, "Winston Roeth at Stark," *Art in America* 79, no. 5 (May 1991): 170.

Ed Ruscha

Born 1937, Omaha, Nebraska, works in Venice, California

74
Self, 1967
Pastel and gunpowder on paper
14 ½ × 22 ½ inches

Ed Ruscha was born in Omaha, Nebraska, in 1937 and lived in Oklahoma City until he was 19. According to Ruscha, growing up in a city he described as "culturally impoverished" had a profound effect on his work.[1] He never visited museums as a child and had little exposure to so-called fine art. Instead, he absorbed an aesthetic language of billboards, logos and Western movies. The influence of this popular visual culture is evident in his works of the 1960s and 1970s. In paintings like *Actual Size* and *Annie*, as well as in books like *26 Gas Stations*, Ruscha dedicated himself to illustrating contemporary, prosaic subject matter like gas stations, brand name logos and everyday words and phrases. In an interview early in his career Ruscha explained, "I don't have any Seine river like Monet, I've just got US 66 between Oklahoma and Los Angeles."[2]

Ruscha regards this everyday material as cultural refuse. As he described it: "I have always operated on a kind of waste-retrieval method. I retrieve or renew things that have been forgotten or wasted."[3] By making simple but loaded words like "self" the subject matter of his drawings or paintings, Ruscha pulls the word away from the noise or hype that surrounds it in mass media. Lost in common phrases like self-help, self-serve and self-addressed, the idea of a self is the byproduct of the media that overproduce it. Ruscha recontextualizes the word and pulls it into focus, providing occasion to pause and reconsider the word produced anew.

Ruscha's use of words not only challenges what the words signify; it also disrupts expectations about what constitutes appropriate subject matter for a painting. Torn between studying commercial art versus fine art at the Chouinard Art Institute (now CalArts) between 1956 and 1960, Ruscha found a way to synthesize the two. As an alternative to the subjective, expressive application of paint endorsed by the abstract expressionists, Ruscha produced carefully planned paintings involving typography that imitated commercial logos. In these works, words take on the illusion of three-dimensional objects that have visual weight and yet still carry linguistic significations. Words as the subject of paintings then function as both visual subjects and abstract signifiers of meaning.

In 1967 Ruscha created a series of paper-tape drawings with pastels and gunpowder. Clean and precise, these drawings, including *Self* (1967), reflect Ruscha's commercial training; yet their unconventional material suggests a category more closely aligned with conceptual art (although Ruscha strongly resists such categorization). These drawings were clearly meant to function as finished works in themselves and not as studies for paintings. Ruscha noted, "To me drawings have always been for themselves, not studies for paintings."[4] Once the viewer pairs the medium, gunpowder, with the word illustrated, the next logical question is: How does the medium relate to the subject? In gunpowder drawings like *L'Amour*, the material seems to fit the subject. While teasing the audience with a deliberate double entendre, the key reference is to Louis L'Amour, a popular author of novels about the Old West. The material makes sense as a kind of physical trace of the subject matter L'Amour dealt with in his novels—gun fights between "Indians" and white settlers.

Likewise, another gunpowder drawing, *I Think There Is Something Dangerous Going on Here*, makes witty reference to the threat of the material shaping the letters. Yet the relationship of gunpowder to the subject of *Self* is less clear, leaving the viewer with more questions than answers. If the negative space that shapes the word is shaded with gunpowder, should the idea of self be perceived as explosive or dangerous? The thinness of the sheet of paper or tape that forms the word suggests a whimsical, unstable self that is perhaps even more threatened by the gunpowder that surrounds it. Is Ruscha illustrating a self liable to burn up or explode? Or need the word be directly related to the medium? Furthermore, to whom does "self" refer? The author? The viewer? What constitutes a self?

By provoking unanswerable questions, *Self* retrieves an ordinary word from its mundane usage. Dave Hickey suggests that the mystery of works like these lends them much of their power: "Never knowing for sure is the first rule in Ruscha's game of redeeming entropy, and unrequited conjecture is its primary pleasure."[5] ❖ SLE

[1] Edward Ruscha, "A Conversation between Walter Hopps and Edward Ruscha," in *Edward Ruscha: Romance with Liquids, Paintings, 1966–1969* (New York: Rizzoli International Publications, Inc. 1993), 100.
[2] Ibid.
[3] Edward Ruscha, interview by Bernard Brunon, in *Edward Ruscha* (Lyon: Octobre Desarts, 1985), 95.
[4] Ruscha, "A Conversation," 97.
[5] Dave Hickey, "Wacky Moliere Lines: A Listeners' Guide to Ed-werd Rewshay," *Parkett* 18 (1988): 29.

E. Ruscha 1967

Ed Ruscha

75
*Suspended Sheet
Stained with Ivy*, 1973
Gunpowder and ivy
stains on paper
14 × 22 ½ inches

nother gunpowder drawing, *Suspended Sheet Stained with Ivy* (1973), like *Self*, involves the illusion of a thin sheet of paper afloat in a shallow space; however, unlike *Self*, there are no words. Instead the faint stain of an ivy leaf smeared on the floating sheet of paper occupies the center of the image. Other stain drawings from 1973 feature blood and grass stains. All of these drawings were created during the period 1970–1975, when Ed Ruscha temporarily stopped painting and instead "stained" fabric with juices like blueberry, cherry extract or egg yolks mixed with various materials like cilantro. For the Thirty-fifth Venice Biennale of 1970, Ruscha filled a room with sheets of paper stained with chocolate. Ruscha explained that his turn toward stains had to do with his dissatisfaction with painting,

> For a whole year I couldn't paint. It was 1970 and I didn't do any painting. It was the idea of putting a skin of paint to the canvas support, I would stain the surface, so it was another way out of this box I had painted myself into. I was in a corner and this was the most logical thing, and it involved liquids. Now where does that come from?[1]

In typical Ruscha style, he does not answer his own question but only explains that liquids were important to him.

Although it is unclear from where his obsession with liquids derived, Ruscha's use of stains is consistent with his theory of his artistic project as trash retrieval. Stains are literally leftovers and usually involve the ruin of that with which they come into contact, such as stained clothing. With his use of words, Ruscha decontextualizes an everyday material by concentrating on it with a focus that dissociates it from its surroundings. The artist has stained a sheet of paper with ivy, and then he has drawn the three-dimensional illusion of a sheet of paper around the stain. Ruscha creates an image of the drawing itself—a drawing of a drawing with a stain on it. The stain is caught in a space where, like a hologram, one moment it is flat on the original piece of paper, and the

next it is seen from a side angle floating on an illusionistic image of a sheet of paper. Like the word "self" which hangs in limbo between a material object and an abstract concept, it is difficult to perceive the stain as both real and an illusion at the same time. The viewer has to question what is real and what is merely realistic, that is, what only imitates reality through illusion.

An admirer of both Marcel Duchamp and Kurt Schwitters, Ruscha found new ways to articulate elements of their artistic projects. When asked what Duchamp's greatest contribution to art was, Ruscha replied:

> That he discovered common objects and showed you could make art out of them.... He played with materials that were taboo to other artists at the time; defying convention was one of his greatest accomplishments.[2]

Like Duchamp, Ruscha defies convention with the use of "taboo" materials like ivy stains, blood and chocolate. And along the same lines, like Schwitters, he literally transforms trash into art. Yet, Ruscha not only challenges convention by introducing the unconventional; he challenges our ability to find concrete meaning in his work. As if to ensure the continued bafflement of the viewer, Ruscha again leaves us with the question: Why gunpowder? What do ivy stains and gunpowder have to do with each other? Is there a visual pun we are missing? Or is Ruscha simply insisting on the impossibility of finding satisfaction in rational answers? By using gunpowder as his medium in this series, regardless of the subject matter, perhaps Ruscha is deliberately mirroring the often arbitrary yet formulaic character of popular visual culture. ❖ SLE

1 Edward Ruscha, "A Conversation between Walter Hopps and Edward Ruscha," in *Edward Ruscha: Romance with Liquids, Paintings, 1966–1969* (New York: Rizzoli International Publications, Inc. 1993), 103.
2 Edward Ruscha, "Interview with Ed Ruscha and Bruce Conner," interview by Elizabeth Armstrong, *October* 70 (fall 1994): 56.

Ed Ruscha

76
Gray Sex, 1979
Pastel on paper
23 1/8 × 29 1/8 inches

In explaining how he chooses words to draw and paint, Ed Ruscha explained, "Words have temperatures to me. When they reach a certain point and become hot words, then they appeal to me."[1] In *Gray Sex* (1979), Ruscha renders "sex," a hot word, cold. *Sex* is perhaps one of the best and most complex examples of Ruscha's ability to recontextualize a word. Ironically, the word "sex" is so charged that it is almost impossible to see it clearly. While it blinks in neon lights, suggests scandal and is whispered in front of children, Ruscha lays "sex" bare. In fact, he deconstructs the word into its most literal components—not just letters but parts of letters.

Ruscha's technique is simple. Rather than drawing the word, it seems that Ruscha stuck separate pieces of tape directly onto the paper, near each other but not connecting, and then rubbed pastel over the entire sheet. He then lifted the tape, leaving clean, sharply defined rectangular shapes that when viewed as a group register as the word "sex." Unlike *Self*, the word remains flat on the surface of the paper with no illusion of space. The broken pieces of the letters suggest a kind of sterile, deconstructed sex. The neutrality of the color and the simplicity of the technique make the word visible and material rather than allusive. But is the word more than its material components? Is it a visual pun for boring sex? Could it be about ambiguous gender? While Ruscha, as usual, does not provide answers, he has succeeded in making the word visible for interrogation. ❖ SLE

[1] Yve-Alain Bois, "Thermometers Should Last Forever," in *Edward Ruscha: Romance with Liquids, Paintings, 1966–1969* (New York: Rizzoli International Publications, Inc., 1993), 20.

Robert Ryman

Born 1930, Nashville, Tennessee, works in New York City

77

Untitled, 1961
Pencil and gouache on wove beige paper
18 3/4 × 18 3/4 inches

Having given up a career as a saxophonist, Robert Ryman arrived in New York in 1952 and found work in 1953 as a guard at the Museum of Modern Art.[1] It was the heyday of abstract expressionism, and after some time in the presence of the museum's paintings Ryman himself decided to start painting. Ryman rejected the idea of art as a record of the artist's introspective struggle with the external world; his art relates to the artist's representation of paint, brushstrokes and materiality—the elements that constitute the image of painting. Ryman proposed an aesthetic in which art concentrates on itself alone, its materiality and the process of making it.

Ryman's *Untitled* (1961) demonstrates this approach, emphasizing the materiality of art. In this subtle drawing, a square outlined in black on a slightly off-centered grid is filled in with white gouache, over which Ryman has scattered a collection of marks and forms. Multiple irregularities in the squares within the larger square, the grid lines and the loose shapes, dominate the interior of the grid and become the subject matter of the drawing. The images make no reference to any natural forms; they derive purely from the artist's interaction with the physical presence of the materials. Furthermore, two vertical stacks of graphite marks—lined along the upper and lower left edges—transgress the outlined boundary of the square and spill over onto the raw sheet that frames it. The quantity and variety of marks, with the mixed gouache and graphite surface, seem textured and sensual. While Ryman makes this drawing look effortless and casual, he in fact has carefully calculated its balance and cohesion. But the subtle calibration of the work is worked out as he goes along. As Ryman pointed out, "When I begin, I'm never quite sure what the result is going to be…I don't have a plan…I have…a certain feeling of what I want."[2]

Ryman composed this drawing in three layers, and his attention to detail demonstrates his idea of process and materials as subject. The underpainting consists of various pencil drawings of subtly irregular squares, grid lines and loose shapes. Ryman painted over these pencil drawings with a thick white gouache, showing traces of the time elapsed during the execution of the work. The translucent white is the second layer of the drawing. The vertical stacks of graphite marks look fresh over the chalky white; they are the final, third layer of the work, although some of the grid lines that extend beyond the central square are also fresh and on the surface. Even if the images and textures of each layer are different, they are unified by similar materials and coexist on the same picture plane. This dynamic composition, as it demonstrates the artist's process of thinking, constitutes the main subject of the drawing.

Ryman's work focuses on an aesthetic of self-sufficiency, the autonomous experience of art. There is no illusion, no myth, no metaphor, no symbolism. The image of the drawing comes from the realistic representation of each material because it analyzes the physical reality of material manifest in lines, white gouache, grids and graphite marks. This analytical and process-oriented approach suggests that art is what you see and that simply seeing what is there is profound. ✣ LLT

[1] Robert Storr, exhibition brochure, *Robert Ryman: Paintings 1955–1993* (New Jersey: The Star-Ledger, 1999), 2.

[2] Robert Ryman, "Interview with Robert Ryman," interview by Phyllis Tuchman, in Gary Garrels, *Robert Ryman* (New York: Dial Art Foundation, 1988), 22.

Robert Ryman

78
Core XII, 1995
Encaustic, graphite
pencil and crayon on
corrugated cardboard
19 1/4 × 19 1/4 inches

In the 1980s and 1990s, Robert Ryman's work engaged more with nuances of his manipulation of art materials than the tactile physicality and mark making that preoccupied him in the 1960s. This subtle change conveys a poetic and lyrical shift in Ryman's later work and suggests a new relationship between the work of art and its viewer. *Core XII* (1995) demonstrates this change.

The artist created this collage-like work in encaustic with graphite pencil and crayon on corrugated white cardboard. In this drawing, horizontal graphite lines are overlaid with warm white encaustic that serves as an underpainting. Ryman's encaustic technique consists of painting with a mixture of oil pigments, refined white molten beeswax and resin. The translucent white wax does not create the strong, sensuously tactile, gestural style that it often does in Ryman's work of the 1960s, where the encaustic accentuates each distinct brushstroke. This thin wax with its neutral color and consistent quality instead seems harmoniously to unify the surface elements. Ryman's manipulation of encaustic is lyrically beautiful. The simple clarity of the construction and materials reflects his emphasis on painting as a reflection on painting.

In *Core XII*, Ryman loosely sketches with white crayon in the center of the grid, stopping and starting unevenly at the right and left edges. He also mysteriously raises the corrugation pattern from beneath the paper's surface, as the warm wax slightly darkens the protuberant ridges beneath. The composition absorbs these very subtle horizontal stripes as yet another layer of technical fascination. His technique remains mysterious in part because one cannot quite see how it was done. At some point in the process the board gently was run through a press. And given how the front and back of the cardboard are pressed to a fine edge in alternating dashes, it would seem to have been cut by the teeth of a stamping machine.

Ryman has said that white carries no symbolic or referential quality for him at all, "it's to make it clear that I use white; it's so that everything will be visible."[1] Free of symbolic associations, Ryman's use of white crayon over the refined white transparent wax creates poetic emptiness or silence. Everything here points us to the pleasure in the physicality of the craftsmanship and materials. This, in itself, revises the relationship between the viewer and the work of art. The viewer no longer passively receives visual information but actively observes, critically rethinking and reconstructing, in his or her own mind, precisely how the work was made. ❖ LLT

[1] Thomas McEvilley, "Absence Made Visible," *Artforum* (summer 1992): p. 96.

Fred Sandback

Born 1943,
Bronxville, New York,
works in Rindge,
New Hampshire,
and New York City

79
Situations, 1970, 1970
Pastel or ink and
graphite on paper
9 × 11 ¾ inches each

Untitled (1973) and the series *Situations 1970* address the same issues of space that concerned Fred Sandback when he created installations of string stretched across and between gallery walls. However, the lack of diagrammatic detail in these drawings suggests they are more than plans or schematic views. Sandback labels no lines here; there are no measurements of any kind. As the artist sees it, "a set of previous measurements can only be a hindrance."[1] Eliminating any reference to a particular environment, Sandback allows the drawing to exist as more than an installation plan.

> What I object to in a lot of art is its illustrative quality, the quality of being an execution of an idea. I don't have an idea first and then find a way to express it. That happens all at once. That notion of executing an idea is the same as giving form to a material, and it's a confusion of terms. Ideas are executions."[2]

These drawings are thus both a documentation of an installation and a meditation on an idea.

In the five-part *Situations 1970*, Sandback concerns himself with the entire space of the gallery, taking extreme care to interpret its specific configurations and sketch each wall. Each of the five drawings in this group shows a different installation, as is indicated by the varying colors of lines running through the envisioned gallery, from gray to blue, yellow and black. The drawings themselves have relatively little difference between them; they are almost serial in their arrangements of rectangular spaces on the page. Sandback does not use shading to indicate boundaries or solidity but instead draws faint open lines to indicate walls. As a result, the space remains open and indeterminate.

These five drawings also illustrate Sandback's concern with breaking free from the rectangle, which restricts the art object to the framed space and, thus, a structured state of mind. For most artists, as Allan Kaprow has written, the artwork is "made in a rectangular studio, to be shown in a rectangular gallery, produced in a rectangular magazine, in rectangular photographs, all aligned according to rectangular axes, for rectangular reading movements and rectangular thought patterns."[3] Sandback sought to define volume without the pictorial characteristics of sculpture.[4] His drawings and installations first delineate the rectangular environment or format and then destroy it by cutting it with a drawn line or an installed thread, angled across the architectural space.

In drawings like *Untitled* (1973) (see page 139), Sandback generalizes the spatial context even more than in *Situations 1970*, where he indicates the specific proportions of the installation space. Here he draws a simple corner as a backdrop to the one vertical and two horizontal lines. The space is not distinctive; it could be any corner, but Sandback's idea of the work's relation to the generic corner is immutable. The drawing exists ambiguously, neither on the flat plane of the two-dimensional paper nor in a palpable three-dimensional space. ❖ JEM

[1] Fred Sandback, "Lines of Inquiry," interview by Joan Simon, *Art in America* 85, no. 5 (May 1997): 89.
[2] Fred Sandback, "Notes," in *Fred Sandback* (Munich: Kunstraum München, 1975), 11.
[3] Allan Kaprow, "The Shape of the Art Environment: How Anti-form is 'Anti-form'?" *Artforum* 6, no. 10 (summer 1968): 32.
[4] Sandback, "Lines of Inquiry," 88.

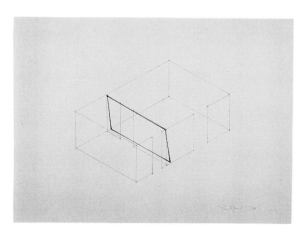
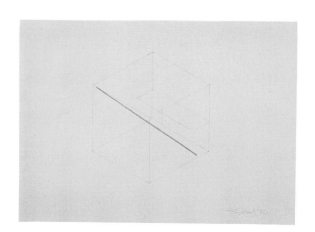
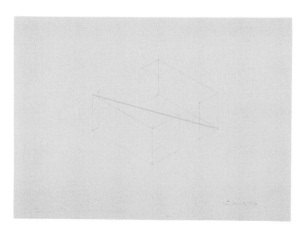
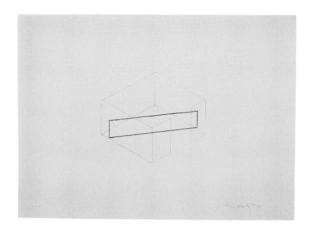

Fred Sandback

80, top
Untitled, 1973
Felt tip pen and
pencil on paper
11 × 14 inches

81, bottom
Untitled, 2000
Colored pencil, graphite
and ink on board, triptych
11 × 20 7/8 inches

Like Fred Sandback's work of the 1970s, *Untitled* (2000) acknowledges the line as the defining element of space. Drawn lines traverse this arrangement of rectangles on three board panels. The boundaries of the rectangular boards can neither contain nor control the nature of the line. Pastel, graphite and ink lines coexist with linear cuts that Sandback said he "generated out of nowhere."[1] The ideal arrangement of these pieces, with the boards mounted onto a lighter background, draws equal attention to both the lines drawn onto the boards and those created by the space between them. A difference in thickness between the gray boards and their white background casts shadows around the edges similar to the drawn and cut lines.

The artist's arrangement of the boards references the tripartite form of Renaissance altarpieces, which combined painting and sculpture. Renaissance artists were among the first to explore one-point perspective and to venture to transpose convincing three-dimensional illusion onto two-dimensional surfaces. The format of three-dimensional panels bearing two-dimensional paintings overcame the limitations of pictorial flatness and disproved the mutual exclusivity of painting and sculpture. Sandback attempts to escape the boundaries of rectilinear space and the picture plane. His dedication to the liberation of linear, pictorial and architectural space has remained central to his work. In this drawing, he successfully challenges the containment of the line, which ranges uncontrolled over the two-dimensional space and seems to act on its own accord. ❖ JEM

[1] Fred Sandback, "Lines of Inquiry," interview by Joan Simon, *Art in America* 85, no. 5 (May 1997): 88.

Erik Saxon

Born 1941, San Francisco, California, works in New York City

82, left
Untitled, 1974
Graphite on vellum
18 × 18 inches

83, right
Untitled, 1989
Oil on Arches paper
30 × 22 inches

As a critic, Erik Saxon theorizes in writing about his ideas of a pure abstract art. As an artist he draws his ideas. Together the two practices form a complete and integrated discourse about his art, and like many artists Saxon is quite self-conscious about such issues as authenticity in his personal practice and his relationship to the history of art. *Untitled* (1989) is a highly conceptual work of minimal monochromatic painting. There is nothing but a white quadrilateral on the paper. The work compels the attention of the viewer to what at first appears to be an imageless picture, until gradually a white on white rectangle emerges. The internal variation, surface texture and tone all grow increasingly unfamiliar and distinct the more they are scrutinized. Although the form is simple, this drawing is difficult to fathom.

Lucy Lippard once wrote that "white paintings" were generated simply by a desire to make paintings, and that the paintings' meanings rest in a silent, blank nothingness.[1] Lippard's models were Robert Ryman and Kasimir Malevitch. Indeed, primal forms and monochromatic painting, which aimed to break the traditional composition and pictorial space with their singularity and nonillusionism, were widely explored at the time Lippard wrote in the late 1960s. Saxon was of course familiar with these works when he made his drawing in 1974, and he consciously addressed these early monochromatic paintings with his own. For Erik Saxon, theory and practice are inseparable.

In 1983, Saxon wrote an important review of three abstract artists working in New York: Nancy Haynes, Paul Mogensen and César Paternosto. In the article, he summarized his thinking on "primal forms and primal divisions," and his statement serves as a note on his own drawings,

> Primal forms and divisions can be defined as shapes that transcend time and place; the forms, which are seen in prehistoric wall drawings, in primitive art, and in religious art, are the square, the circle, the triangle, the spiral, and the cross. The quarterly division of the square or circle by a vertical and a horizontal and the nice square division are primal divisions. Primal forms and divisions usually have symbolic meanings which vary with culture. The crossing (cross) of the vertical and horizontal can represent the union of two opposing forces.[2]

In *Untitled* (1974), Saxon establishes a regular grid of pencil lines which form nine squares. He fills in a horizontal row of the central three, leaving precisely defined spaces between them. In the upper row of three he fills in only the spaces on either side of each square, but here too the dark lines have an almost mechanical perfection to their edges. Despite the systemic unity of the grid and the reductive simplicity of the compositional components—only black and white, only squares, in one size, and lines equivalent to the square edges—the pattern is complex. Saxon's drawings are carefully premeditated works, as though each is the necessary result of mathematical calculation. ❖ CW

[1] Lucy R. Lippard, "The Silent Art," *Art in America* (January-February 1967): 61.

[2] Erik Saxon, "Primal Forms and Primal Divisions," *Appearances* (winter 1983–1984): 67–71.

Carole Seborovski

Born 1960, San Diego,
California, works in
New York City

84
*Thinking About Mu Ch'i's
Six Persimmons*, 1985
Charcoal and pastel
on paper
19 × 25 ½ inches

Thinking About Mu Ch'i's Six Persimmons (1985) combines clear geometric form with indistinct distortion and haziness, inviting spiritual and mystical readings. Carole Seborovski has constructed four vertical rectangles on a large, monochrome field. The rectangles progressively lighten in color from the left rectangle's deep black to a dark blue, then lighter blue to a soft, pastel blue. The artist forcefully builds up the black rectangle while the lightest blue rectangle appears the least labored. She also modulates the geometric ordering of the composition by placing the second rectangle lower than the other three. Instead of constructing sharply defined geometric forms, a slight mist of color surrounds each box, undermining any notion of solidity. Each rectangle stands in a state of transition, as if unstable and ready to dissolve. In comparison with her heavily worked *Red Line—Graphite Painting*, this drawing exhibits a more ephemeral effect.

Traces of folds in the paper demonstrate the artist's process in establishing the lines and reference her presence. Seborovski views drawing as an independent medium and values the flexibility of paper. As she explains it, "paper is an extremely manageable material that can be easily folded, cut, torn, bent, glued, and collaged. Its most endearing characteristic is its unassuming quality." The soft texture of the paper in this composition allows for hazy and subtle visual effects. The size of the composition, nineteen by twenty-five inches, corresponds to the artist's desire for control and her sensitivity to small detail. She doesn't allow the scale of the work to extend beyond the length of her arms, allowing intimacy and manageability.[1]

Seborovski uses the square and rectangle to represent materiality in a personal examination of the immaterial. The artist has studied and frequently makes reference to the Spontaneous Style of Song painting.[2] This drawing's title alludes to Mu Ch'i, a thirteenth-century Chinese artist who founded a school of Buddhist painting at the Lui-tung temple-monastery in Japan.[3] Mu Ch'i's famous Zen painting *Six Persimmons* foregrounds formal process and compositional harmony over subject matter. The six persimmons, four in solid black ink and two transparent, rest upon a hazy color field of blue and green. Just as Mu Ch'i places one persimmon lower than the rest in a diaphanous color field, Seborovski borrows the artist's color softness and organization to assert a harmonious equilibrium. Mu Ch'i joins material form with the immaterial by placing the persimmons in an ethereal setting.

Seborovski borrows an interest in formal dissolution from Mu Ch'i but sets her forms in a western minimalist grid. She often evokes the spiritual through circles, crosses and diamond shapes.[4] Here she relies upon the softly fading forms of rectangles on a misty monochromatic field, creating, after Mu Ch'i, a space between material substance and enigmatic immateriality. ❖ PW

[1] Judy Van Wagner, *Lines of Vision: Drawings by Contemporary Women* (New York: Hudson Hills Press, 1989), 122.
[2] Steven S. High, *Surface and Intent* (Virginia: Anderson Gallery, 1989), 23.
[3] Ibid.
[4] Ann Wilson Lloyd, "Carole Seborovski at Karsten Greve," *Art in America* (December 1992): 124–125.

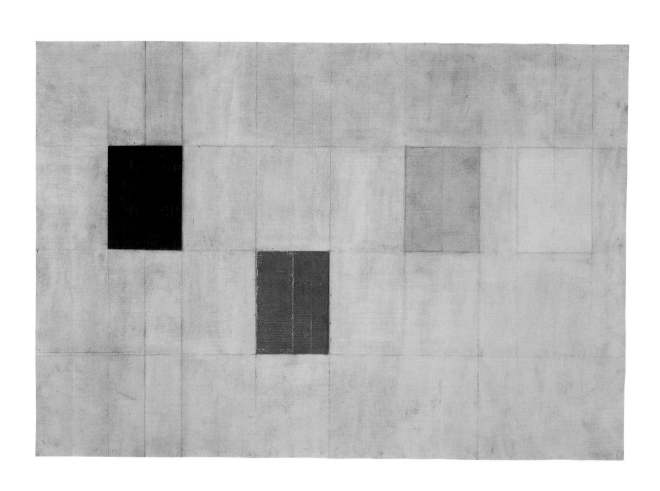

Carole Seborovski

85
Red Line—Graphite Painting, 1989
Graphite acrylic on charcoal paper
8 1/8 × 10 1/4 inches

My work embodies a series of decisions both logical and illogical. Making art is an act in which to bring these seemingly chaotic decisions into a composed state of being.[1]

Carole Seborovski's statement refers to both the rational and irrational elements of *Red Line—Graphite Painting* (1989), which displays a controlled ordering of geometric form alongside an obsessive process of building up thick layers of graphite. Ostensibly simple and undemanding, the work includes a deeply spiritual dimension. At first glance, the drawing appears to be a monochrome gray rectangle horizontally intersected by a thin red line. But the composition's gray field is not as lifeless as it might initially seem. Its built-up layers of graphite create a lush, reflective surface. In addition, three rectangles grow progressively smaller as they approach the center of the composition. In the center, a rectangle collaged to the surface slightly protrudes from the seemingly flat composition. A vertical red line painted over with gray acrylic bisects the horizontal red stripe. The vertical component all but dissolves into the monochrome gray in a light, palimpsest effect, while the warmth of the horizontal red line glows against the darkness of the graphite, which the artist manipulates in a sophisticated and mysterious way.

Seborovski affirms the physical character of her materials through her labor-intensive process. The work articulates the heaviness of graphite and the time-intensive building of the dense layers. Yet the very nature of Seborovski's painstaking process suggests an almost meditative repetitiveness in the drawing's construction. According to Ken Johnson, "[Seborovski's] involvement with processes—applying charcoal, graphite and ink and cutting and pasting paper—may be thought of as a kind of spiritual communion with the material world."[2] Seborovski collaborates with her materials, as if they are an extension of her. The material forms thus surpass the everyday, evoking physical and spiritual sensations, suggesting both corporeality and transcendence. ❖ PW

1 Carole Seborovski, "Artist's Statement," in *The New Generation* (Bridgehampton, N.Y.: Elaine Benson Gallery, 1988), unpaginated.
2 Ken Johnson, "Transcendental Materialism: Carole Seborovski's Recent Work," in *Carole Seborovski* (Köln: Galerie Karsten Greve, 1992), 37.

Richard Serra

Born 1939, San Francisco, California, works in New York City

86

Untitled (Study for "To Encircle Base Plate Hexagram, Right Angles Inverted"), 1971
Black oilstick on paper
41 1/4 × 29 3/4 inches

Untitled (1971) is one of several drawings executed following Richard Serra's 1970 installation of *To Encircle* in a dead-end street in the Bronx. A departure from his typical outdoor commissions, which usually dominate highly visible public spaces, *To Encircle* was denied the level of attention enjoyed by other of Serra's controversial works precisely because of its location. Douglas Crimp has noted that because of that work's "sinister" location in the Bronx, *To Encircle* became recognizable to the art world primarily through photographs.[1] When one approached the twenty-six-foot steel circle, it was hardly visible in the rough concrete surface of the street. Nevertheless, by positioning it in the middle of a street where parked cars would frame it on either side, Serra achieved a spatial definition in this sculpture that related to his other works. In his subsequent drawing *Untitled* (1971), the artist concentrates specifically on the composition of the sculpture, joining his interest in weight and materiality to expose the provocative hostility inherent in the original work.

Serra claims that his drawings are "the result of trying to assess and define what surprises me in a sculpture."[2] This drawing highlights key parts of *To Encircle* that might be difficult for one to perceive even at the site of the work.[3] It captures the elements of precision and weight that made this sculpture intriguing despite its subtle placement in the ground. Heavy black lines signify one half of the inverted steel rings that were visible on the pavement; hatch marks indicate the embedded lead. In the drawing, Serra demonstrates the composition of *To Encircle* independent of its setting to exhibit the internal positioning and relationship of the compositional parts. The exclusion of depth-defining markings conveys a sense of the work's flatness. A formal language of dark, broad lines articulates the weight of the material, while the lines' rough sketchiness indicates the conceptual nature of the drawing as it relates to the redefinition of site in the outdoor sculpture. ❖ KB

1 Douglas Crimp, "Redefining Site Specificity," in *October Files: Richard Serra* (Cambridge: The MIT Press, 2000), 159.
2 Richard Serra, "Notes on Drawing," in *Richard Serra: Writings, Interviews* (Chicago: University of Chicago Press, 1994), 181.
3 Christine Mehring, "Richard Serra," in *Drawing Is Another Kind of Language: Recent American Drawings from a New York Private Collection*, eds. Pamela Lee and Christine Mehring (Cambridge: Harvard University Art Museums, 1997), 164.

To Encircle a Base Plate Hexagram, Right Angles Inverted, 1970, steel, 312 inches in diameter with a one-by-eight-inch rim, installed in Bronx, New York.

Richard Serra

87
Untitled, 1976
Litho crayon and
litho ink on paper
40 ½ × 30 ¾ inches

My preoccupation with site and context was parallel in drawing, in that my drawings began to take on a place within the space of the wall. I did not want to accept architectural space as a limiting container. I wanted it to be understood as a site in which to establish and structure disjunctive, contradictory spaces.[1]

In *Untitled* (1976) Richard Serra triumphs over architectural limitations by creating a site-defining drawing that captures the viewer's attention in a way similar to that of his monumental sculptures. With this large drawing Serra extends his interest in spatial definition. Drawn on thick paper and executed with black litho crayon, the work belies the notion that weight cannot be achieved on paper. The off-centered circle dominates most of the paper, its prevalence on the paper's surface emphasized by an outline in litho ink that defines the outer edges of the black shape. Concentrated layers of black crayon create a waxy surface that makes the weight of the blackness even more tangible.

Serra claims there are no illusionist strategies in his drawings. However, one cannot be in the presence of a work like *Untitled* without feeling drawn to the powerful black circle that lures the viewer in with its illusion of physical weight.[2] Serra's earlier sculpture *Delineator* (1974–1975) organized space in a room such that its visitors were frightfully aware of their confinement between the lead slabs hovering above and below them. Like *Delineator*, *Untitled* creates a tension with the viewer that is felt at first contact. Because of the even, saturating distribution of black litho crayon, the circle appears almost to occupy a space apart from the surface of the paper. This is one of Serra's most intriguing works on paper, achieving the gravity and impression of an object, while staying true to abstract principles in drawing and painting. ❖ KB

1 Richard Serra, "Notes on Drawing," in *Richard Serra: Writings, Interviews* (Chicago: University of Chicago Press, 1994), 178.
2 Paul Collins, "Richard Serra," in *Minimalism and Post-Minimalism: Drawing Distinctions* (Hanover, N.H.: Hood Museum of Art, Dartmouth College, 1990), 56.

Richard Serra

88
Videy Drawing XII, 1991
Paintstick on German
etching paper
18 1/2 × 25 1/2 inches

nstalled on Iceland's Videy Island, Richard Serra's site-specific sculpture *Afangar* arranged columns of basalt rock across the island's vast expanse of hardened lava. Serra's site-specific sculptures are often placed in urban settings of concrete, which perhaps predisposed him to the island's rocky grayness. In a discussion about *Afangar*, he described the importance of the space of the island and how he used the basalt columns as a way to come to terms with the "strangeness" of its landscape,

> The Icelandic landscape is radically different and varied in its proportions; to put it simply, it is "another" space. I made no secret of the fact that I was in awe and that I wanted to explore the possibility of working in this landscape rather than to build a sculpture for the museum or the city.[1]

The meaning of *Afangar* as translated by Serra is "stations, stops, on the road, to stop and look forward and back, to take it all in."[2] He arranged his stone columns in pairs along the island's edge, where their straight lines mark and define the landscape.[3]

Serra's drawings after this 1990 installation are among the largest bodies of drawings the artist has produced in relation to a single sculpture. In *Videy Drawing XII* (1991), he focuses on rendering the weight and texture of the basalt rock, whose graininess reflects the surface texture of the island. Two monumental forms dominate the composition, giving an impression of broad, roughly hewn stone (which contrasts with how the tall, narrow columns appear in photographs). The monoliths are rendered in heavy, black paintstick on rough paper. This magnified engagement with the stone emphasizes the material's surface and character, its coarseness and weight. Serra primarily features the rough outlines of the stones, but his technique makes the viewer aware of the work as a two-dimensional drawing while building up a three-dimensional texture that hints at the materiality of rock. He signals the disposition of the sculptures in space by creating a second, lighter stone behind the larger, heavier one. He even uses a touch of orange highlight to create space-defining shadows. These subtle gestures give the viewer a sense of walking around and among these stones, as one might encounter them in the island landscape. ❖ KB

[1] Richard Serra, *Interview*, interview by Mark Rosenthal, in *Richard Serra: Writings, Interviews* (Chicago: University of Chicago Press, 1994), 247.
[2] Ibid., 248.
[3] Pamela Lee, "Richard Serra," in *Drawing Is Another Kind of Language: Recent American Drawings from a New York Private Collection*, eds. Pamela Lee and Christine Mehring (Cambridge: Harvard University Art Museums, 1997), 168.

Afangar (1990), basalt stone in nine pairs on two contour elevations, nine stones, 118 x 24 x 24 inches, and nine stones, 157 x 24 x 24 inches, Videy Island, Reykjavik, Iceland.

Richard Serra

89
*Study for Two Forged
Rounds for Buster
Keaton*, 1991
Paintstick on paper
19 ½ × 27 ¼ inches

n an interview with Lizzie Borden, Richard Serra declares that, "the aesthetic experience of the work is concomitant with its form. How the artist makes a drawing gives to the work its credibility, distinctness, uniqueness— its character."[1] In this drawing, Serra refers to a large, forged steel sculpture in the form of two 64 by 89-inch cylinders, installed in the Gagosian Gallery in 1991. Serra, who is known for creating drawings after his finished work, emphasizes the distinct relationship of the audience to the two large forms by outlining them in profile.

The forms on paper are rendered in broad, black strokes of paintstick. Serra's execution of black paintstick against the stark white of the paper gives the viewer the sense of the weight and bold presence the work must have generated in the gallery. As Christine Mehring has noted about a similar drawing by Serra based on the same sculpture, the dark outlines indicate the forging process the steel underwent during the work's production, wherein the edges of the rounds darkened first as they cooled.[2]

The square shapes of the two forms imply that Serra sketched the rounds from a side angle, emphasizing their width. A second, fainter box shape loosely drawn like a shadow around the dark lines gives a sense of the sculpture's three-dimensionality. In contrast to works of art wherein the viewer is the beholder of the art object, Serra's rounds dominate the space of the gallery and the viewer. ❖ KB

[1] Richard Serra, "About Drawing: An Interview," interview by Lizzie Borden, in *Richard Serra: Writings, Interviews* (Chicago: University of Chicago Press, 1994), 52.

[2] Christine Mehring, "Richard Serra," in *Drawing Is Another Kind of Language: Recent American Drawings from a New York Private Collection*, eds. Pamela Lee and Christine Mehring (Cambridge: Harvard University Art Museums, 1997), 170.

Two Forged Rounds for Buster Keaton, 1991, forged steel, 64 x 89 inches each, installed at Gagosian Gallery, New York.

Robert Smithson

Born 1938, Passaic,
New Jersey, died 1973

90
Juggernaut, 1970
Graphite on paper
11 ½ × 17 ½ inches

One's mind and the earth are in a constant state of erosion, mental rivers wear away abstract banks, brain waves undermine cliffs of thought, ideas decompose into stones of unknowing, and conceptual crystallizations break apart into deposits of gritty reason....This movement seems motionless, yet it crushes the landscape of logic under glacial reveries. This slow flowage makes one conscious of the turbidity of thinking. Slumps, debris slides, avalanches all take place within the cracking limits of the brain. The entire body is pulled into cerebral sediment, where particles and fragments make themselves known as solid consciousness. A bleached and fractured world surrounds the artist. To organize this mess of corrosion into patterns, grids, and subdivisions is an esthetic process that has scarcely been touched.[1]

This excerpt from Robert Smithson's 1968 article "A Sedimentation of the Mind: Earth Projects" outlines some of the "muddy thinking" that he refers to as "abstract geology" in regard to his own earth projects.[2] As the excerpt suggests, entropy in particular is a consistent theme throughout Smithson's work. Using drawing as part of his process, Smithson maps with ink and paper ideas relating to his own executed and planned pieces as well as to geography, geology, natural history and science fiction.

The title for *Juggernaut* (1970) points back to the "eighth avatar of Vishnu whose idol at Puri, India is annually dragged in procession on an enormous car, under the wheels of which devotees are said to have thrown themselves to be crushed."[3] The common definition of the word describes it as an "institution, practice, or notion to which persons blindly devote themselves, or are ruthlessly sacrificed."[4] In this drawing we find a cart on which concrete has been poured over stacked rocks replacing the idol of Juggernaut. The Juggernaut theme relates to the effects and the irreversible nature of entropic processes that have long interested Smithson. He conceived *Island of Broken Glass* (1969), for example, as an island he would make of broken sheets of glass that over time, water would slowly wear away, turning the glass into sand.[5] He was also interested in the idea of an area "where logic is suspended—an irrational area."[6] In an essay entitled "Entropy and the New Monument," Smithson criticizes his colleagues for trying to defy time. "Instead of causing us to remember the past like old monuments, the new monuments seem to cause us to forget the future....They are not built for the ages, but rather against the ages."[7] Smithson's monuments celebrate their inevitable disintegration over time. *Juggernaut*, with its pile of rocks rolling forward, reminds us not only of the lost past but also of the continuing entropic dissolution of the present. ❖ DW

[1] Jack Flam, ed., *Robert Smithson: The Collected Writings* (Berkeley: University of California Press, 1996), 100.

[2] Ibid.

[3] *Oxford English Dictionary*, 2d ed. (London: Oxford University Press, 1991).

[4] Ibid.

[5] Robert Hobbs, *Robert Smithson: Sculpture* (Ithaca, N.Y.: Cornell University Press, 1981), 185–186.

[6] Flam, *Robert Smithson*, 199.

[7] Ibid., 11.

Concrete
poured
over
rocks
on
Flat truck
trailer

R. Smithson
70

JUGGERNAUT

Robert Smithson

91
#7 Red Sandstone Mirror, 1971
Pencil and ink on paper
24 × 19 inches

Robert Smithson's *#7 Red Sandstone Mirror* (1971) is his only drawing in this exhibition that is a study for work to be placed in an interior space. The inscription "3 mirrors set into a corner" specifically locates the work within a space and within Smithson's thinking. The use of earth against mirrors concerns, in part, the way in which the mirror (albeit fleetingly) reproduces the landscape, simultaneously mapping and displacing it.

Smithson's essay, "Incidents of Mirror-Travel in the Yucatan," documents the artist's travels through the Yucatan. But Smithson undertook the trip not to record his sightseeing among the Mayan ruins. He instead went to construct and photograph his mirror displacements throughout the area. By creating nine separate mirror displacements, photographing them with an Instamatic camera and then removing them, Smithson writes,

> A scale in terms of "time" rather than "space" took place. The mirror itself is not subject to duration, because it is an ongoing abstraction that is always available and timeless. The reflections, on the other hand, are fleeting instances that evade measure. Space is the remains, or corpse, of time, it has dimensions.[1]

Mirrors for Smithson are also a means of separating an object from its environment as a shore separates land from water. In an interview with Dennis Wheeler, Smithson gets a dictionary to look up the word "shoring," featured in this drawing's inscription "sandstone shoring it up."[2] Reading through the definition they find references to,

> shore, bank, the tangled embankment…referring to an edge for land on an ocean, lake, or other large body of water…shore, shored, shoring, support post or beam, auxiliary member, one placed obliquely against the side of a building, ship and dock or the like…support by shores or shoring.[3]

"Shoring" supports the mirrors against the wall—"shoring" them up with the rocks. But Smithson also manages an oblique reference to a "shore" eroded by waters during the passage of geological time, repeating his interest in the theme of entropy. Even Smithson's mirrors themselves imply dissolution,

> Why do the mirrors display a conspiracy of muteness concerning their very existence? When does a displacement become a misplacement? These are forbidding questions that place comprehension in a predicament. The questions the mirrors ask always fall short of the answers. Mirrors thrive on surds [irrational equations] and generate incapacity.[4]

❖ DW

[1] Jack Flam, ed., *Robert Smithson: The Collected Writings* (Berkeley: University of California Press, 1996), 122.
[2] Ibid., 225.
[3] Ibid.
[4] Ibid., 124.

Reflection

4'

4'

WALL
FLOOR

#7

RED SANDSTONE MIRROR
3 mirrors set into corner
Sandstone shoring it up
leave dust streaks on mirrors

R. Smithson

Robert Smithson

Shed With Asphalt (1970–1971) and *Asphalt Spiral* (1971) display Robert Smithson's strong interest in the associations and use of asphalt, as well as refer to the earthworks he was creating in the 1970s. Robert Hobbs attributed Smithson's interest in asphalt to the fact of it being both natural (occurring in the tar pits of prehistoric times) and modern (fabricated and used as an industrial material). "Smithson plays on the idea of asphalt as a trap for energy: he makes a tacit suggestion that asphalt highways are the 'entropic' tar pits of the present."[1] In *Asphalt Rundown* (1969), Smithson poured a truckload of asphalt down an eroded hill in Rome. The asphalt passed down the eroded channels of the hill and left a cast of the hillside. Just as the tar pits of an earlier geological age had captured and preserved plants and animals, Smithson had frozen the eroded landscape.[2] Smithson in 1973 stated: "My interest here is to root it to the contour of the land, so that it's permanently there and subject to the weathering. I'm sort of curious to see what will happen to this. But at the same time, the density of the material will make it—it's not a completely ephemeral piece."[3]

Shed With Asphalt originated with a project entitled *Partially Buried Woodshed*, executed in 1970 on the Kent State University campus. For *Partially Buried Woodshed*, Smithson found an abandoned woodshed and "took twenty cartloads of earth and piled them on [top of it] until the center beam cracked."[4] Once the center beam cracked, *Partially Buried Woodshed* became one of Smithson's entropic monuments destined for slow degradation. "You have a closed system which eventually deteriorates and starts to break apart and there's no way that you can really piece it back together."[5] Smithson drew *Shed With Asphalt* substituting asphalt for the mud and earth that crushed *Partially Buried Woodshed*. Depicting asphalt as a material, it both destroys and preserves the shed.

In 1971, Smithson executed *Broken Circle* and *Spiral Hill*, two large earthwork projects in Emmen, Holland. He turned down a site at one of the town's parks and instead selected an abandoned quarry. Hobbs writes that Smithson "referred to the place as 'a disrupted situation' and 'a whole series of broken landscapes.'...When Smithson found the quarry it had already reached a heterogeneous 'entropic' state."[6] *Spiral Hill* is a spiral mound of earth with a path of topsoil and white sand; in form, it closely resembles *Asphalt Spiral*. Because of its placement in the quarry, *Spiral Hill* overlooks *Broken Circle*, a flat work composed of parallel semicircles of water and land.

As in *Shed With Asphalt*, the difference between *Spiral Hill* and the drawing, *Asphalt Spiral*, centers on the materials Smithson has selected. The drawing lists "raw earth" and "asphalt with stones," whereas he built *Spiral Hill* with earth, black topsoil and white sand. Smithson's return to asphalt in his drawings was his attempt to capture an entropic motion while still creating monuments subject to the same entropic action.

> I'm not interested in process, but only insofar as the process is absorbed into the experience of the piece. And then you have just the piece. The piece is at once solidly there, but it's subject to the elements. And yet, all the battering they take, and as parts break off...the trickles and the bleeds on the side might disintegrate, the main body of it will just sort of lie there. I'm interested in that downslope.[7]

Smithson offers a new kind of landscape that bridges the entropy of nature with the action of humankind upon the earth. Combining this project with the romantic nature of his expressive line quality, Smithson places these works in the history of landscape. ✤ DW

1 Robert Hobbs, *Robert Smithson: Sculpture* (Ithaca, N.Y.: Cornell University Press: 1981), 173–174.

2 Ibid.

3 Jack Flam, ed., *Robert Smithson: The Collected Writings* (Berkeley: University of California Press, 1996), 224.

4 Ibid., 305–307.

5 Ibid., 301.

6 Hobbs, *Robert Smithson*, 209.

7 Flam, *Robert Smithson*, 215.

Stephen Sollins

Born 1967, Washington, D.C., works in New Orleans, Louisiana and Brooklyn, New York

94
Marker #8, 2000
Tape and newspaper transfer on mylar
42 × 54 inches

I cover up extraneous information or cut it away, or trace onto clean pages. To what effect? On the one hand, I am trying to make an absence of information into a silence that tells, that describes the distance between people, and the desire to bridge that distance.[1]

Stephen Sollins's *Marker* series focuses on aspects of the printed page that are easily overlooked. In *Marker #8* (2000), the artist has gathered into thirty-four columns and fifty-five rows 1,870 cruciform registration marks from the margins of *The New York Times Book Review*. Elizabeth Finch, the curator of a recent Sollins show, said, "This process creates an ordered expanse of signposts, the visual result of weeks looking beyond the perspectives offered by the *Review's* pages to the rhythmical space holders that keep such systems of information in place."[2]

The drawing as a whole looks like digital rain, evoking a sensation of virtual reality in which a plethora of messages have been encoded and transmitted. But Sollins' drawing also conveys a sense that it can never fully be decoded. In grasping the very unreality of cyberspace, his brilliant work casts doubt on our perception of reality in the digital age and suggests an uncertain future. ✛ CW

[1] Stephan Sollins, Statement on Receiving the New York Foundation for the Arts Artists' Fellowship, http://www.nyfa.org/artists_fellowships/af_fellows2001_printmaking.htm.
[2] Elizabeth Finch, ed., *Stephen Sollins: Dwelling* (New York: Mitchell-Innes and Nash, 2002), 4.

Richard Tuttle

Born 1941, Rahway, New Jersey, works in Abiquiu, New Mexico

95

Leaning Drawing, 1970s
Green paint and marker
on cardboard
1 ¾ × 6 inches

After Richard Tuttle received his B.A. from Trinity College, Hartford, he moved to New York where in 1965 he had his first solo exhibition at the Betty Parsons Gallery. Most of Tuttle's work in the 1960s and 1970s—whether small sculptures, installations or drawings—is simple, subtle and tranquil. Tuttle intently focuses on things that often escape notice, a characteristic of his early work that relates to Zen.[1] Identifying a parallel between Tuttle's working methods and the meditative practice of Buddhist monks, Margrit Franziska Brehm states,

> [The work] actually begins when the artist, pencil in hand, stands parallel and in close proximity to the white wall for the first time....The pencil is not applied until after a phase of acclimation and orientation...then comes a moment of calm in which the artist bows his head, coming to dwell "within himself." When he finally raises his head, the drawing begins—with the undivided attention and concentration of the artist.[2]

After achieving this state of clarification and concentration, Tuttle begins to draw. This process sustains the spiritual pursuits of self-reflection and self-discovery.

Tuttle's drawing is not a mere illustration of a concept but the record of an experience the artist has when he draws. As Tuttle himself put it, "It's a cat and mouse game. You can see canvas. You can see paint. But you can't see the crossover. You need enough of a suggestion to awaken the mind to the crossover so it can see it, the invisible."[3] In his small drawings and sculptures of the 1960s and 1970s, Tuttle sought not to awaken, but rather to be awakened.

Leaning Drawing, here shown in actual size, is one of the small works of the 1970s that had been stored for two decades in a cardboard box in Tuttle's studio. In 1996, Tuttle and his friends rediscovered these works and organized a show called *Small Sculptures.* During the installation of the works, Tuttle made discoveries, "Much to my surprise, pieces I didn't understand became understandable."[4] He placed this drawing at the join of a wall and a floor and titled it *Leaning Drawing* (see below).

Tuttle doesn't present finished solutions or products. Like the almost invisible pencil lines hanging in irregular loops on a wall in *Wire Pieces* (1972), *Leaning Drawing* is an impalpable abstract form as well as a tangible object in real space. In both the process of its creation and its installation, it is an open-ended experiment and an investigation into the artist's own spirit. ❖ CW

[1] Jonathan Fineberg, *Art Since 1940: Strategies of Being,* 2nd edition (London: Laurence King, 2000), 318.

[2] Margrit Franziska Brehm, "...It Comes from Art, " in *Richard Tuttle: Chaos, the Form* (Stuggart: Edition Cantz, 1993), 18.

[3] Valerie Wade, *Richard Tuttle: New Release: Any Two Points* (San Franciso: Crown Point Press, 2000), 1.

[4] Richard Tuttle, *Small Sculptures of the 70s* (Zurich: Annemarie Verna Gallery, 1998), unpaginated.

Leaning Drawing installed at Annemarie Verna Gallery, Zurich, Switzerland, as part of *Small Sculptures of the 70s,* 1998.

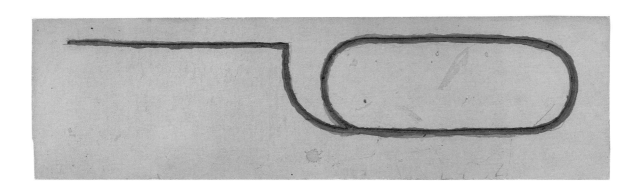

Richard Tuttle

96, top
Step (#35), 1971
Watercolor on paper
8 ⅞ × 5 ¾ inches

97, left
Drawing (#15), 1970
Pencil on paper
11 ¾ × 8 ⅞ inches

Marcia Tucker, curator of Richard Tuttle's 1975 show at the Whitney Museum of American Art, stated "Tuttle's work is most immediately and clearly perceived on an intuitive, physical, experiential level; it is 'felt' rather than 'understood,' and lends itself to a powerful, often transcendental physical assimilation rather than to verbal analysis."[1] Tuttle's small drawings can be felt without the intervention of language. They look impermanent and informal. However, when you begin to look at a Tuttle drawing very carefully and closely, as Jonathan Fineberg has written, "there seem to be so many little things that make it more complicated to describe than you thought at first."[2]

Drawing #15 (1970) is like an amber of fossilized life forms. The slightly trembling brushwork resembles a cluster of worms, the most mundane of creatures, but the work transforms life into abstractions on paper. "Whatever is abstract," Tuttle said, "is not in the world. But when it comes together as art it is in the world."[3] Tuttle understands simplicity as the essence of abstraction as well as the core of the dialectic between the world and his minimal approach to art. He seems to endow every form in his drawings with an organic life.

Tuttle takes a humble, almost devotional attitude to nature. He believes that "nature admires the simpleminded. Nature's admiration is exactly the opposite of human admiration."[4] In this, Tuttle grasps the kernel of Buddhism: The thousands of things in the world can be reduced to a simple point, and this is how enlightenment begins.

In *Step (#35)* (1971), dozens of small irregular bricks in green watercolor sort themselves into a complex pattern, like a visual poem composed of vivid and living elements. The impression is casual and comforting, though the arrangement is complicated. Again, Tuttle masters the dialectics of simplicity and complexity. The green watercolor squares trace Tuttle's own spiritual reflection: The green suggests life and creativity; the scattering composes an irregular shape that resists definition and category. Like an electroencephalogram (a graphic record of electrical activity in the brain), this pattern appears both incomprehensible and at the same time the most faithful record of Tuttle's mind. Yet the work resists scrutiny by formal analysis, because what you literally see is not important; what matters is the artist's engagement with nature in the process. For Tuttle, drawing is an open-ended and spiritual journey. ✤ CW

1 Marcia Tucker, *Richard Tuttle* (New York: Whitney Museum of Modern Art, 1975), 20.
2 Jonathan Fineberg, *Art Since 1940: Strategies of Being*, 2nd edition (London: Laurence King, 2000), 318.
3 Valerie Wade, *Richard Tuttle: New Release: Any Two Points* (San Francisco: Crown Point Press, 2000), 1.
4 Ibid.

98, right
Pyramid (#16), 1975
Pencil on paper
12 × 9 ⅞ inches

Pyramid (#16) (1975) highlights Richard Tuttle's artful ambiguity and simplicity. Unlike the delicate line that appears in *Leaning Drawing* and *Drawing (#15)* or the seemingly evanescent scatter in *Step (#35)*, this drawing's architectural construction of five small, black rectangles seems to defy gravity, as if Tuttle conceived the composition as an agravic (zero gravity) state. The structure appears temporary, at risk, as if on the verge of collapse. It reflects Tuttle's exploration of the spatial possibilities of the picture plane—a project that culminates in his major work of the mid-1990s *Replace The Abstract Picture Plane*.[1] The unsettling spatial tension of the blocky, floating forms in this work contrasts with the tranquility and calm of Tuttle's early drawings. The precarious balance of the block-like structure seems to reflect the fragility of every moment. Tuttle's "pleasure," John Hutchinson wrote, is to "reveal the beauty of the transient and ordinary."[2] *Pyramid (#16)* seems to reflect his full awareness of the uncertainty and impermanence of the world. ✤ CW

1 Matthias Haldemann, ed., *Richard Tuttle: Replace The Abstract Picture Plane* (Zug: Hatje Cantz Verlag, 2001).
2 John Hutchinson, "Festina Lente," in *Richard Tuttle* (London: Camden Arts Center, 1996), 2.

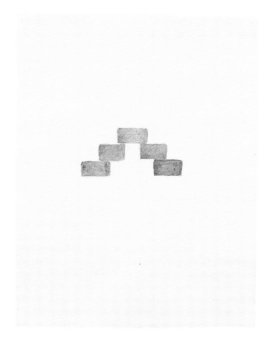

Lawrence Weiner

Born 1940, Bronx, New York, works in New York City

99, opposite
Paradigmatic Scheme for a Book About Books, Art Metropole Catalog, 1984
Ink, pencil, paint and collage on paper
$9\,5/16 \times 8\,5/8$ inches

Language plays a key role in Lawrence Weiner's art. While in the early 1960s Weiner created solid, three-dimensional sculptures, by 1967 he no longer used tangible materials; instead he began to use words that described those materials such as slabs of stone. In the 1990s his linguistic references grew decreasingly material, such as in the phrase, *As Long as it Lasts*. Despite such immaterial subjects, Weiner still describes his project in sculptural, physical terms, "I think that I am really just a materialist. In fact, I am really just one of those people who is building structures out in the world for other people to figure out how to get around."[1] Weiner regards even immaterial prepositional phrases or abstract ideas as sculptural material.

The medium of language allows his sculptures to be presented in a variety of contexts—from gallery walls to city streets—constantly changing the sculptures' meaning. In 1968 Weiner published his first book, *Statements*. Books allowed the sculptures to be moved even more easily into new contexts, and their reproducibility made them accessible to more people.

Although the only recognizable words in Weiner's drawing *Paradigmatic Scheme for a Book About Books, Art Metropole Catalog* (1984) are the title words, the rectangular shapes, which look almost like musical staffs, function as a visual shorthand for the material space Weiner ascribes to language. In essence, he has cleared an abstract space for the words that will fill the published book. Weiner often draws boxes around words, and in many cases the boxes have a notch missing from the top, which he describes as an intrusion or a removal (like the notch missing from the top rectangle in *Paradigmatic Scheme*). According to Weiner, the removal of a notch objectifies a neutral rectangle.[2] Imagining the rectangles as objects in Weiner's conceptual layout emphasizes the physicality of the ideas that will fill the pages.

The space that ideas occupy has been a concern of Weiner's since early in his career. In a 1969 conversation with Seth Siegelaub, Douglas Huebler, Joseph Kosuth and Robert Barry, Weiner insisted that all art takes up space, even when it is an idea that is not executed in material form: "Anything that exists has a certain space around it; even an idea exists within a certain space."[3] Weiner's rectangles, then, visually signify the abstract space that language fills. This shorthand, however, does not need to objectify the space of language, because Weiner considers the space language fills to be infinite. As he explained later in the same conversation, "When you are dealing with language, there is no edge that the picture drops over or drops off. You are dealing with something completely infinite. Language, because it is the most non-objective thing we have ever developed in this world, never stops."[4] Weiner's drawing embodies this paradox. The empty rectangles both mark out a space for the ideas and express the infinite possibility of the words they will contain. ❖ SLE

[1] Lawrence Weiner, interview by Benjamin H. D. Buchloh, in *Lawrence Weiner*, ed. Alexander Alberro et al. (London: Phaidon Press, 1998), 13.
[2] Lawrence Weiner to Julie Vicinus, correspondence, 13 May 1997, in reference to his *Serpent Mounds Ohio* (1984).
[3] Weiner, *Lawrence Weiner*, 94.
[4] Ibid., 98.

100, pages 168–169
Polaris, 1990
Black ink, felt tip pens, rubber stamp, colored inks and watercolor on vellum
19×48 inches each
Museum of Modern Art, New York

Sailors have long navigated by Polaris, the North Star, because it is the star nearest to the North Pole and supposedly remains nearly stationary throughout the night. Yet, in his two drawings entitled *Polaris* (1990) (see pages 168–169) Weiner calls this stability into question by juxtaposing the word "Polaris" with the phrase, "Stars Don't Stand Still in the Sky." The cut-out holes in the drawing, always located next to the stamped label "Polaris," further emphasize this contradiction by suggesting lack or negative space where the stationary, guiding star should stand. The quickly drawn arrows that always accompany the circled phrase "& so it goes" also suggest movement in a designated direction—"& so it goes," meaning "it goes this way."

Much like the stars that don't stand still in *Polaris*, Weiner's sculptures are often placed in different contexts that encourage new and sometimes contradictory meanings. For example, Weiner denied having intended a metaphor for the destruction of World War II when he placed his piece *(SMASHED TO PIECES) IN THE STILL OF THE NIGHT* on a World War II antiaircraft defense tower in Vienna. In an interview he explained the same sculpture could be placed in a variety of contexts and express numerous metaphors,

> Art is fabulous because it starts off as one thing and becomes something else for somebody….If I put it in another context, which I often do as you know, it has a totally different metaphor. You put that piece in the South Pacific and all night you will hear coconuts falling.[1]

Polaris's emphasis on movement suggests a metaphor for Weiner's sculptural project: Just as the stars keep moving, Weiner's constantly recontextualized sculptures cannot be pinned down with one ideal metaphor or meaning. ❖ SLE

[1] Lawrence Weiner, interview by Benjamin H. D. Buchloh, in *Lawrence Weiner*, ed. Alexander Alberro et al. (London: Phaidon Press, 1998), 26.

PARADIGMATIC SCHEME FOR A BOOK ABOUT BOOKS
ART METROPOLE CATALOG

LAWRENCE WEINER AMSTERDAM / NEW YORK CITY 1984

Mark Williams

Born 1950, Pittsburgh,
Pennsylvania, works
in New York City

101, top
Geist drawing #1, 1996
Ink wash on
Arches paper
22 × 30 inches

102, bottom
Geist drawing #5, 1996
Ink wash on
Arches paper
22 × 30 inches

Mark Williams's drawings assume a familiarity with the monochromatic experiments of minimal and conceptual art in the late 1960s and early 1970s, as this is the discourse on which his nuanced, formal compositions have centered.

In *Geist drawing #1* (1996), a dark ink stripe separates two quadrilateral fields; the gray-toned half-quad embraces a white rectangle on the left edge of its center, whereas the right half of the drawing is completely white. *Geist drawing #5* has a family resemblance to *Geist drawing #1* with its composition of two fields of gray wash. "My compositions have geometric rhythms and I develop them into a group of paintings," Williams said. But he also noted that "I make the rules and I can change them."[1] Both drawings are meticulously made with barely legible lines over modulated washes of ink on uniform sheets of Arches paper. The geometric clarity and the modulated tonalities are defining characteristics of Williams's work. The pictorial fields, separated yet related across an interstice in *Geist drawing #5*, direct the viewer to the subtle formal relations and variations that define the whole series.

Williams wishes to represent nothing in his works. *Geist #1* and *Geist #5*, he says, have "No color. No line. Only a drop or two of ink in water. A light touch. The title 'Geist' does refer to ghost. (*Geist* means "ghost" in German.) The image is soft, spectral, so in a real sense the drawing is barely there."[2]

These drawings are stylistically reductive and emerge through a modular process.

Indeed, seeing them in a series brings out the individual nature of each one separately. However, juxtaposing several of Williams's works in the same series also make them appear more uncontrolled than connected, as differences emerge. ❖ CW

[1] Mo Eich, *Mark Williams Recent Painting Exhibition News Release* (New York: Eich Space, 1997), 1.
[2] Mark Williams, electronic correspondence with author, 18 May 2002.

Permissions

Artwork copyright by catalogue number:

1–3: © Carl Andre / Licensed by VAGA, New York

4–5: © Jill Baroff

6–7: © James Bishop

8–9: © Louise Bourgeois, courtesy Cheim & Read, New York

10–13: © Trisha Brown

14–15: © Courtesy the John Cage Trust and Margarete Roeder Gallery, New York

16–17: © Anne Chu

18–19: © Marsha Cottrell

20: © Walter De Maria

21–23: © Estate of Dan Flavin / Artists Rights Society (ARS), New York

24–25: © Suzan Frecon

26–27: © Simon Frost

28–29: © Cheryl Goldsleger

30–31: © Robert Grosvenor, courtesy Paula Cooper Gallery, New York

32–33: © Nancy Haynes

34–35: © Reproduced with the permission of The Estate of Eva Hesse. Galerie Hauser & Wirth, Zurich

36–37: © Christine Hiebert

38–42: © Jasper Johns / Licensed by VAGA, New York

43 and figure photograph: Art © 2002 Estate of Donald Judd / Licensed by VAGA, New York

44–45: © Ellsworth Kelly

46: © Eve Andrée Laramée

47–51: © 2002 Sol LeWitt / Artists Rights Society (ARS), New York

52: © Glenn Ligon, courtesy of the Artist and D'Amelio Terras, New York

53–54: © Sharon M. Louden

55–56: © 2002 Robert Mangold / Artists Rights Society (ARS), New York

57–60: © 2002 Brice Marden / Artists Rights Society (ARS), New York

61: © Tom Marioni; photograph on page 104 by Larry Fox, courtesy of Crown Point Press

62–64: © Agnes Martin, courtesy PaceWildenstein Gallery

65: © Stefana McClure

66–67: © Paul Mogensen

68: © 2002 Robert Morris / Artists Rights Society (ARS), New York

69 and figure photograph: © 2002 Bruce Nauman / Artists Rights Society (ARS), New York

70: © Laurie Reid

71: © 2002 Dorothea Rockburne / Artists Rights Society (ARS), New York

72–73: © Winston Roeth

74–76: © Ed Ruscha

77–78: © Robert Ryman, courtesy PaceWildenstein Gallery

79–81: © Fred Sandback

82–83: © Erik Saxon

84–85: © Carole Seborovski

86–89 and figure photographs: © 2002 Richard Serra / Artists Rights Society (ARS), New York; photograph on page 146 by Peter Moore; page 150, Dirk Reinartz; page 152, Huger Foote

90–93: © Estate of Robert Smithson, courtesy of James Cohan Gallery, New York / Licensed by VAGA, New York

94: © Stephen Sollins

95–98: © Richard Tuttle; photograph on page 162 by Thomas Cugini, Zurich, 1998

99–100: © 2002 Lawrence Weiner / Artists Rights Society (ARS), New York

101–102: © Mark Williams

All photography for the main catalogue images by Peter Muscato.